Love

Jim Carter

BARBARA CARTLAND'S

Book of Love and Lovers

Michael Joseph
London

First published in Great Britain by
Michael Joseph Limited
52 Bedford Square
London WC1
1978

ISBN 0 7181 1719 0

This book was designed and produced by
The Rainbird Publishing Group Limited
36 Park Street
London W1Y 4DE

Text filmset by SX Composing Ltd, Rayleigh, Essex
Printed and bound by Dai Nippon Printing Co.,
Tokyo, Japan

Contents

Preface

I think a picture should be an inspiration, informative or amusing. It is with that idea in mind that I have chosen the pictures – from over two thousand – for this book.

I also feel that love should be represented at its highest level – the spiritual combined with the physical – and lovers should look attractive and romantic.

Some of the greatest masterpieces of mankind have been inspired by love, just as man has been elated, enriched, transformed and transfigured by being in love. He has equally suffered torture, betrayal, poverty, degradation and death in the name of love.

For all of us Love is the greatest and the most irresistible force in the world and our hope of Heaven.

Adam and Eve

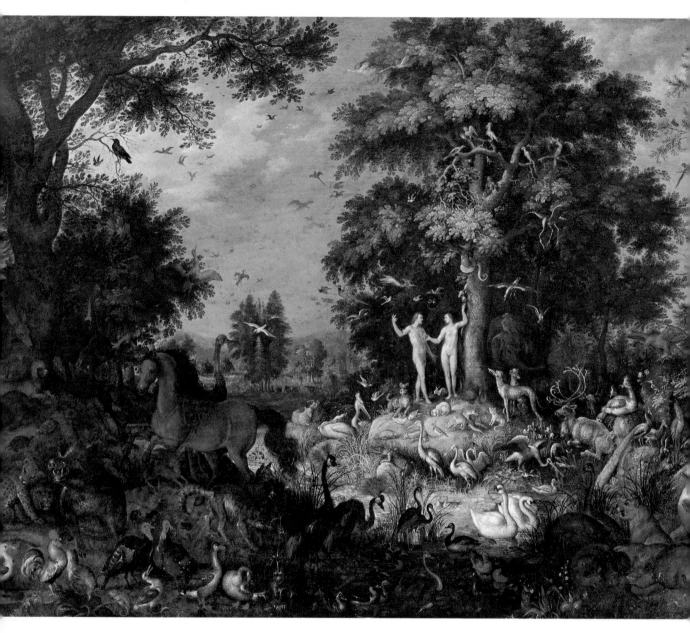

We each create an Eden for ourselves. For some it is a oasis of quiet and gentleness, for others a place of gaiety and laughter. For me it is where I find love, and that is the Eden everyone seeks.

Love is not just the attraction of a man for a woman, or a woman for a man. It is something far more fundamental. It is the life-force which is transmitted through everything which lives, from the earth to the creatures that dwell on it.

The life-force animates our flesh but it also gives our minds the insight which enables mankind to reveal a little of the 'world beyond the world'. Music, painting, writing and sculpture are all a finite effort to produce the infinite.

It was the Ancient Greeks who first opened men's minds to beauty. To them, men were only a little less than gods and they saw the divine beauty which was, in the words of Socrates, 'pure, clean and undefiled, untouched by the corruption of mortality and the vanities of human life'.

The Greeks saw holiness wherever they looked, and it was beautiful. It was a child singing in

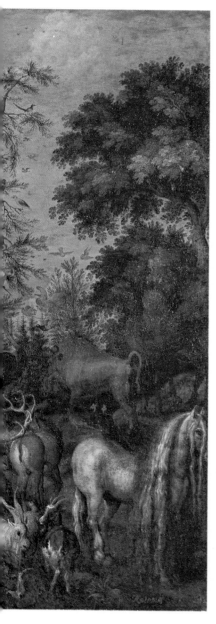

The Garden of Eden with Adam and Eve and all Creation Roelandt Savery 1576–1639

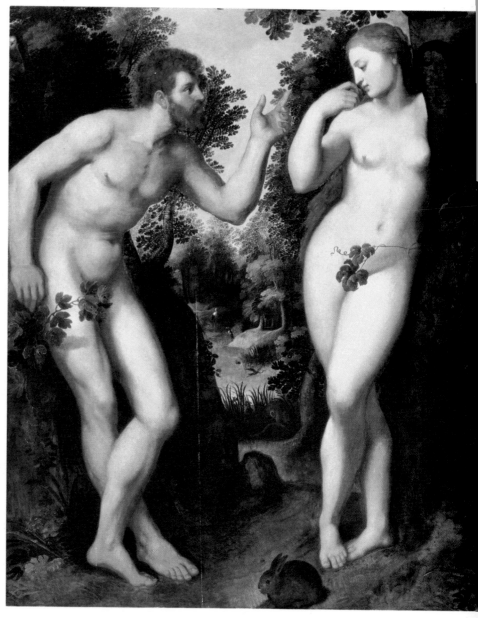

Adam and Eve Peter Paul Rubens 1577–1640

the cornfield, the sand washed by the sea, the 'rosy-fingered dawn', a woman smiling at her lover.

This is the beauty we all seek, which is perfect love lifting those who know it on the quivering silver wings of ecstasy into the Divine light.

God gave us the key to the Garden of Eden – it is called imagination.

My Adam is strong, handsome, courageous, dominant and very masculine.

With woman as his guide and inspiration Adam can also be the perfect gentle Knight. But modern woman has undermined his authority as master in his own house, and in a plastic apron doing the washing-up he is a pathetic pseudo-man.

My Eve is beautiful, alluring, seductive and irresistibly feminine.

She has in the past inspired, through love, the greatest masterpieces in every aspect of Art, she has started and ended wars, she has built and destroyed nations and advanced civilization. But she has done this through love and beauty.

Today, in trousers, she is an inadequate imitation of Adam.

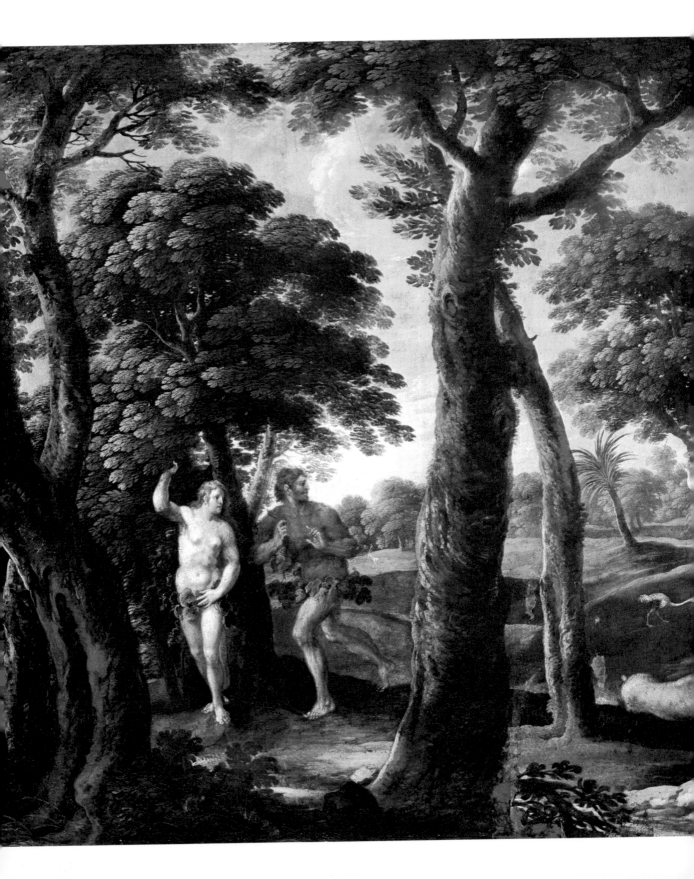

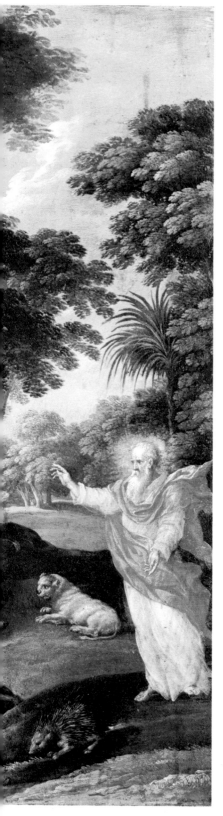

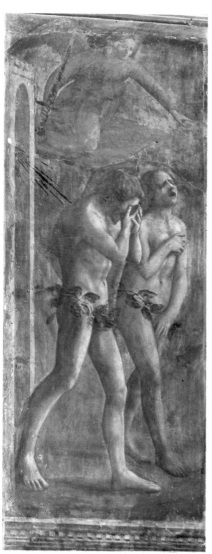

▲ *The Expulsion* Rogier Van der Weyden, *c.*1400–1464

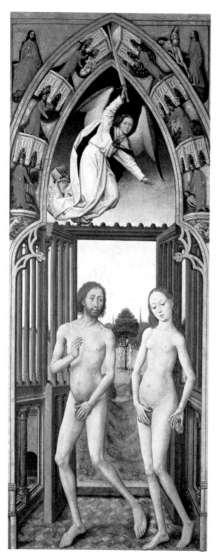

The Expulsion Tommaso Giovanni di Mone Masaccio 1401–1428

Betrayed by Eve who could not resist the serpent, they go naked. Having been expelled from Eden and Paradise into a hard, difficult, heart-breaking world, every one of us wants to get back. There is only one possible way in which we can slip past the Angel with the flaming sword – it is by using the password – 'Love'.

◄ *Expulsion from Paradise* Anonymous; Flemish, 17th century

In sorrow, repentance and tearful regret they leave Eden. This was the first time Eve tried tears to get her own way – they were not effective! But she has tried them ever since, at times much more successfully. When they left Eden, Eve's nakedness was considered degrading. What would she think today, when stripping is so commonplace that one has to be fully dressed to be sensational!

The Goddess of Love

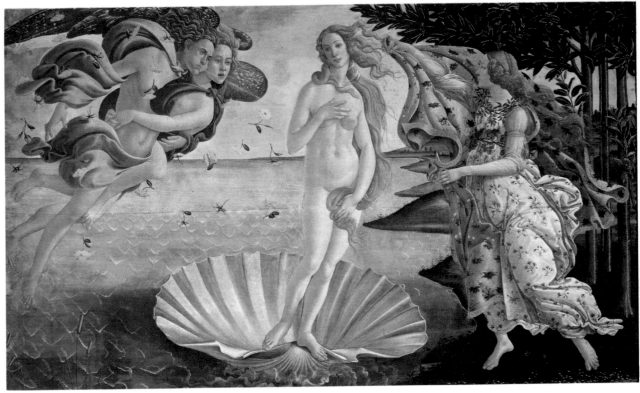

The Birth of Venus Sandro Botticelli
1445–1510

Man has always identified the goddess of love with the woman he loves. Pictures through the ages have therefore often depicted ugly as well as beautiful women.

I think the loveliest of them all was Simonetta Vespucci, immortalized by Botticelli. She inspired a whole generation of artists, and was the mistress of Giuliano de Medici, the brother of Lorenzo the Magnificent, who wrote an ode in her honour.

She died of consumption when she was twenty-three and her body was carried through the streets of Florence with her face uncovered so that all could see her beauty.

A poet who was present, looking up to the heavens, cried 'Her soul hath passed into a star.'

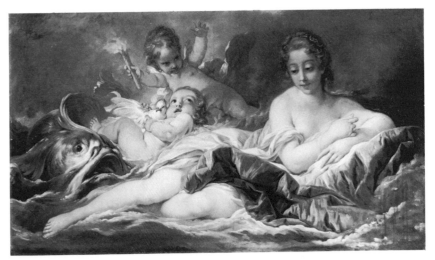

The Birth of Venus François Boucher
1703–1770

The legend tells us that Cronus castrated Uranus, his father, and cast his genitals into the sea. They floated on the surface producing white foam, from which rose Aphrodite. She was carried on the breath of Zephyrus the West Wind to Cyprus. Here she was conducted by the Hours to the Assembly of Immortals, where the gods each 'wished in his heart to take her as a wife and lead her to his abode'.

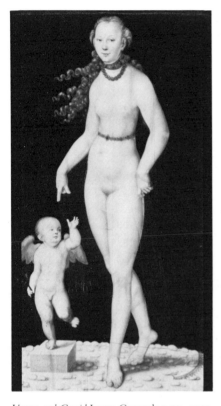

Venus and Cupid Lucas Cranach 1472–1553

In 1509 Cranach was responsible for the first completely naked Venus in the history of Northern European painting (now at Leningrad). His discovery of the secular nude was, surprisingly, as the result of a visit to Flanders!

The Birth of Venus Alexandre Cabanel 1824–1889

I love this Venus – she has a physical and spiritual charm. The more one reads history and studies pictures, the more one realises that the women who inspired men to greatness and changed the world had an inner beauty – a spiritual radiance.

Cabanel was noted for his slightly erotic treatment of the female nude.

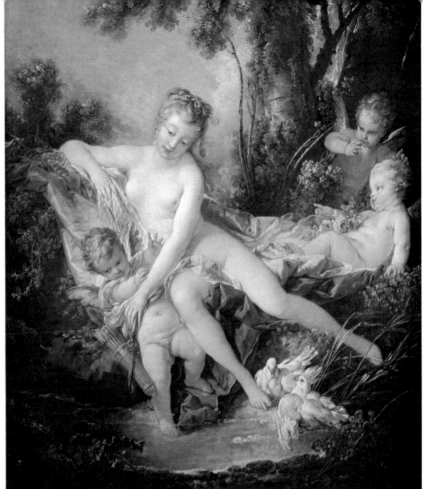

Venus Consoling Love François Boucher 1703–1770

I think better than any other artist, Boucher portrayed goddesses who were lovely and yet very human.

In this picture Venus appears exactly as she was described by the poet, as mistress of 'seductive conversation, gracious laughter, sweet deceits, the charm and delights of love'.

François Boucher began his career by making engravings. He became the Director of the Académie in 1765 and was the first painter to Louis xv.

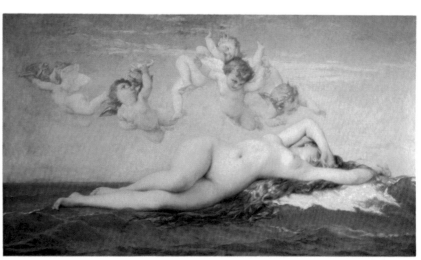

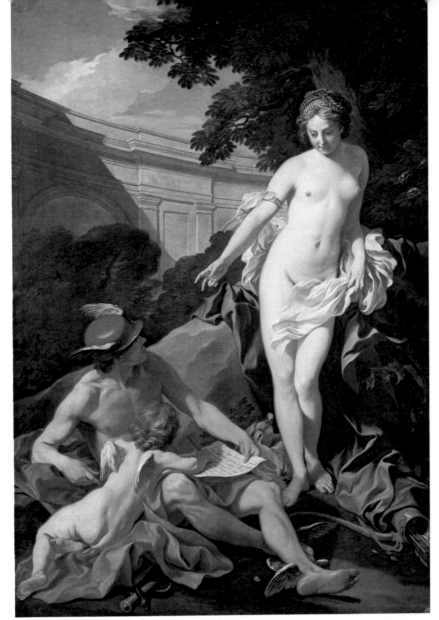

◀ *Venus, Mercury and Cupid* Louis Michel Van Loo 1707–1771

Hermes, or Mercury, was above all the god of travellers, whom he guided on their perilous ways, and as an extension of this rôle Hermes was also charged with conducting the souls of the dead to the Underworld.

Homer made him the Messenger of Zeus and idealistically he is depicted as an athletic god with a lithe graceful body.

Aphrodite was married to Hephaestus but Hermes was her lover and they had a son called Hermaphroditus. He was a shy youth brought up by the nymphs of Mount Ida, who concealed him from Hephaestus. Accosted by a water nymph, he tried to resist her advances. But she prayed that nothing should separate them and they were united in a single body of dual sex.

Hermes is the benefactor of mankind, protecting their goods, guiding them on their voyages, presiding over their business affairs. He inspires their melodious speech and eloquence.

His winged sandals carry him like a breath of wind.

Venus and Love Titian *c.* 1487–1576 ▶

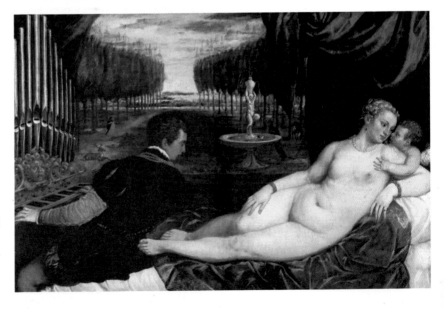

It seems to me extraordinary that while in 1863 *Déjeuner sur l'herbe* by Manet, which showed a naked woman sitting with three clothed men, caused violent denunciations as 'obscene' and 'indecent', Titian, by labelling this woman Venus, 'got away with it'.

The large fleshy if lovely model, not in her first youth, has obviously diverted the over-dressed gentleman from the organ, but the fact that Cupid is whispering in her ear makes the picture respectable, if provocative.

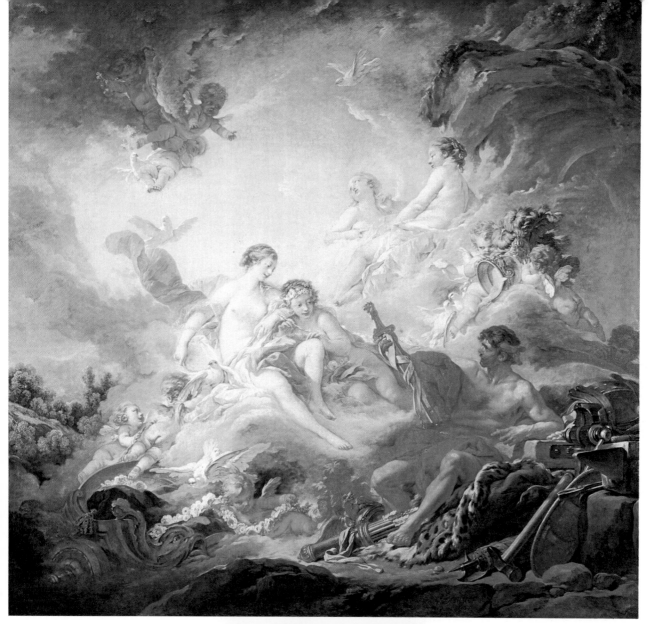

I love this picture: the idea of Venus, like any other wife, visiting her husband's place of work is fascinating. Vulcan was one of the oldest of Latin gods, predating Jupiter.

God of the thunderbolt, he was associated with life-giving warmth. His Greek counterpart Hephaestus was the son of Zeus and Hera: she disliked him because of his lameness and cast him out of Olympus.

But he was the greatest artist among the gods and a brilliant worker in metal. Zeus gave him Aphrodite as a wife because he invented the thunderbolt.

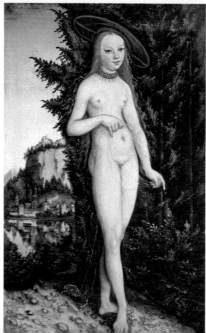

▲ *Venus in the Forge of Vulcan* François Boucher 1703–1770

◀ *Venus in a Landscape* Lucas Cranach 1472–1553

What woman with a figure like that would not want to wear her best hat and necklace for a walk in the woods.

'She is Venus when she smiles;
But she's Juno when she walks,
And Minerva when she talks.'

But all woman – charming, enchanting, alluring, feline, seductive – and who can resist her?

Dreams of Love

The Dream Arthur Rackham 1867–1936 ▶

My childhood and therefore my whole life was influenced by Arthur Rackham's pictures. His sensitive lovely drawings awoke my imagination and inspired me with a belief of fairies in the flowers, goblins working deep beneath the hills, elves hidden in the trees.

There were Dragons in the dark depths of the pinewoods and nymphs rising in the mist over the streams. There, good and evil was clearly defined and the magic he evoked has never left me. Every time I see the leafless branches of the trees silhouetted against the winter sky or the sunset I feel a spiritual awareness which was so much part of my childhood.

Arthur Rackham gave me dreams which still carry me to fairyland.

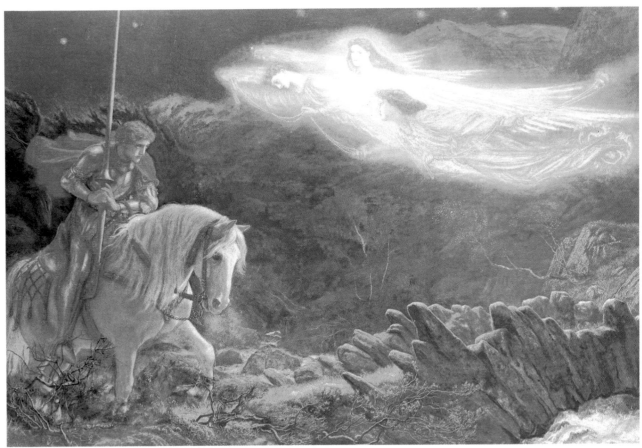

Sir Galahad Arthur Hughes 1837–1915

I find this picture very inspiring. To me it is what we all feel when, determined to pursue the path of duty, we are tempted into other and much more attractive pursuits and pleasures. We all know the course Sir Galahad will take, but what will be ours?

Arthur Hughes was one of the closest followers of the romantic Pre-Raphaelites and particularly influenced by Millais.

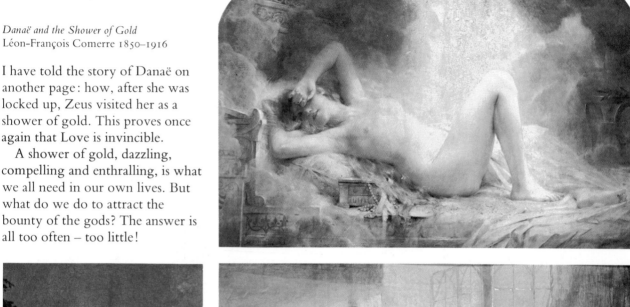

Danaë and the Shower of Gold
Léon-François Comerre 1850–1916

I have told the story of Danaë on another page: how, after she was locked up, Zeus visited her as a shower of gold. This proves once again that Love is invincible.

A shower of gold, dazzling, compelling and enthralling, is what we all need in our own lives. But what do we do to attract the bounty of the gods? The answer is all too often – too little!

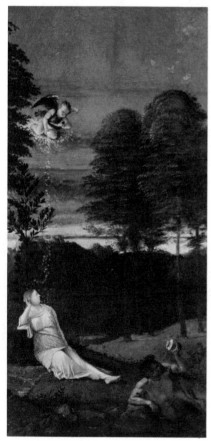

A Maiden's Dream Lorenzo Lotto 1480–1556

What could this poor girl, who is as plain as a pikestaff, dream of, except love – which in her case will only be a dream.

Dreams John Austen Fitzgerald 1832–1906

I have chosen this picture because it is a clever portrayal of the adolescent mind – fairy tales, goblins, elves and other nameless beings, all tinged with the romanticism of the lovers in the background.

'I dream, I wake, but only see
My dream world still enfolding me.'

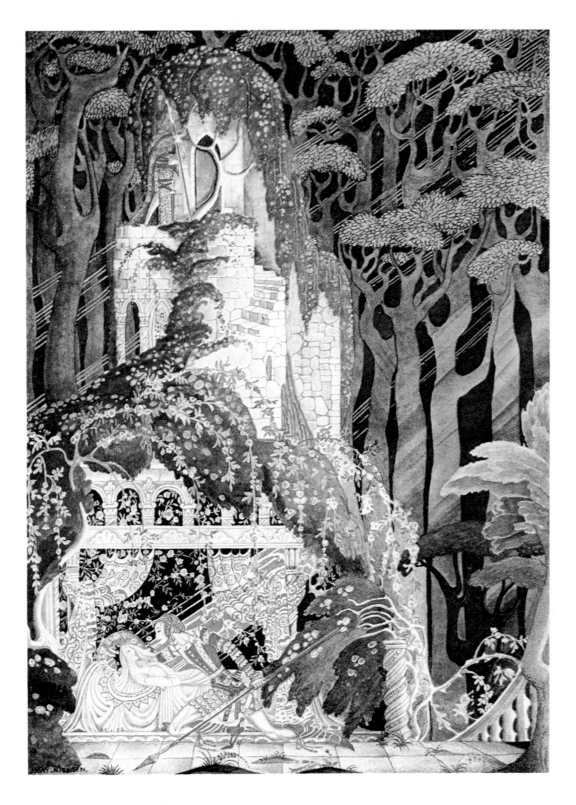

Rosebud Kay Nielsen 1886–1957

This is the loveliest picture of Sleeping Beauty. I have always adored this story and I have visited the Castle of Usse, which inspired Perrault to write it. It gave me a fascinating plot for my novel called *The Castle Made for Love*.

I think the story is really symbolic of the secret wish of every man to awaken to desire the woman he loves. The true heroine of romance is young, innocent and untouched until Prince Charming finds her and claims her as his own.

What a pity so many girls do not wait for their Prince, but 'make do' with the counterfeit.

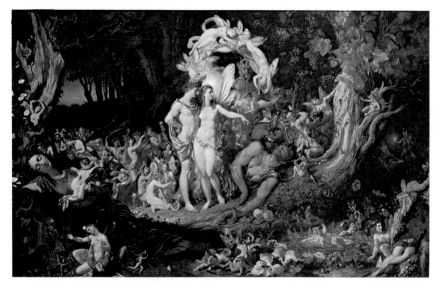

The Reconciliation of Oberon and Titania
Joseph Noel Paton 1821–1901

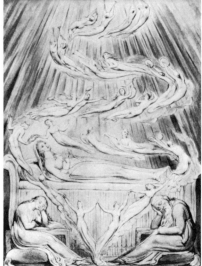

Queen Katherine's Dream William Blake
1757–1827

The wild celtic imagination of Sir Joseph runs riot in this painting. I see myself as the girl asleep, dreaming of the exquisite, if somewhat sexual, fairy figures. The Victorians had a fascination for the subconscious and today, however much we know about science and the exploration of space, what the Chinese call 'the world beyond the world', it is still a mystery. It is the subconscious which gives us an insight into nature and an appreciation of beauty and music.

Blake drew what he imagined and this particular picture stirs my imagination. He longed to be the Michelangelo of his day but became more like a medieval monk working alone in his cell.

Yet a painter said of him: 'He ennobled poverty and by his conversation and the influence of his genius made two small rooms in Fountain Court more attractive than the threshold of Princes.'

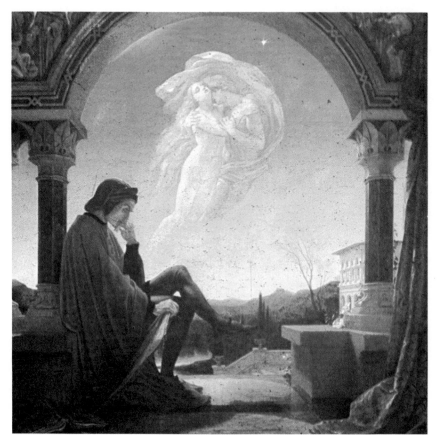

Dante's Dream Joseph Noel Paton
1821–1901

Dante's vision of the dead Beatrice is sheer romanticism. It is amazing that the story of a man obsessed with a young girl to whom he never spoke should excite so much sentiment and inspire so much poetry and painting.

I think there is a longing within us all for the unattainable and also an instinctive desire not to be awakened by reality and disillusionment.

Beatrice is the perfect love all men keep enshrined in their hearts and which only once in a blue moon are they fortunate enough to hold and possess.

[19]

Diane de Poitiers

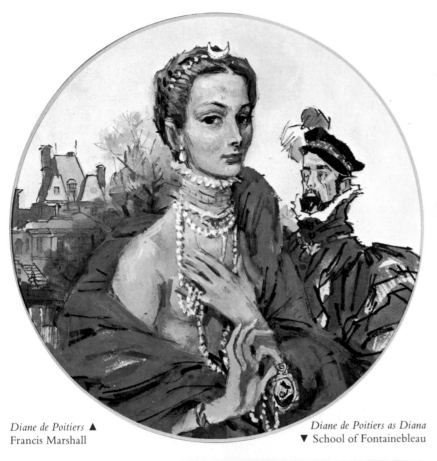

Diane de Poitiers ▲
Francis Marshall

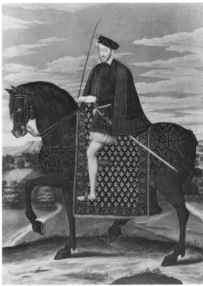

Henri II François Clouet 1516–1572

Diane de Poitiers as Diana
▼ School of Fontainebleau

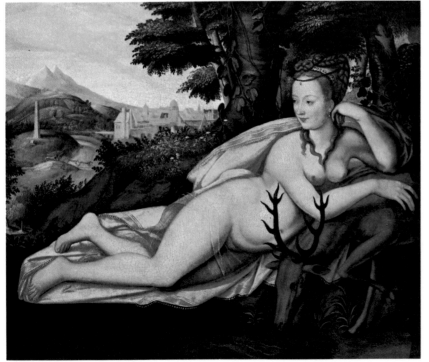

The most beautiful woman in France, Diane de Poitiers was eighteen years older than the King – Henri II – when he fell madly in love with her. The subject of one of the most famous love stories of all times, from 1547 until Henri's death in 1559 she virtually ruled France.

Because of her adoration of her country, Diane realised the King must have heirs. On many nights when Henri came to her arms, she would return his passionate kisses, then suddenly say: 'Go to your Consort and lie with her.'

The Queen became pregnant and Diane received from the Royal Exchequer a gift of 5,500 *livres* for her 'good and commendable services . . . for the welfare of the Queen'.

Diane's statesmanship made Henri's reign one of the most remarkable in French history.

Henri had many pictures painted of the woman he worshipped. Opposite, he rides past as Diane is portrayed as her immortal namesake, listening to the pipes

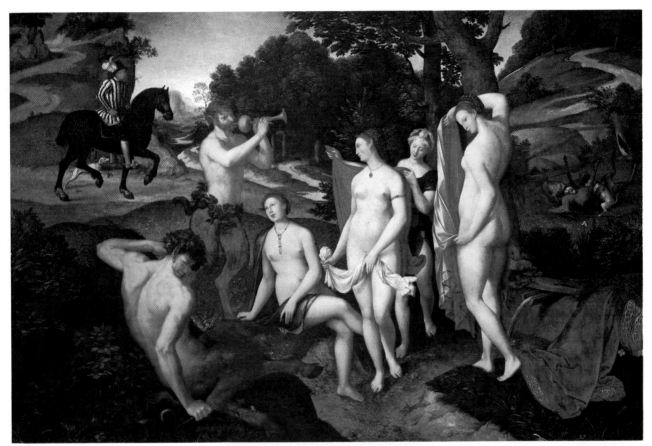

Catherine de Medici School of Clouet

of Pan. Because she was so beautiful it was whispered at Court: 'It is witchcraft that explains Madame's youth. She communes with Satan.'

The real reason for her perfect figure and glowing health was that she bathed every day in well water and replaced the rich dishes and heavy wines with fresh fruit and vegetables.

The King's love expressed itself everywhere: today we can still see the cipher D and H entwined on the Palaces and Chateaux of France. He said to his artists and sculptors:

'It is my duty to see that the generations as yet unborn have some knowledge of Madame la Duchesse's transcending beauty, for surely it is not of this world.'

Queen Catherine de Medici, an Italian, was crazily jealous. She held Satanic Black Magic ceremonies to try to destroy Diane.

At one Palace she had a carpenter bore two holes in the ceiling above Diane's bedroom. Here, lying full length on the floor, she could watch the King and his mistress make love, with wild uncontrollable passion, then lie entwined together, content and at peace.

Henri was killed in a jousting tournament, when a broken lance passed through the gap in his vizor, and penetrated his skull. Diane retired to her home at Anet. She died in 1566, still gloriously beautiful.

Love at First Sight

The Bridesmaid James Joseph Jacques Tissot
1836–1902

I love the fascinated, slightly lustful expression on the man's face, and one wedding always leads to another. Love at first sight happens, but it is wise to take another look and make sure.

She appears deliciously unaware of the effect she has had on him but that sixth sense tells her he is caught, captured and conquered. The usual gaping sightseers that appear at every wedding are in the background.

Tissot was handsome and cut a figure in society after he arrived in England. His pictures are haunted by his mistress, an obscure *femme fatale*, Mrs Kathleen Newton, who died of consumption in 1882, aged twenty-eight. After this, his painting of elegant society life ceased. He turned to religion and spent ten years in the Holy Land.

His 865 New Testament illustrations were published in 1896 in *La Vie de Notre Seigneur*, and he was working on an Old Testament series at his death.

Love at First Sight William Holman Hunt
1827–1910 ▶

This is an unusual picture as the gentleman appears to be going fishing! It is my experience that when men concentrate on sport they would not notice Venus de Milo if she appeared naked.

Holman Hunt was a founder member of the Pre-Raphaelites.

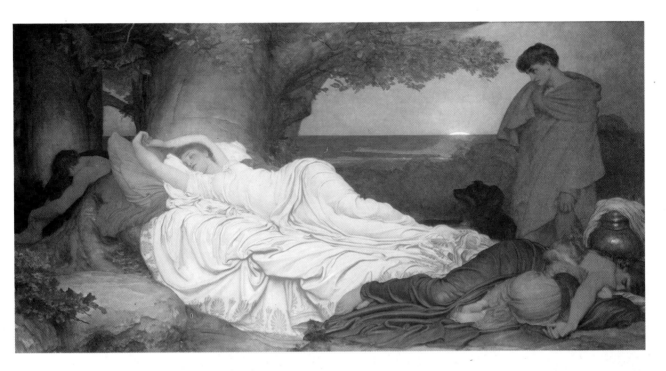

Cymon and Iphigenia Frederic Leighton 1830–1896

Leighton turned to classical Greece for inspiration because of its 'impulse towards an absolute need for beauty'. He was the much-fêted leader of the nineteenth-century return to Classicism in England.

This picture illustrates the story of Cymon and Iphigenia, one of Dryden's fables. Cymon is the son of the King of Cyprus, but although handsome, he is so stupid that his father hides him away.

He finds Iphigenia asleep and, transfixed by her beauty, he is transformed into his true princely self. She is promised in marriage to a Prince of Rhodes, but Cymon wins her back in battle and they are married.

Love can make a monster into a man, but inevitably the opposite is also true. False love or betrayed love can brutalize him.

The Meeting of Jacob and Rachel William Dyce 1806–1864

This is the longest engagement of the most determined lover of all time! Rachel having brought her father's flocks to the well to drink, Jacob falls in love with her and works seven years for her father to gain her hand – but is forced to marry her elder sister Lea. He works another seven years in order to win Rachel.

I cannot help feeling that Rachel must have lost some of her youthful charms, but we are told a woman never alters in the eyes of the man who loves her.

Love and Magic

The Love Philtre Mezzotint by Thomas
Appleton after a painting by William
Wontner, published in 1895

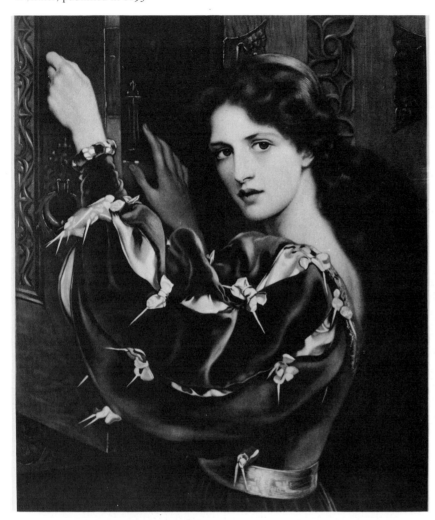

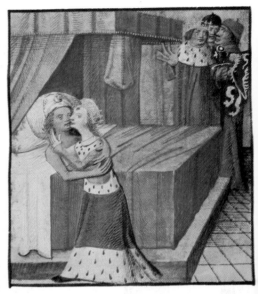

Tristan and Yseult Maitre Luces, 15th
century

Tristan escorts Yseult from Ireland
as a bride for his uncle, Mark. On
their voyage they drink a love
potion and become lovers.

They are discovered, and
Tristan escapes to Brittany, where
he marries. Dying of an arrow
wound, he asks Yseult to come to
him – her ship is to have white
sails if she will, black if not. Lying,
his wife says the sails are black and
he dies of a broken heart.

Yseult arrives and dies at his side.

Cup-Tossing

Love potions and philtres are the
beverages of Love Magic. White
witches knew the value of
aphrodisiac herbs, many of which
are still in use today.

There was, of course, a correct
procedure. For instance, black
hellebore had to be plucked with
the right hand and then
transferred to the left by a
barefooted witch dressed in white.

Mistletoe, called 'All-heal' by
the Druids, must be cut with a
gold knife six days after the new
moon. Verbena should be
gathered when neither the sun nor
moon was shining.

Black magic was punished by
death. Petronilla de Meath was
burned at the stake in 1323 after
confessing that she made her
philtres from the flesh of adders,
spiders, cinquefoil and the brains
of unbaptised babies.

Fourteenth century French
philtres contained arsenic, mercury,
dried toads, lizards, the tails of
rats, spiders, the hair of a hanged
criminal, verbena and marjoram.

Very effective, it was believed,
was toads' venom, the flesh of a
brigand's parboiled limbs, the
blood of infants and dust from the
grave.

Proposals of Love

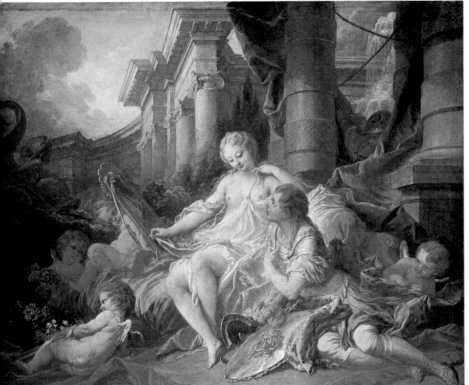

◄ *Rinaldo and Armida* François Boucher
1703–1770

This lovely Boucher illustrates
Tasso's story *Jerusalem Delivered* –
an epic of a crusade. Armida is the
niece of the wizard King of
Damascus, who lures Christian
knights to her enchanted gardens.

Rinaldo, Prince of Este, rescues
her prisoners and Armida falls in
love with him. By her
enchantments they live happily
together until Rinaldo is
summoned to help the Army. He
takes the chief part in the capture
of Jerusalem.

Love Letters Jean Honoré Fragonard ►
1732–1806

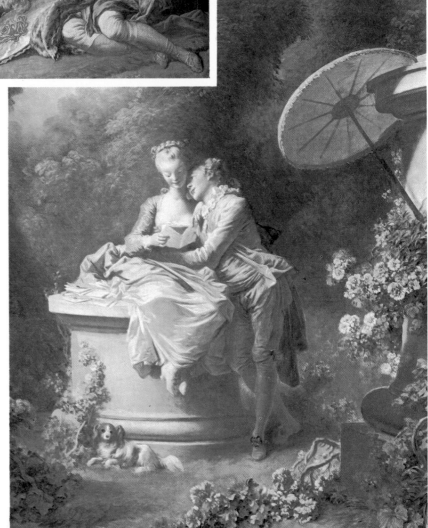

What could be more romantic
than this moment when the lover
kisses a softly rounded neck,
causing strange sensations she has
never felt before?

At the same time her eyes are
lowered, she is pensive, obviously
debating, having led him on,
whether or not she will accept
his proposal.

Fragonard ceased to paint after
the French Revolution, as if it had
made an anachronism of his art.

Attempting to ingratiate
themselves with the authorities,
his wife and sister-in-law offered
their jewels to the National
Assembly in 1789.

He died in 1806, obscure and
forgotten.

Plighting their Troth Nicolas Lancret 1690–1743

This is an illustration to one of the *Contes* of La Fontaine. Anselme, a magistrate of Mantua, goes on an Embassy to Rome, leaving Argie, his wife, alone. Her lover Atis reaches her room by the help of the fairy, Manto, who, transformed into a spaniel, has only to shake itself to produce coins and jewels.

The Proposal Françis Marshall

He is proposing to her in public, which always makes a young girl very shy.

My first proposal was more frightening than exciting. It was from a middle-aged Colonel with a red moustache in a cornfield nine days after I had left school. All I wanted to do was to run away from him.

I think proposals are more thrilling when one looks back on them than at the time – except, of course, for the rapture of the wonderful one to which the answer is 'Yes'.

◀ *Mated* Anonymous 19th century lithograph

This is a play on the word 'checkmate' as they have been playing chess. But love is a far more exacting, predictable game. The lover proposes on his knees in the honoured fashion and there is a Church conveniently in the background to remind us that his desires are strictly honourable.

François I

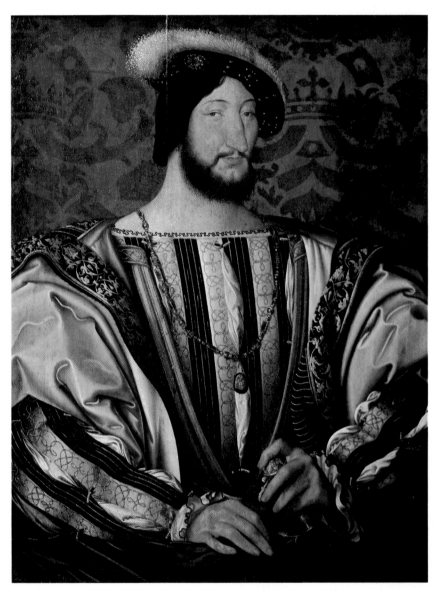

François I Jean Clouet 1485–1541

François I, builder of Blois and Chambord, the host at the Field of Cloth of Gold, the restorer of Fontainebleau (where he actually installed bathrooms), the founder of a great school of artists, was one of the great lovers in history.

He was handsome, gallant, full of grace and majesty, so much so that everyone loved him. A Venetian ambassador recorded that

'The King's way of life is as follows: he rises at eleven o'clock, hears Mass, dines, spends two or three hours with his mother, then goes whoring or hunting, and finally wanders here and there throughout the night.'

He started his sexual adventures at the age of fifteen and he began to enjoy women in two ways – on a purely sensual level, and aesthetically. He regarded them as works of art. His sister was always

his ideal woman. She had 'the beauty of a woman, the heart of a man and the head of an angel'. François, in turn, was her idol.

His sexual adventures were the talk of his own Court and those of Europe, where his harem was known as '*la petite bande*'.

'On one occasion King François wished to sleep with a lady of the Court . . . but found her husband waiting with his sword, ready to kill her. But the King pointed his own sword at the gentleman's throat and commanded him, on his life, to do her no harm, adding that if the gentleman hurt her he himself would kill him or have somebody else cut his head off.

For that night he sent the gentleman outside and took his place.'

Françoise de Foix, Dame de Chateaubriant Jean Clouet

Françoise de Foix, Dame de Chateaubriant, became, when she was twenty-three, the first of the King's great mistresses. Large, strong, dark and forceful, she was demanding and promiscuous. The relationship was stormy and jealous.

Queen Claude (?) Jean Clouet

Claude de France, Duchess of Brittany, married the King in 1514. She was 'very small, strangely fat, walked with a limp and had a marked squint'. He grew fond of her because she was charming, kind and a good mother.

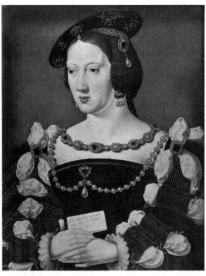

Eleanor of Austria Anonymous; Spanish School *c*.1530

François married Eleanor of Austria in 1530 after the death of Claude. Tall, with the long face of the Hapsburgs, and a sallow complexion, though only in her early thirties she already looked middle-aged and colourless.

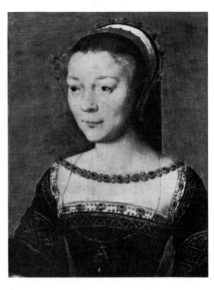

Duchesse d'Etampes Corneille de Lyon *d.c.*1574

Anne d'Heilly became the King's mistress at eighteen. Elegant, blonde, sensitive and artistic, she remained his acknowledged mistress until he died, though she may have been unfaithful and he certainly was.

Marie de Langeac, Dame de Lestrange Jean Clouet

Marie de Langeac, one of '*la petite bande*'. François was described as being 'as amorous as a cat – amorous and inconsistent'. His mistresses were all madly in love with him and, like his wives, forgave his infidelities.

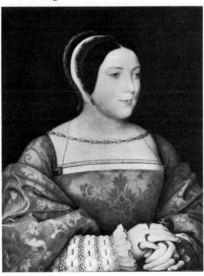

Marie d'Assigny, Dame de Canaples Jean Clouet

Marie d'Assigny, like most of the King's loves, was a brunette with a rounded figure and sparkling eyes. The King's *seraglio* included Madame de Montchenu (his friend's wife) and the charming Madame de Canaples.

Marie de Macy, Dame de Montchenu Jean Clouet

On his way to sleep with one of his mistresses, the King almost caught her in bed with another lover, who hid in the fireplace. The King relieved himself there before leaving, drenching the man to the skin.

Love in Flight

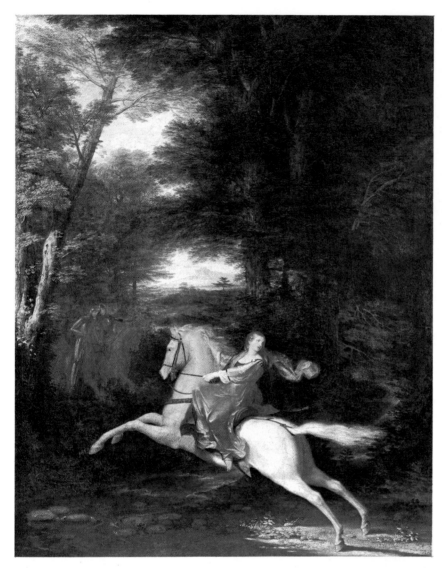

The Elopement at Night Engraving after Baudoin, 18th century

Very exciting, but with full dresses, walls and ladders, very complicated. But once in the lover's arms, could anything be more enthralling? Hurry, an angry father will soon be in pursuit!

Eloping Lovers ▼

The Flight of Florimell Washington Allston 1779–1843

Florimell is the symbol of chastity and virtue in woman. She takes refuge from her pursuers in the sea and is imprisoned by Proteus.

In his early years Allston came under the spell of Italy, where he lived for a certain period, and had admiration for Poussin. Later he attempted to rival Salvator Rosa, imitating his sombre and tragic subjects. When the Pre-Raphaelites were at work in England, Allston too dreamed of Knights-at-arms and tales of Chivalry.

Friend of the poet Coleridge, with his idyllic landscapes in the tradition of Claude and Turner he transplanted the complete stock-in-trade of European legend and history to his native Boston. In the United States as well as Europe, Romanticism often meant a flight into distance – in time and space – and Allston was typical of this trend. His work is full of escapist nostalgia and second-hand memories.

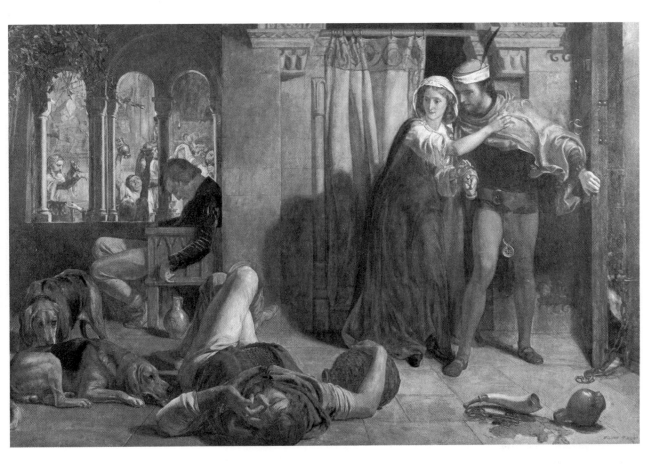

The Flight of Madeleine and Porphyro
William Holman Hunt 1827–1910

St Agnes' Eve is traditionally the night on which maidens will have a vision of their lover if they go to bed alone, in the darkness, and without looking behind them.

Madeleine tries this ancient magic. Meanwhile, her lover Porphyro, who (as in the case of Romeo and Juliet) is of hostile lineage, is smuggled into the house by Madeleine's devoted old nurse. She takes him to Madeleine's bedroom, avoiding the drunken revelling of the household.

When Madeleine wakes from her dream of him, he is there. They elope together and, of course, live happily ever afterwards.

'And they are gone: aye, ages long ago
These lovers fled away into the storm.'

I think when lovers encounter difficulties and have to fight to get married, it intensifies their love and makes them appreciate each other more.

Today everything is too easy, so young people do not value their happiness. This is one of the reasons why the Divorce Courts are crowded.

William Holman Hunt, the son of a warehouseman, had earned a precarious living from painting since the age of sixteen. A founder of the Pre-Raphaelite Brotherhood, he remained the most loyal to their tenet of 'truth to nature', with his scrupulous attention to detail.

The Elopement ▼

Love Rebuffed

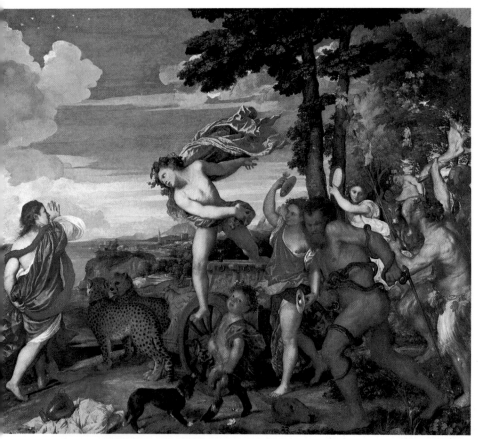

Bacchus and Ariadne Titian c. 1487–1576

I have told the story of Theseus, who killed the Minotaur with Ariadne's help and then took her with him as far as Naxos before he forsook her.

One legend says she hanged herself, another that Bacchus found her, consoled her and married her.

It was a blatant piece of ingratitude for which I hope Theseus was punished. But people are ungrateful, and kindnesses are too often forgotten.

What I find sad today is that few young people realise how much people like to be thanked by a letter which takes a few minutes to write and post.

It is not only a self-discipline that is good for the character, it can also bring dividends from those who appreciate good manners.

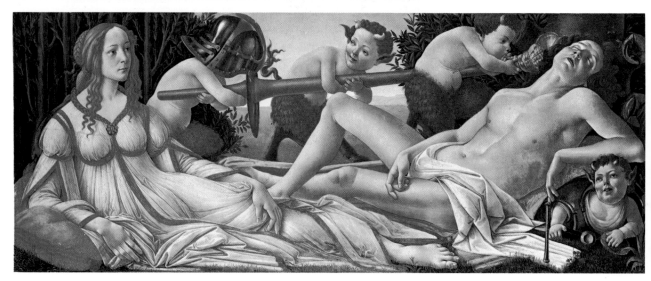

Venus and Mars Sandro Botticelli 1445–1510

Botticelli's picture shows Mars, the god of war, subdued by the power of love. Personally I think he is proving a sleepy, disappointing lover so how could Venus be anything but cross, sour and frustrated.

'Courted and with presents fed,
Finding pleasure in her bed,
Until he yawned and yawned and
 slept
While she waited, watched and wept

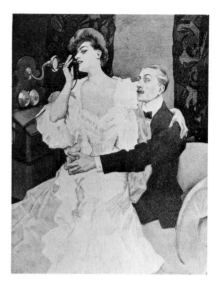

The Banquet of Herod 1515, from the monastery of Wettenhausen, Donau

Salome is presenting the head of John the Baptist to her mother Herodias. This is one of the most charming of all the many Salomes and I tell the familiar story on another page. How many women all through history have betrayed men? And except under torture, for some very personal reason, usually connected with love.

> 'Heav'n has no rage, like love to
> hatred turn'd,
> Nor Hell a fury, like a woman
> scorn'd.'

On the Telephone Ferdinand Freih. van Reznicek 1868–1909

Could anything be more damping to the ardour of love than for her to whom you have given your heart to telephone *another* while sitting on your knee? Dammit, enough is enough!

A Little Incident Charles Dana Gibson ▶
1867–1944

'Will you forgive me?'
'No.'
'You know I didn't mean it.'
'Do I?'
'I love you.'
'You have a strange way of showing it.'

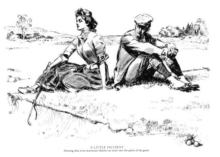

A LITTLE INCIDENT
Showing that even minimum objects can enter into the spirit of the game

Cephalus and Aurora Nicolas Poussin
1594–1665

I have told this whole story on another page and I find Cephalus' trick of testing Procris' fidelity in disguise extremely unfair. Because she succumbed to his seductive wooing he was furious and drove her away from him.

But the gods, intensely concerned with looks, apparently never thought that something far stronger than appearance makes us love each other.

It is a closeness which takes no heed of time and space, of heart calling to heart, spirit to spirit, soul to soul, and no disguise can prevent that from happening. 'Love built on beauty, soon as beauty, dies'.

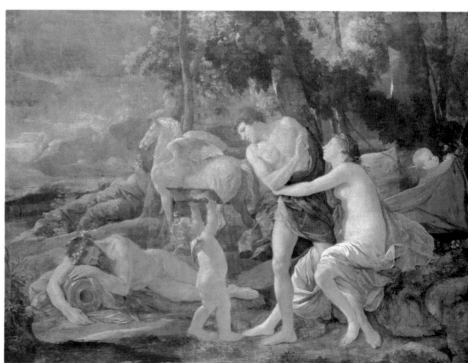

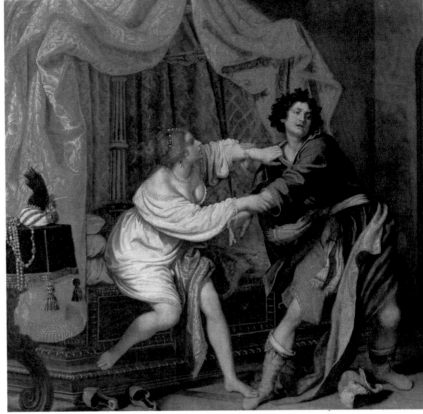

The Tree of Forgiveness Edward Coley Burne-Jones 1833–1898

Demophoön was the lover of Phyllis, daughter of the King of Thrace. He left her to visit Athens, where his stay was prolonged. She thought he had deserted her, killed herself and was changed into a tree.

Joseph and the Wife of Potiphar Giovanni Biliverti 1576–1666

This is one of the most dramatic and colourful pictures of the story which has inspired so many artists. I like this wife's appearance better than any others. I can hear her pleading in John Donne's words,

written in a very different context:

> 'Take me to you, imprison me, for I
> Except you enthrall me, never shall
> be free
> Nor ever chaste, except you ravish
> me.'

I think Joseph was rather a tiresome prig to refuse, but perhaps his interests were elsewhere.

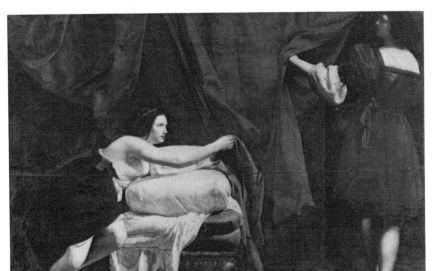

Joseph and Potiphar's Wife Orazio Gentileschi 1563–1639

Joseph is sold in Egypt to Potiphar, who trusts him and elevates him in his household. Potiphar's wife tries to seduce Joseph, finally catching hold of his garment, which he sheds as he escapes, and using it as evidence that he had tried to assault her.

Potiphar believes her and imprisons Joseph.

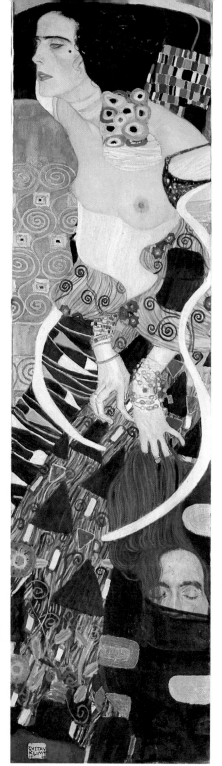

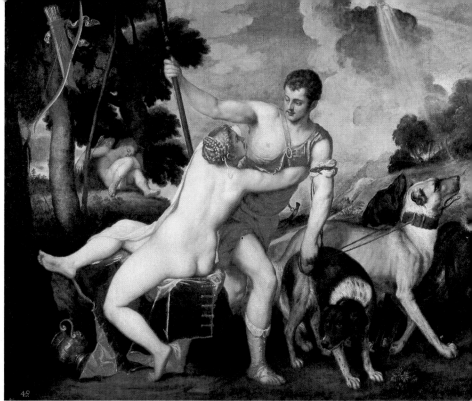

Venus and Adonis Titian c.1487–1576

Adonis, son of the King of Cyprus and beloved of Venus, ignores her warnings that he should not hunt and receives a mortal wound from a wild boar. Dying, red anemones spring from his blood as it falls to the ground.

How many women have pleaded with their men not to go into danger, but men will never listen. I often think we are still being punished for the loss of Eden.

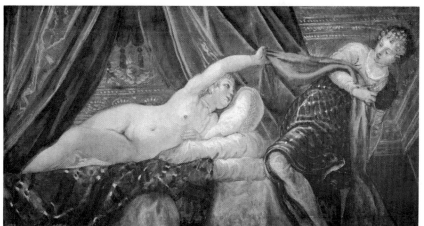

Salome Gustav Klimt 1862–1918

This is Salome as I feel she really was, bitter, revengeful, hating with violence which came from a heart dripping venom. She has not only lost the man she desires but her pride, her self-control, her very self. Savage and primitive, she would, with her own hands, murder the man she wishes to destroy. Fanatical, poisoned by her own thoughts in her madness, she despises not one man but all of them, and only blood will assuage the deafening clamour of her need to conquer and destroy.

Joseph and the Wife of Potiphar Jacopo Tintoretto 1518–1594

'Come live with me, and be my love,
And we will some new pleasures prove
Of golden sands, and crystal brooks
With silken lines and silver hooks.'
JOHN DONNE, *The Bait*

[35]

Peter Paul Rubens

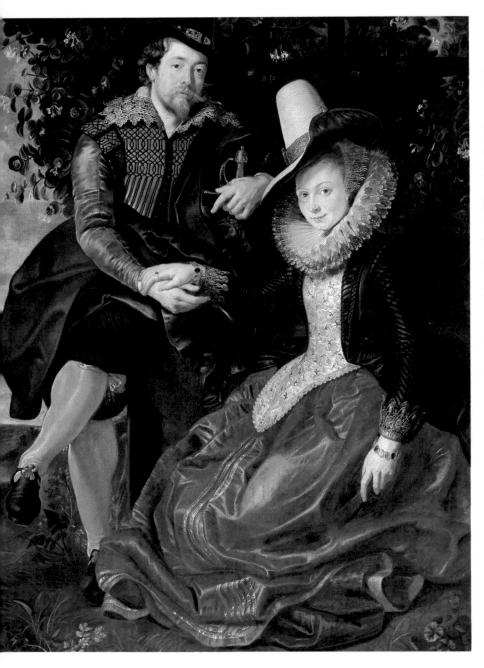

Self Portrait with Isabella Brandt
Peter Paul Rubens 1577–1640

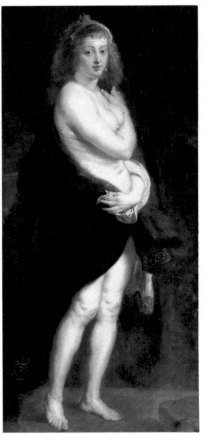

Hélène Fourment in a Fur Wrap
Peter Paul Rubens

Rubens was a brilliant artist who enjoyed painting rapes and nudes.

'Throughout his life he found women a great source of joy and inspiration in his work. No other artist painted his wives and children as often and as lovingly.'

The Honeysuckle Bower was painted as a wedding present for his first wife Isabella. She was very attractive, he was handsome and very sure of himself – 'My talents are such that I have never lacked courage to undertake any design, however vast.'

Rubens' first wife died tragically of the plague and he married Hélène Fourment in 1630. A silk merchant's daughter, she was sixteen and he well over fifty.

A masterful, but satisfying lover, he confesses in a letter to a friend that he is tired of celibacy. He became infatuated with his wife's blonde beauty. Hélène's face and body recur in all categories of his art. In *The Garden of Love* he painted her and her six sisters.

On his death Rubens left his wife this portrait of herself wrapped in a fur coat. She bore him five children, one posthumously. Opposite she holds their son François.

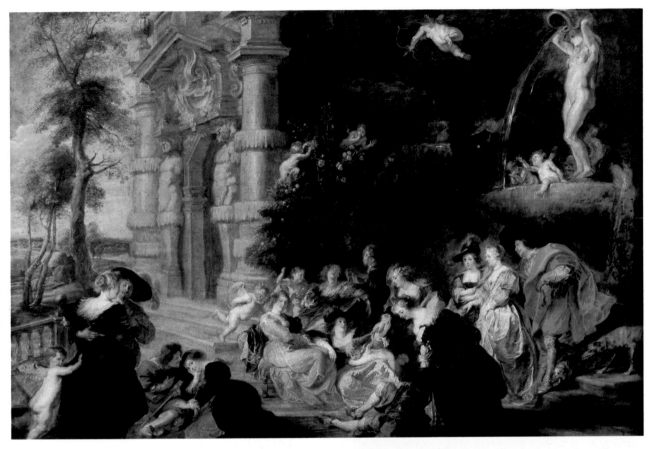

The Garden of Love
Peter Paul Rubens

Rubens is a wonderful example of a lover who wants the woman he loves to share his interests and be a part of everything he does.

Love made him pander to the romanticism of his young wife and he painted this picture rich in colour and feeling, with adorable cupids to add to the fantasy.

Rubens always had a sense of his own destiny, an unshakable belief in his own power. He stage-managed his opportunities brilliantly. He used colour in a way that conveyed emotion.

It is easy to understand how his fantastic energy, his vision, his sexual response to beauty wherever he found it, made him an ideal lover. He was famous, fashionable, and commercially successful.

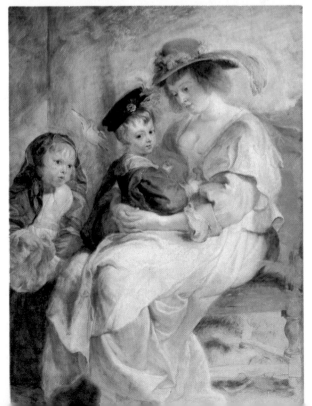

Hélène Fourment and her Children Peter Paul Rubens

The Arrow of Love

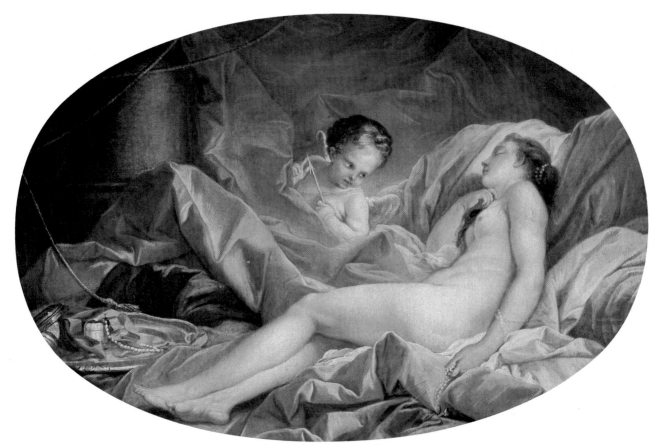

Venus Asleep François Boucher 1703–1770

This is one of my favourite pictures. Venus looks so lovely asleep and is an example to women who forget it is important to look beautiful in bed. Curlers, face creams, chin straps, and scowlies are nails in the coffin of marriage and effective antidotes to love.

Venus and Cupid Palma Vecchio 1480–1528

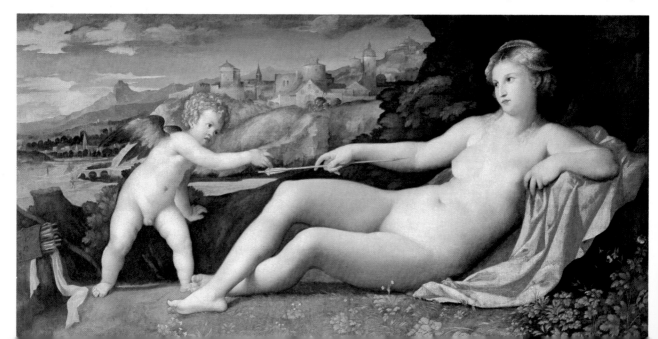

Venus and Cupid Titian *c.* 1487–1576

Venus is blindfolding Cupid in this brilliant picture by Titian. How many of us try to do the same thing. We pretend, we prevaricate, we deny our own hearts even while our sixth sense tells us that there is nothing more important, more compelling, more wonderful than love.

Cupid Blindfold ▼

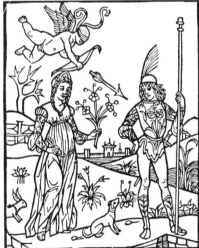

◄ *Cupid a Captive* François Boucher 1703–1770

We all try to keep Love captive to hold on to when we are privileged to know it is ours. But what foolish jailors most women are, over-possessive, demanding rather than pleading, commanding not coaxing. Love can only be caught and kept captive by Love.

[39]

The Pursuit of Love

Cupid and Psyche Anthony van Dyck
1599–1641

Here is the moment in the story when Psyche has been left on the mountain top to be carried away by a monster, but is saved by Zephyrus on the instructions of Eros. How often we are saved from horrors of every sort at the last moment or by what we say to ourselves afterwards was 'a miracle'!

What is important is to believe that we are protected by a Power greater than ourselves.

People attract disaster and misfortune by their own attitude. 'It always happens to me' they moan, 'I never get a break!' 'Just my luck!' These very words send out vibrations which attract just what we are trying to avoid.

I am more and more convinced that the blessings of God are there for those who seek for them. 'Think happy and you will be happy.'

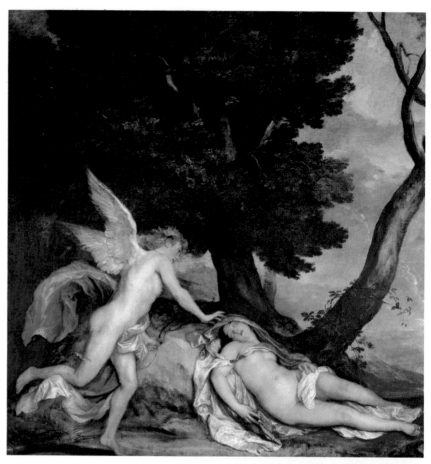

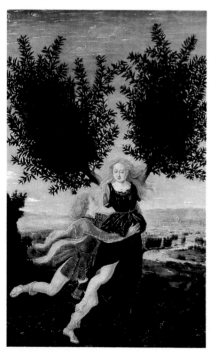

◀ *Apollo and Daphne* Antonio de Pollaiuolo
1432–1498

Daphne rejected the suit of Apollo and, fleeing from him, prayed for the assistance of the gods, who changed her into a laurel tree. How could she refuse Apollo, the most exciting of all the gods?

Apollo is the god of divine radiance and is present wherever there is light. When Apollo conquered Greece he took for his possession the loveliest view in the country and the white and gold glory of his temple at Delphi attracted thousands of pilgrims.

There he is still visible in the Shining Cliffs which rise a thousand feet above the fallen pillars.

Illustration from *Sir Charles Grandison*, 18th century

The unscrupulous Sir Hargrave Pollexfen has the beautiful Harriet Byron carried off in his coach, but she is rescued by Sir Charles Grandison and they fall in love.

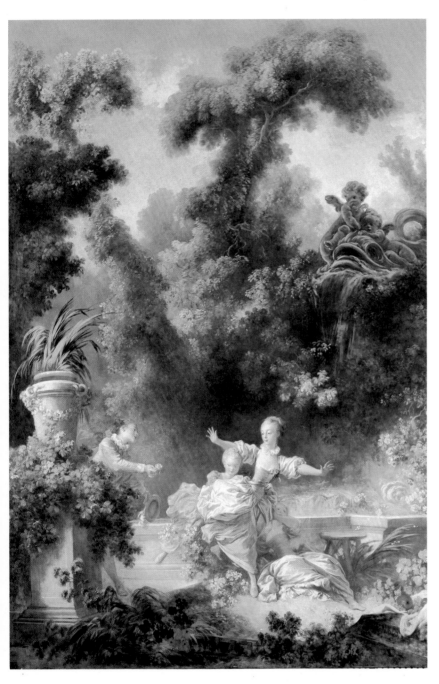

The Pursuit Jean Honoré Fragonard
1732–1806

This was the first of the panels intended for Mme du Barry which formed a series called *The Progress of Love*, painted in 1770 to decorate her new pavilion at Louveciennes.

Mme du Barry refused them when completed, perhaps because she discovered meanwhile that Fragonard had fallen from favour in the advanced circles beginning to turn to Neo-Classicism.

This picture has a grace we as women seem to have lost since our sex became emancipated.

Perhaps it is our clothes – it is difficult to be graceful in jeans and boots! I found in the war that women in uniform with low-heeled shoes *clumped* and were unnaturally clumsy.

If we had any sense we would look at this picture, stop trying to be pseudo men and become adorable, feminine women again.

Pan and Syrinx Arnold Böcklin ▶
1827–1901

Syrinx was a lovely Arcadian maiden who, chased by the god Pan, threw herself into the river Ladon, where she was made into a reed. Of this reed Pan, in her memory, made his pipe.

Pan is the god of shepherds and huntsmen, represented as a Satyr – with the legs of a goat, horns and a ruddy face. Sometimes he is said to be the son of Hermes but to me he will always be the little boy who lives in Never-Never-Land.

Captured by Love

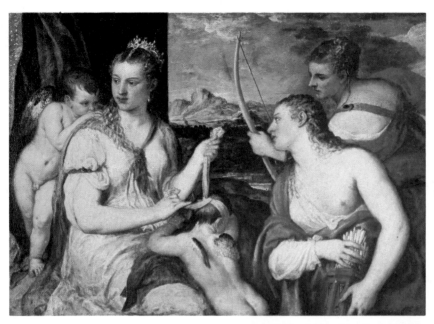

Europa, daughter of the King of Phoenicia, was gathering flowers when her attention was caught by the sight of a majestic bull with a glistening hide among her father's herd.

She did not suspect that the bull was none other than Zeus who was disguised in order to deceive the girl of whom he was enamoured. Europa caressed the animal, who knelt before her. She climbed on to his back. The bull reared to his feet, at a bound sprang into the waves, and carried the weeping virgin across the sea.

The Abduction of Rebecca Eugène Delacroix
1796–1863
▶

Eugène Delacroix was hailed as the leader of the Romantic movement in France, though he himself mistrusted the term. His visit to England in 1825 involved him in Romantic poetry and drama.

The Death of Sardanapalus was inspired by Lord Byron, and he did a self-portrait as Hamlet. His pictures, filled with colour, richness and tremendous dramatic effect, were influenced by his visit to Spain and Morocco in 1832. To me they have an emotional appeal that is irresistible.

This story is of *Ivanhoe* by Sir Walter Scott. The villain, the Knight Templar Bois-Gilbert, falls in love with Rebecca, the beautiful daughter of Isaac the Jew, and carries her off. The Grand Master of the Templars, although saving her from Bois-Gilbert, accuses her of witchcraft, and she is saved by Ivanhoe, who champions her in trial by combat.

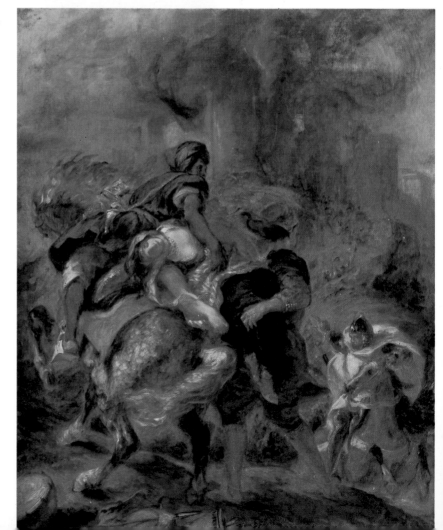

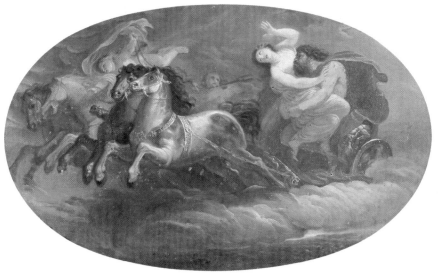

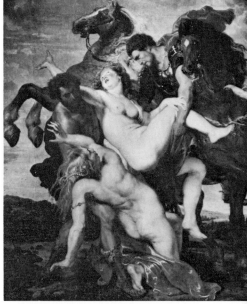

Pluto abducting Proserpine Andrea Appiani 1754–1817

These two delightful pictures tell the fascinating story of the lovely Proserpine who, while gathering flowers with her friends in the Vale of Enna, was carried off by Pluto who ruled Hades.

He made her Queen of the Underworld. But her mother Demeter wandered over the world seeking her, and Zeus, the master of the gods and her father, consented to Proserpine's return on condition that she had eaten nothing in the Underworld.

She had however eaten six pomegranate seeds, but to appease Demeter Zeus allowed Proserpine to spend six months on earth (Summer) and six in the Under-world (Winter) – a symbol of the burying of the seed in the ground and the growth of the corn.

I think women have always been fascinated by abduction by a brutal, determined villain who, of course, eventually is reformed by love.

The Appiani picture shows Pluto in his chariot which is so much more realistic; the difficulty of carrying a struggling captured woman any distance might even defeat the inexorable King of the Underworld.

The Rape of Proserpine Niccolo dell'Abate 1512–1571

The Abduction of the Daughters of Leucippus Peter Paul Rubens 1577–1640

The twin sons of Zeus, Castor and Pollux, before becoming immortal, abducted the beautiful daughters of Leucippus – Phoebe and Hilaeira. Their brothers pursued and fought to save them – both they and Castor were killed.

Charles II

Queen Catherine of Braganza D. Stoop
*c.*1618–1681

She was Portuguese, fanatically religious, had a bad digestion, bad breath and no personal hygiene, but she fell in love with Charles at first sight. His pet fox jumping on her bed caused her to miscarry and Charles never had an heir.

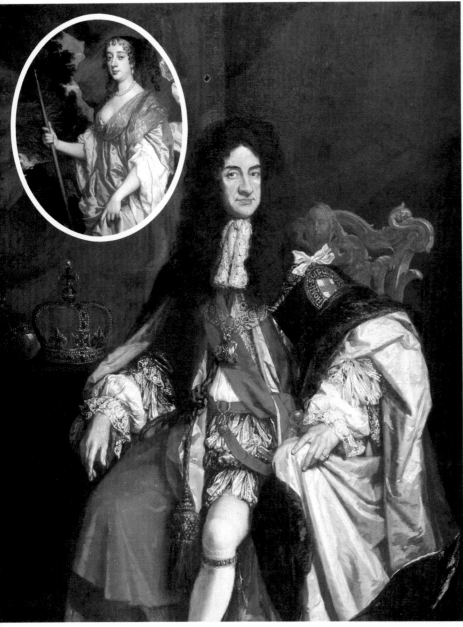

Charles II Godfrey Kneller *c.*1649–1723
INSET *Barbara Villiers* Peter Lely 1618–1680

Louise de Kéroualle, Duchess of Portsmouth
Pierre Mignard 1612–1695

The most gallant, exciting King England ever had, he brought her prosperity and peace, and an imperial and commercial expansion.

Fascinating, alluring and seductive, he loved women passionately. Barbara Castlemaine

had 'the body of a goddess and the mind of a devil', but she had a wild, irresistible, passionate, physical attraction for the King and he for her. She was covetous, a firebrand, greedy and unfaithful.

Charles was furious and she even disgusted him but she had only to look deep into his eyes to arouse his desire.

French, pretty, refined, ruthless, greedy, unprincipled and the evil genius of the Court, Louise was a spy for Louis XIV of France. Charles called her 'Fubbs' and made her a Duchess. Louis paid her well and made her the Duchesse d'Aubigny.

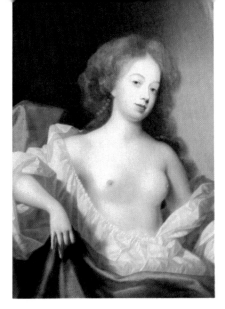

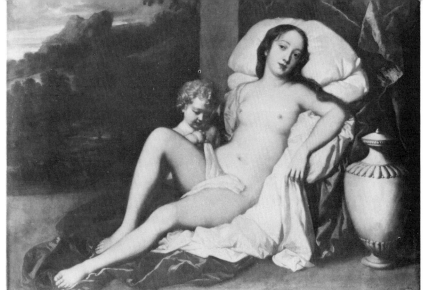

Nell Gwynne Simon Verelst 1644–1721
Nell Gwynne and the Duke of St Albans
Peter Lely

Nell Gwynne sold oranges outside the King's Theatre and later became an actress. She was piquant, famous, good-tempered with high spirits. She was also exceptionally clean, which was astonishing in that age. The King became an assiduous playgoer to see 'pretty, witty Nell' perform.

She became his mistress, their son was born prematurely in 1670. She was never greedy, she gave the King a gentle unaffected happiness he found with no one else.

When driving in Hyde Park her coach was mistaken for that of Louise de Kéroualle whom the mob hated. They surrounded it but Nell stuck her head out of the window, crying 'Desist good people, I'm the Protestant whore!'

Nell's second son died at the age of nine but the King made their first the Duke of St Albans.

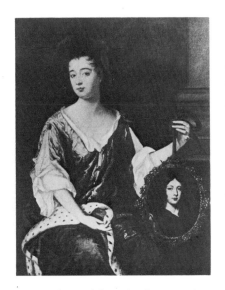

Lucy Walters and the Duke of Monmouth
Attributed to Godfrey Kneller

She was Charles' first love. She had brown, naturally curly hair, bright blue eyes, a rather large nose and all the passion of a Celt.

After a brief affair in midsummer, the result was a son, who was to become the tragic, ill-fated Duke of Monmouth.

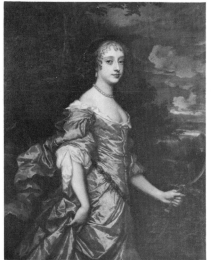

Frances Stuart
Peter Lely

Frances Stuart was the one woman who never succumbed to the King's intense and passionate wooing. Described as a Greek statue with perfect teeth, she had unfortunately no wit and no heart. She married the old, drunken, stupid Duke of Richmond for position.

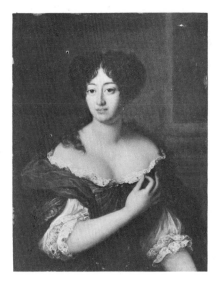

Hortense Mancini, Duchess of Mazarin (?)
Anonymous portrait

Abominably treated by her vicious husband, she gave the King happiness. Her scintillating wit, brilliant brain and pagan beauty infused him with new life, new youth and new ideas.

They found together a spiritual as well as a physical ecstasy.

Love Rewarded

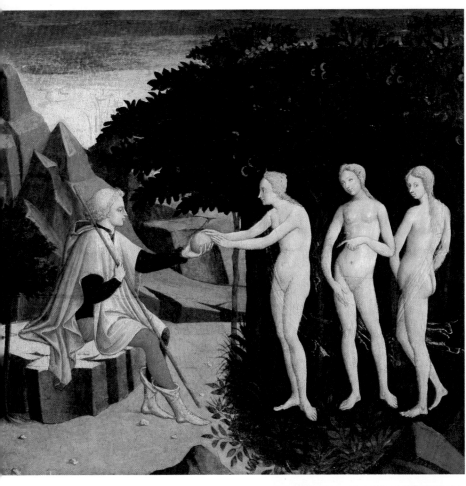

This picture is an excellent example, at an early date, of what women can do to themselves by slimming. Every result shows, from the puny little breasts to the fat tummies which are seldom affected by any diet.

Goddesses should be softly curved, a comfortable armful, but these pathetic creatures would certainly not get an apple from me! What women will not realise is that they should look like women and that one slims, as one ages, downwards.

Greying, lank hair, wrinkles and lines on the face, a scraggy neck, drooping breasts are all the first results of a slimming treatment.

What all men find attractive is *joie de vivre,* laughter, gaiety and a sparkle which comes from a happy disposition. No woman can have that on a diet of lettuce leaves and grapefruit!

Psyche Crowning Love Jean Baptiste Greuze
1725–1805
▶

I get very tired of pictures of Eros, who is very unlike my idea of an exciting, passionate lover. My heroes are all dark, handsome, and great sportsmen, but cynical and disillusioned. It is only the unique and perfect quality of the heroine which can wipe the mocking words from their lips and find that after all they have a heart.

Greuze became famous after 1769 when the pretty but wanton girl he married began to appear in his pictures and delighted the public. She embezzled most of his income and became fat and ugly – Greuze finally divorced her.

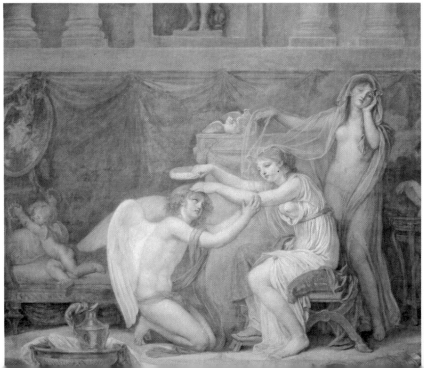

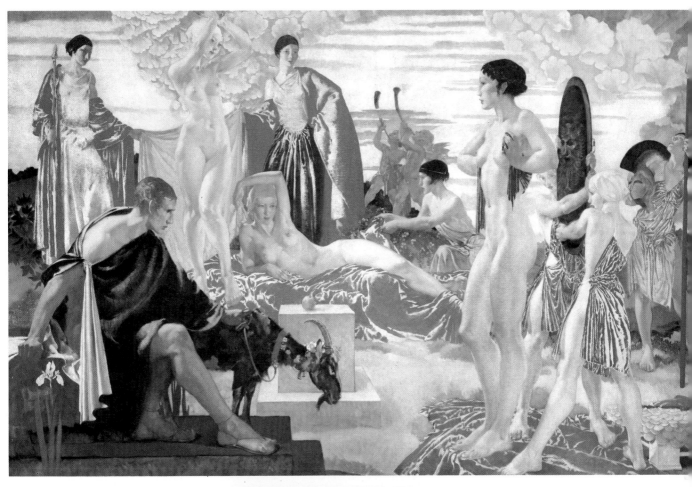

The Judgment of Paris W. Russell Flint
1880–1969

This is a beautiful picture, but I
find it filled with unanswerable
questions. Why is the only man
in the picture ignoring the
glorious nude goddesses? Who is
that staring at the sky? Paris,
looking miserable, holds an
equally unhappy goat.

Many painters who depict
women beautifully take little
trouble with the men. It may be a
touch of jealousy or perhaps just
indifference. All I long to know is,
is it shyness, saturation or
indigestion which has ruined this
Paris' enjoyment of the contest?

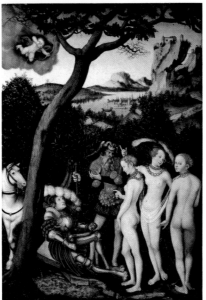

◄ *The Judgment of Paris* Lucas Cranach
1472–1553

Another judgment, but what style,
what polish Cranach could give a
picture with his glossy enamel-like
finish. His erotic nudes are
elegant, sophisticated and very
much women of the world.

The blasé, exhausted Paris is also
obviously a member of the 'jet-
set' of the period. The spoilt
young man of any age never alters.

Certainly the old gentleman
with a beard in a most
extraordinary uniform is far more
interested in 'les girls' than he is.

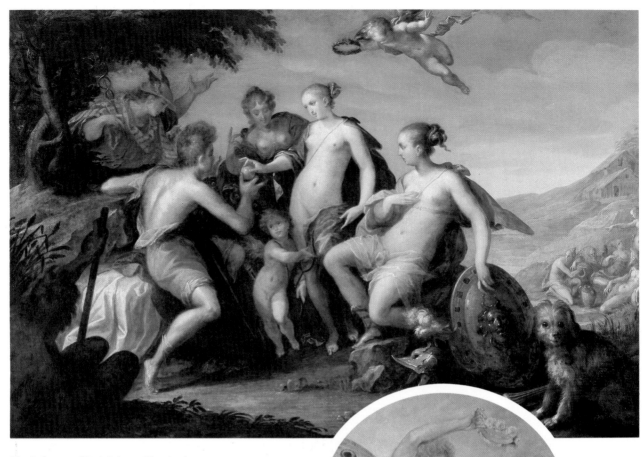

The Judgment of Paris Johann Van Aachen
1552–1616

This judgment of Paris inspired me to write a novel centred around the picture, called *The Judgment of Love*, and my heroine, of course, looked like Aphrodite!

The story of the judgment is fascinating. Paris, a handsome Trojan, was also a shepherd, and the three goddesses appeared before him asking him to decide who was the most beautiful. Being women they did not intend to rely entirely on their charms so Hera offered to make him Lord over all Asia. Athena the goddess of war offered him victory over his enemies, to be the victor in every battle. But Aphrodite, the goddess of love, just undid the girdle of her gown!

This picture is now in the Musée de la Chartreuse at Douai in France.

Cupid and Psyche Jean Antoine Watteau
1684–1721

Watteau was made famous by his *fêtes galantes*, a subject suggested by the open-air parties of his patron, Crocat. He was consumptive and visited London to consult Queen Anne's physician, Mead, spending a winter there which probably hastened his death. He died at thirty-six, having lost his fortune in speculation – his personal melancholy is evident in many of his pictures.

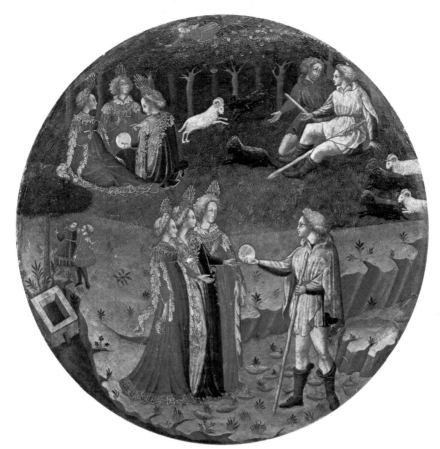

▼ *The Judgment of Paris* François Boucher 1703–1770

The Judgment of Paris Cecchino da Verona, 15th century

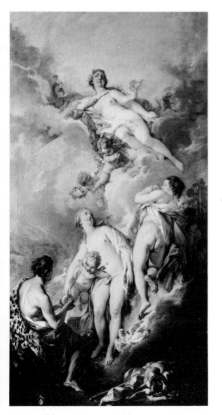

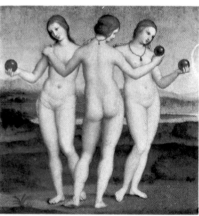

The Three Graces Raphael 1483–1520

This is the most entrancing picture, with all the goddesses fully dressed and Paris, somewhat oafishly, holding an apple the size of a football. It poses the age-old question as to whether women are more attractive dressed or undressed. We have seen so much nakedness lately that I have begun to think the completely naked can lose their attraction and be a bore.

I look at women of all ages, lying on a beach, their bodies frizzling like bacon in the sun, and I wonder why they do it and for what?

The Boucher goddesses on the left, half draped, are very alluring, but I find myself, as I feel any man would be, intrigued and curious about Cecchino's tiara-ed and graceful ladies. What are they like underneath the long frilled sleeves, the lace-trimmed gowns?

This is another manifestation of the triple goddess: Aglaia (the brilliant), Euphrosyne (she who rejoices the heart), and Thalia (she who brings flowers) were all part of Venus' retinue. Originally nature goddesses, they presided over the budding of plants, and mingled with dancing nymphs on earth at the beginning of Spring. By 300 BC they were traditionally represented as three nudes.

Louis XIV

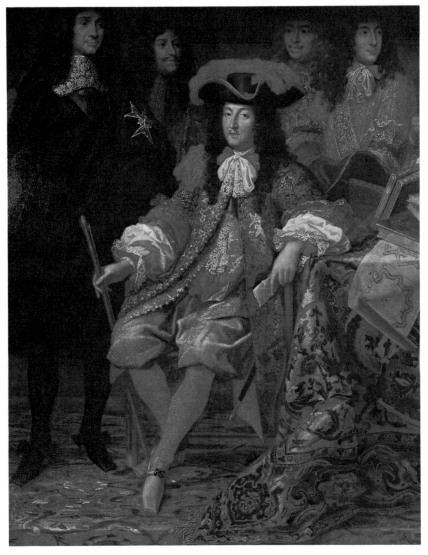

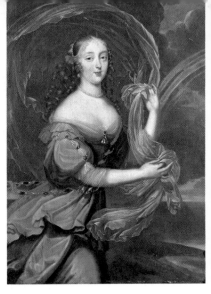

Madame de Montespan as Iris French School, 18th century

Madame de Montespan and her children ▶
After Pierre Mignard

Magnificent fair hair, sweetly pretty mouth, captivating smile; the King loved Athénaïs de Montespan.

Surprisingly, Monsieur de Montespan made a fuss. He boxed his wife's ears, wore mourning for his *late* wife and drove about in a hearse.

She established her Empire – houses, honours, a percentage on the meat and tobacco sold in Paris. However, she had her pride and would never take jewels from the King! Those he lent her were larger!

Louis XIV at the Establishment of the Academy of Science, 1667 (detail)
Henri Testelin 1616–1695

The *Roi de Soleil* fell in love with Versailles and Louise de la Vallière at the same time. Over the years and many other loves, Versailles won. Tall, dark and impressive, the splendour of his Court, the genius of his age, his favourite occupations – war and building – have made him the most unforgettable and glamorous King in European history. He was always master of himself and his mistresses as well as of France.

A sportsman, he spent each day either hunting or shooting. Yet he inspired terror and was indifferent to the people's sufferings.

When the King travelled he took only women with him in his coach. The journeys, sometimes lasting six hours, were a torment. All the windows were kept open as he could not bear stuffiness and however pressing any natural need, the ladies could not leave the coach.

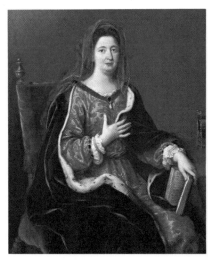

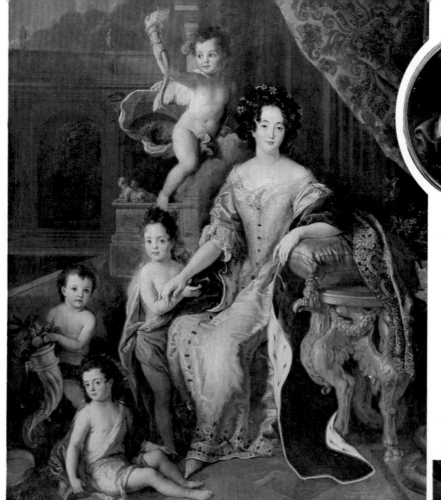

Queen Marie-Thérèse and the Dauphin ▶
Pierre Mignard 1612–1695

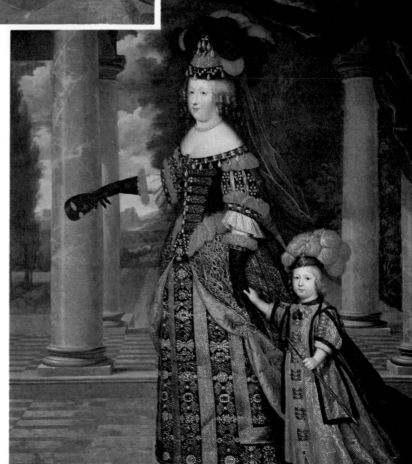

Louise de la Vallière Pierre Mignard
1612–1695

Blonde, modest, slightly lame, 'a little violet', Louise was ashamed of being the King's mistress and twice escaped to a Convent. The King brought her back and threatened to set the Convent on fire. She stayed for seven years.

Then Madame de Montespan, who had desperately tried to attract the King, resorted to invoking Satan and Black Magic, and won.

Having the mentality of a child, the Queen liked to play with little dogs and half-mad dwarfs, and never learnt to speak French properly. She had a pretty face, short legs and black teeth – from too much chocolate and garlic.

She worshipped the King and a kind look from him made her happy all day.

◀ *Madame de Maintenon* Pierre Mignard

Louis married Madame de Maintenon. When she was seventy-five and he seventy she wrote to the Bishop asking, as it was extremely tiring to make love twice a day, was she obliged to do so? The answer was 'as a wife she must submit'.

Inspirational Love

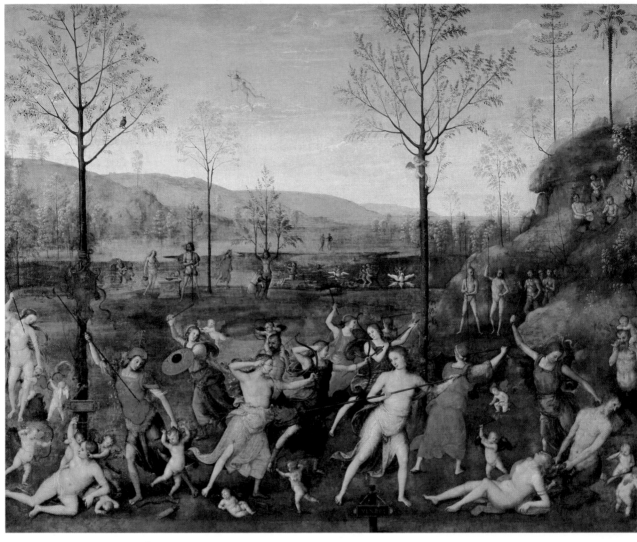

Combat of Love and Chastity Pietro Perugino 1446–1523

Lady Lilith Dante Gabriel Rossetti 1828–1882 ▶

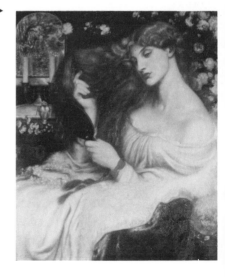

I am fascinated by this picture.

It is a fight against evil and pornography which still continues today. For several years we have allowed all that is dirty, degrading and vulgar to invade our private lives through the radio, the television and the bookstalls. Filth of every sort tempts our young people in every western city.

Only when we fight for high ideals and decency will we have a world of which we can be proud.

As there was a serpent in Eden to tempt Eve, it was only fair that Adam should also be tempted by Lilith. Rabbinical literature makes her Adam's first wife who was dispossessed by Eve.

I believe she was 'the other woman' who turned up at the time of the seven-year itch. So many men meet a Lilith at that time but they should remember that she is a vampire who will suck them dry.

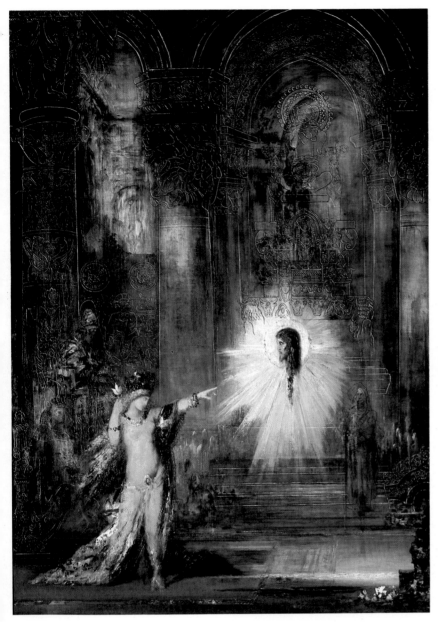

Salome Gustave Moreau 1826–1898

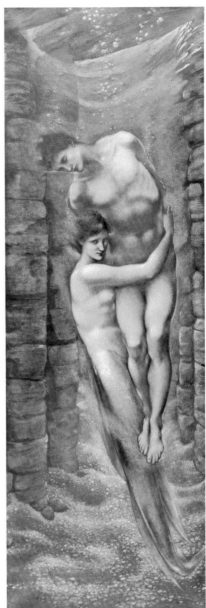

The Depth of the Sea Edward Coley Burne-Jones 1833–1898

Salome was the daughter of Herodias and step-daughter of Herod Antipas. Herod, enchanted by her erotic dance of the seven veils, offered her a gift 'unto the half of my kingdom'. Herodias told her to ask for the head of John the Baptist in a charger.

John had attempted to prevent Herod marrying his brother's wife, and was imprisoned at the instigation of Herodias.

Moreau's Salome, however, is that of Oscar Wilde's play – she has John beheaded as a result of his refusing her sexual advances to him. The play was written six years before this brilliant and, to me, very inspirational painting. It also formed the libretto of Richard Strauss's opera.

Moreau became obsessed by Salome and painted her many times. He was adopted by the Symbolists as their most admired painter.

This lovely and very thought-provoking picture is one of Sir Edward's beautiful romantic dreams.

To me it means that whatever happens to a man, even death, there is always help from above, below, from a mortal woman, or an immortal! Whoever it may be, man will be sustained and saved, if not in this life in the next, or maybe others further away from what we call reality.

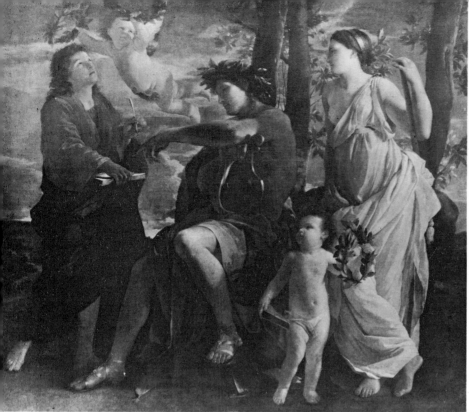

I find this a very inspirational
picture and it has a deep
significance which is unusual in
Fragonard's lovely glamorous
pictures.

Two lovers are drawn as if by a
magnet to the symbol of their
desire, but their desire is not only
for the delights and excitement of
love. It is a search for the spiritual
which makes love the nearest
mankind gets to the Divine.

In real love man reaches the
highest level of which he is capable.
It is love which has inspired the
greatest paintings, the finest music,
the prose and poetry which lives.

At some time we all seek the love
which is part of God, knowing that
all other forms will eventually
disappoint and fail us.

The fountain of love is there and
we have only to look for it within
our hearts and souls.

The Inspiration of the Poet Nicolas Poussin
1593–1665

Poussin formulated what became
the central doctrines of the
Classicism taught in the
Académie. 'Painting must deal
with the most noble and serious
human situations and must present
them in a typical and orderly
manner according to the principles
of reason.'

Painting, he believed, should
appeal to the mind not to the eye.

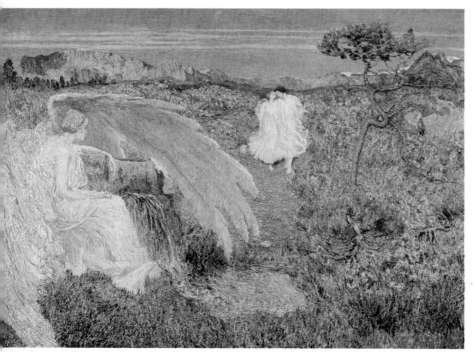

◀ *Love at the Fount of Life* Giovanni
Segantini 1858–1899

Here again is a different inter-
pretation of man's search for love.
The figure of Love as an Angel
waits at the Well of Life, meaning
that without love in its Divine
form there is no real love for the
two lovers coming along the path
of time.

Segantini was Italy's leading
Divisionist and Symbolist artist.
After 1881 he lived a retired life
in the countryside and wrote:

'I went out only at the hour of
sunset to see and feel its impressions
which I then transferred to the
canvas during the day'.

Wooed by Love

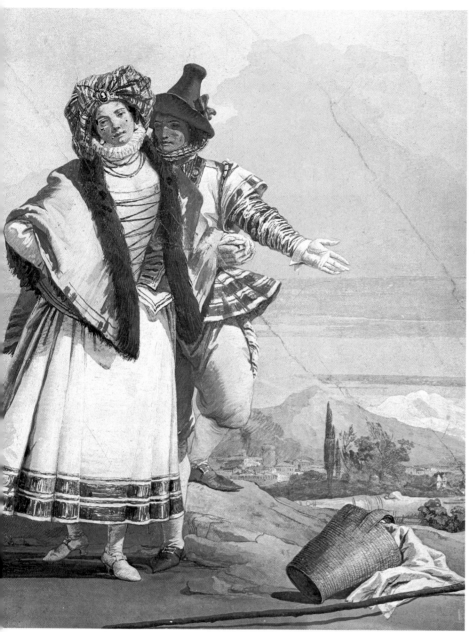

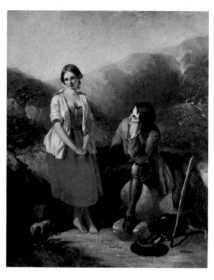

The Dawn of Love Thomas Brooks
1818–1891

'She was a phantom of delight
When first she gleam'd upon my
sight;
A lovely apparition, sent
To be a moment's ornament;'
WORDSWORTH, *Perfect Woman*

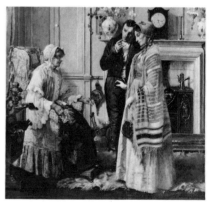

Sweethearts Walter Dendy Sadler
1854–1923

The Declaration of Love Giovanni Battista
Tiepolo 1696–1770

Could anything be more
enchanting than this delightful
couple with the mountains behind
them and their coquettish clothes.
Tiepolo's fame – he was the most
brilliant painter of his period – rests
on his fresco decorations. His clean
sunny palette became, after his
marriage, one of his most
acclaimed characteristics.

The rooms he decorated with
his son in the Villa Valmarana
near Vicenza, are grand, rich and
glowing with colour. The splendid
ceiling in the Throne Room in
Madrid was his greatest
commission.

According to Jeremy Maas, the
lady's decrepit old mother is
inspecting her future son-in-law.
Is he rich enough to keep her
daughter in the style to which she
is accustomed? He looks nervous
and I feel she will be difficult!

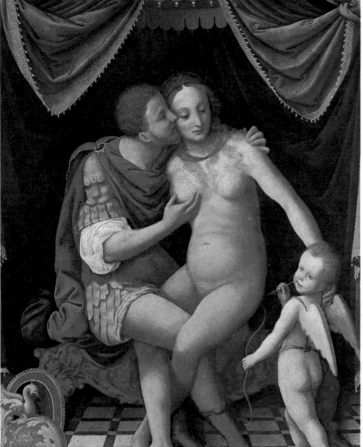

◄ *Mars and Venus* School of Fontainebleau

Venus as Love is not too responsive to Mars the god of War and who shall blame her! He has thrown his weapons on the floor, but how often do men pretend to abandon all fighting only to return to it again. Yet her legs are linked with his and Cupid is playing his part in reconciling them so perhaps after all she will consent to what he is obviously suggesting with some eloquence.

Artists in the School of Fontainebleau were employed by François I in emulation of the Italian Princes.

Cephalus and Aurora François Boucher ►
1703–1770

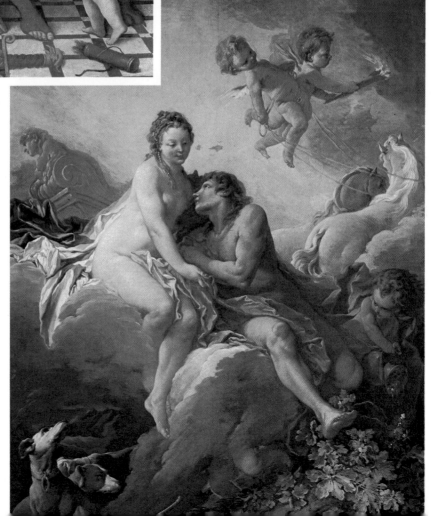

Cephalus was the handsome husband of Procris. The exquisite Aurora fell in love with him but Cephalus loved Procris and would not respond to her advances. Aurora in revenge filled him with jealous doubts of Procris' fidelity and he tested her by appearing in disguise and wooing her.

She relented but he drove her away. Artemis gave her a dog that never lost the scent and a spear that never missed its mark. Procris gave these to Cephalus and they made up their quarrel.

She was very jealous, and spied on her husband when he went hunting. He thought he saw an animal stir in a bush and threw the spear which killed her.

Louis XV

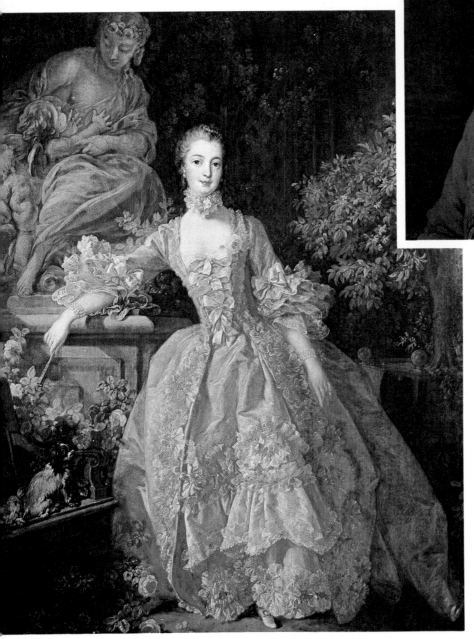

Louis XV François-Hubert Drouais
1727–1775

After a miserable childhood with
no love, Louis grew into a
handsome man, dark, shy and
proud. He came to the throne
when he was five and attended
Council meetings, holding in his
arms his pet cat. He never spoke,
but when his betrothal to a
two-year-old Spanish Infanta was
announced, he cried throughout
the meeting. She was eventually
sent away.

He married Marie Leczinska,
daughter of the exiled King of
Poland. As soon as she arrived at
Versailles the King fell in love with
her. On their wedding night he
gave her proof of his love seven
times. The Queen, although
beautiful, was dull and dowdy.

After two boring mistresses,
he found Madame de Pompadour,
and they were wildly in love with
each other. Cold by temperament,
'making love' tired her and she had
many miscarriages. She tried a diet
of vanilla, truffles and celery to
make herself passionate but it only
made her ill. Yet only when she
was old did the King use the *Parc
aux Cerfs* – the Royal brothel.

Madame de Pompadour François Boucher
1703–1770

Lovely, graceful, fascinating, witty,
sparkling, she 'absolutely
extinguished all the other women
at Court'. She could act brilliantly,
dance, sing, paint and engrave
precious stones. It was
inconceivable for the King to
take a bourgeois mistress but she
charmed, amused and taught him
to appreciate Art.

She worshipped the ground he
walked on, and having educated
her, he would have been lost
without her. She never grew grand
despite her enormous power. She
was never ashamed of her relations
or her old friends.

Queen Marie Leczinska Jean-Marc Nattier 1685–1766

Mademoiselle Romains Dronais

She bore ten children and complained she was for ever '*in bed, or pregnant, or brought to bed*'. To keep the King out of her bed, she barred him on every Saint's day. He finally flew in a rage and ordered the Palace concierge to bring him a woman.

When Madame de Pompadour's health was failing the King took a new mistress who refused to be put in the *Parc aux Cerfs*. The King bought her a house where she gave birth to a son. She was beautiful yet the King soon tired of her, but he recognised her son, who grew up as the Abbé de Bourbon.

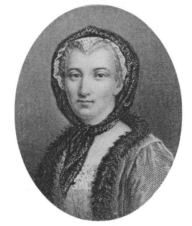

Madame de Mailly Jean-Marc Nattier 1685–1766

Madame du Barry Marie-Louise Vigée-Lebrun 1755–1842

Madame du Barry, a former prostitute, became reigning mistress when Madame de Pompadour was dead. The King, bored and lonely, installed her. Pretty, her language was rough and indelicate when angry.

After the Queen had driven the King to demand 'a woman' and he was given a pretty housemaid, he made the Comtesse de Mailly his mistress.

In 1739 he refused to attend his Easter duties, saying he was living in adultery and had no intention of mending his ways. At the same time, he would not make a mockery of his religion.

Madame de Mailly was a jolly, sporting woman with whom he felt at ease. She never asked him for anything. She unwisely invited her sister to supper parties and the King fell in love with her.

The Marquise de Vintimille Jacques-André Aved 1702–1766

Madame de Vintimille was not so attractive as her sister and behaved with great unkindness to her. She died giving birth to the King's baby. The King went back to Madame de Mailly who adopted the baby, known as *le demi-Louis*.

Preparing for Love

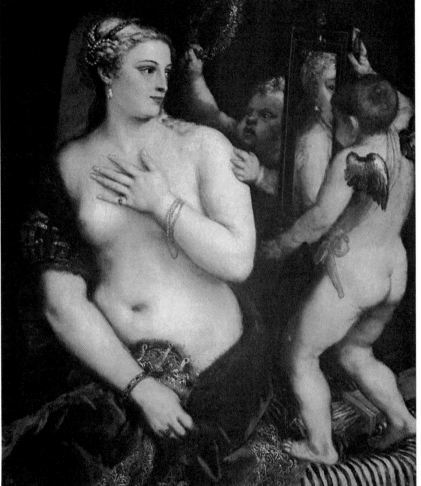

This is the awful moment in a woman's life when she looks in the mirror and sees she has reached the crossroads, when youth goes one way and age another.

What she has to realise is that at fifty she cannot keep her face and her figure. A thin woman will get wrinkles sooner than a fat one. So the choice is, for this Venus: 'Shall I choose face or figure?'

My advice has always been – have a lovely face and sit down. But a woman who wants to keep old age at bay has to use her brains. What every woman dreads is the loneliness of growing old, unwanted, and an encumbrance to those who pity where they once adored. Women avoid this by filling their lives with work, with outside interests, by making themselves indispensable because they are helpful, inspiring, and amusing.

Venus with a Mirror Giovanni Battista Tiepolo 1696–1770 ▶

A woman looks in a mirror and sees what? Not herself – she never looks at herself as a whole – but at her hair, her eyes, her nose, her lips: never at the real self which lies behind them all.

Smile in the looking-glass at yourself, say 'I love you'. That, you hope, is the real you. Now say 'I hate you' and 'I'm jealous', and pray that is not more familiar to those around you!

A smile is the cheapest face-lift: an introduction to friendship, an invitation to love.

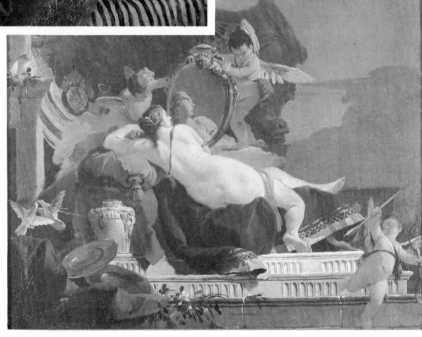

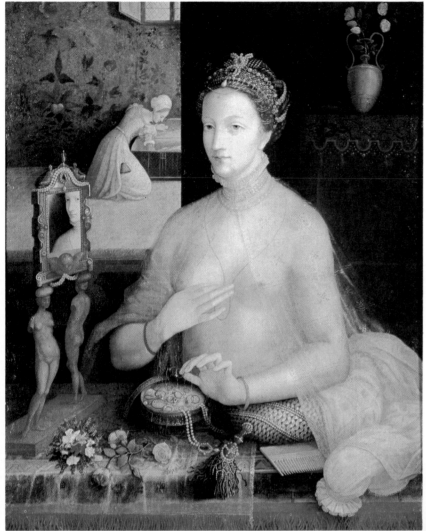

I have chosen this picture not to write about Diane de Poitiers, one of the fascinating women of all time about whom I wrote earlier, but because she is choosing her jewelry. Every woman loves jewels and they have a sentimental value which can never be assessed in terms of cash.

Women also have jewels which they believe bring them luck. I never fly without wearing a little diamond cross my husband gave me. It has travelled well over a hundred thousand miles.

Stones are also believed to have special properties – diamonds make one merry, prevent fear of darkness and guarantee married happiness. Sapphires will ward off the evil eye.

The emerald is believed to be an antidote to any illness caused by poison. The ruby smoothes temper, protects against seduction, and helps the possessor acquire lands and titles.

Prud'hon was patronized by Napoleon and the Empress Joséphine, but he led a very sad life. He contracted at an early age an unfortunate marriage which caused him many years of grief.

He was deeply attached to his pupil and mistress Constance Mayer and it was a shattering blow to him when she committed suicide. The shock led quickly to his own death.

His melting effects of light characterized his work and he designed furniture and decorations for the Court.

Diane de Poitiers at her Toilet
School of Fontainebleau,
16th century

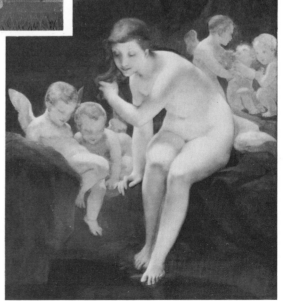

The Bath of Venus
Pierre Paul Prud'hon
1758–1823

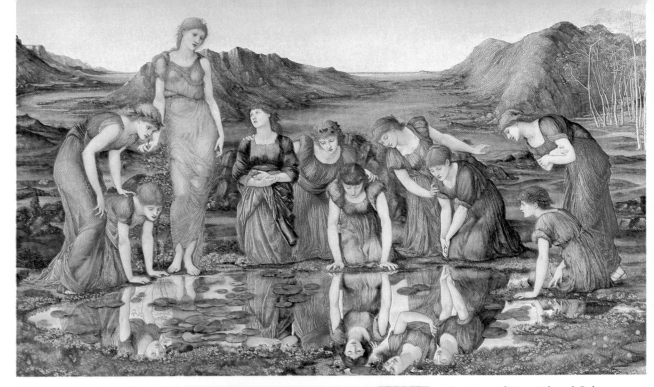

The Mirror of Venus Edward Coley
Burne-Jones 1833–1898

Woman, since the beginning of
time, has wanted to look in a
mirror. At first there was the
water in which she could see her
reflection. Doubtless Eve, staring
into a stream in the Garden of
Eden, tried the effect of many
different leaves until she finally
decided on the one she picked first
– a fig leaf.

This picture I think illustrates
Burne-Jones' words, when he said
that what he meant by a picture
was 'a beautiful romantic dream of
something that never was, never
will be – in a light better than any
light that ever shone – in a land no
one can define or remember, only
desire'.

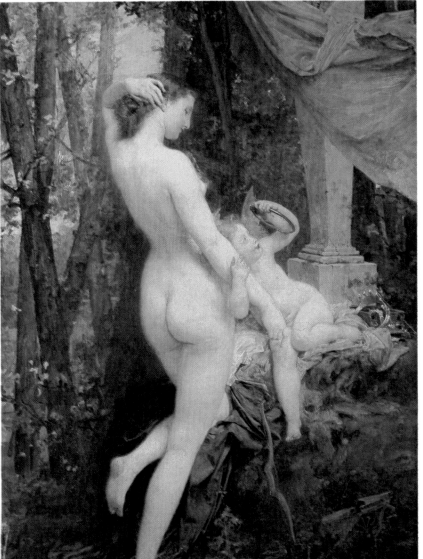

The Toilet of Venus Paul Baudry
1828–1886

This glorious Venus, preparing for
love, knows the secret that it is
not what a woman wears which
makes her beautiful in the eyes of
the man she loves, but how she
thinks and feels.

La Chemise Enlevée Jean Honoré Fragonard
1732–1806

This is an entrancing picture of a
naughty Cupid pulling off Venus'
chemise.

Nakedness at this period was
very indecent and young ladies at
school in convents were told they
must never look at their own
naked bodies.

Many French women actually
bathed in a chemise to protect
their modesty, or, more effective
still, did not bathe at all!

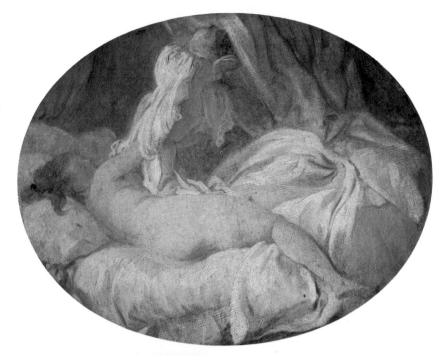

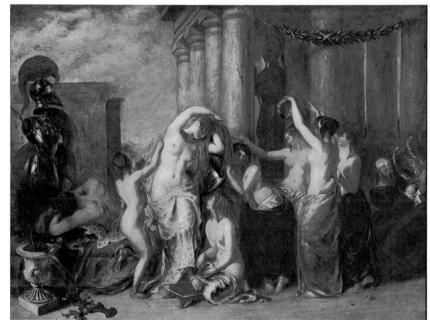

Venus and Her Acolytes William Etty
1787–1849

I do sympathize with Venus as she
tries to dress and make herself
lovely while her attendants,
instead of helping, get in the way.

I live like a Noël Coward play:
the telephones – there are three in
my bedroom – all ring at once,
there are secretaries taking down
letters and instructions, and
bringing in messages, a hairdresser,
a maid, sometimes my small
grandchildren trying on my
jewelry and of course my two
dogs, Duke, a black Labrador and
Twi-Twi, my white Pekingese
who barks and tries to bite all
newcomers.

The Bride's Toilet David Wilkie 1785–1841

Every woman in her bridal gown
feels like a Princess on her wedding
day. With the symbolic significance
of the veil, she feels that she
dedicates herself with sacred vows
to a new life of love.

The crown of orange-blossom is
a sign of victory over the forces of
evil.

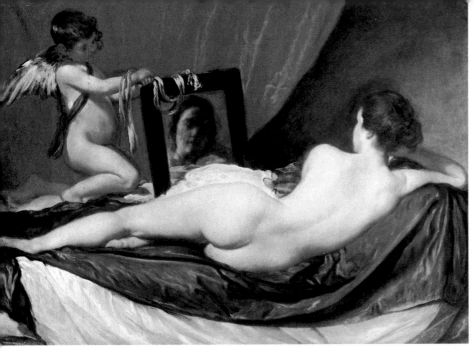

◄ *The Rokeby Venus* Diego Rodriguez de Silva Velazquez 1599–1660

What a glorious back! Women forget that their back is one of their greatest attractions or they would not wear trousers.

Velazquez's only surviving nude is named after Rokeby Hall in Yorkshire, where it once hung. It was painted in emulation of Titian. If you look you will see the mirror is actually held in the wrong place – and ought to reflect the model's stomach!

The Bath of Venus Jacques Charlier, 18th century ►

It is interesting that in the eighteenth century, which was a dirty period, the goddesses were depicted bathing but no one followed their example.

In Spain the bath was forbidden as a heathen abomination, and a lover was, as one of the greatest marks of favour, given permission to search for lice on his fair lady.

In France the Roi Soleil, Louis XIV, never washed himself. After his death people began to be more fastidious and society ladies received guests of both sexes when having a bath.

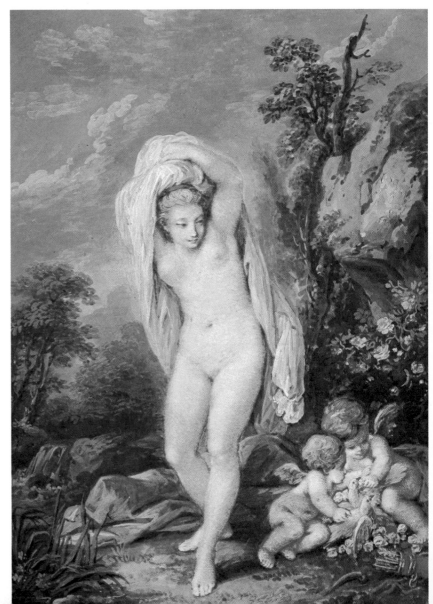

Wherever She flies the Boy her steps pursues

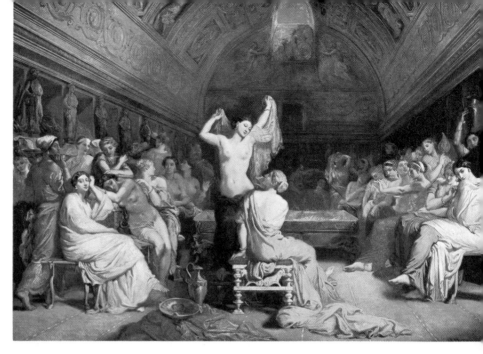

The Tepidarium Theodore Chasseriau
1819–1856

Too many naked women herded
together! No wonder the one on
the left looks bored. The one on
the right is deep in memory's love.
I wonder what he was like?

After sketching a party of
Bedouins in Marseilles,
Chasseriau concentrated on Arab
themes. He was the lover of Alice
Ozy, the courtesan, for two years,
and appears to have been the only
man she really loved.

A Lady and Her Admirer. La Vie Parisienne,
1890s

Women were sexually alluring at
this period because their clothes
were so complicated and obviously
so intriguing to remove. There
were little pads of satin to fasten
into place on the hips and under
the arms which would accentuate
the smallness of the waist already
compressed by the tight corset.

Lovers became quite expert at
pulling in the silk laces. Lord
Worcester, when he was living
with the famous Georgian
courtesan Harriette Wilson,
always laced her up before he left
and was therefore often late for
parade.

A Wedding Morning John H. F. Bacon ►
1868–1914

'May poles, Hock carts, Wassails,
 Wakes
Of Bride grooms, Brides and of
 their Bridale-cakes
I write of Youth, of Love and have
 Accesse
By these, to sing of cleanly –
 Wantonnesse.'

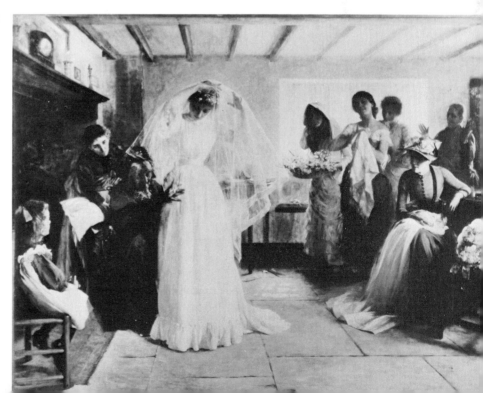

Casanova

Giacomo Girolamo Casanova Attributed to Anton Rafael Mengs 1728–1779

when Prince of Wales. Casanova's first sexual impulse was at the age of eleven; his first experience, with two girls simultaneously, when he was seventeen.

By chance he was introduced to Cabalism and Alchemy, became an occultist and lived off the rich. He was described as 'tall, built like Hercules, eyes full of life and fire – touchy, wary, rancorous – he laughs little but makes others laugh'.

In his unceasing love affairs, he usually found a pretty woman in some difficult predicament from which he rescued her and was rewarded by taking her to bed.

When he was thirty-two, dark and brilliant, Manon Balletti, a seventeen-year-old virgin, fell in love with him. Through his adventures of the next three years, she wrote him endless letters, cried when he neglected her and gradually grew up to see him as he was – fascinating, lovable, but impossible!

Manon Balletti Jean-Marc Nattier 1685–1766

Popularly believed to be the greatest lover of all time, Casanova (1725–1798) was actually a scoundrel, a snob, an astrologer and a devoted Catholic. However, he behaved like a gentleman in one important particular. When he wrote his autobiography, a very romantic account of his adventures, he discreetly changed the names of the women to whom he made love.

He also reduced the ages of his mistresses, who were nearly always older than he was! Born in Venice, his brother was the illegitimate son of George II

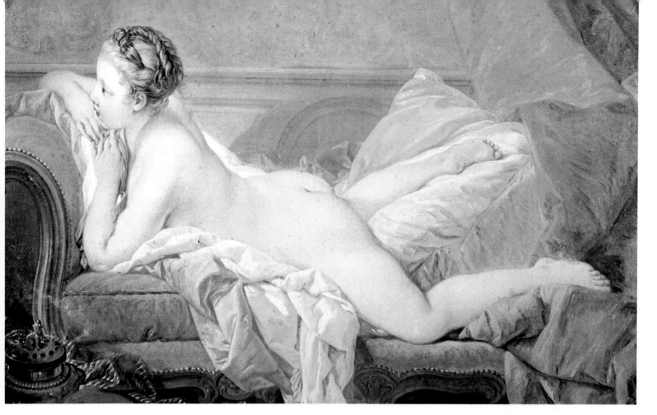

Louise O'Morphy François Boucher
1703–1770

At the Court of Versailles,
Casanova became a pimp for
Louis XV. With an actress called
O'Morphy, he met her thirteen-
year-old sister Louise. She was so
dirty he couldn't see if she was
pretty or not and washed her
himself. He nearly deflowered her
and ordered Boucher to paint her
picture lying on her stomach.

This pose was alleged by Saint
Quentin, the Kings' procurer, to
be guaranteed to inflame His
Majesty, who was obsessed by
girlish buttocks.

Louise was taken to Versailles,
the King inspected her, gave her
sister money and she entered the
Royal 'harem'.

Casanova's fortunes turned,
caused by debt and scandal. Manon
Balletti sent him her diamond
earrings to get him out of prison
then returned his portrait and his
letters. It was the first time a
woman had ever rejected him.
Astonished, he kept her letters
until his death.

A typical Casanova scene with him
bathing the woman with whom he
wishes to make love. He cured the
Duchess of Chartres of acne by
ordering her to purge her bowels
and wash her skin frequently in
cold plantain water. In brief – 'be
clean', but Casanova's fame
spread!

La Sollicitation Amoureuse Pierre Adrien Le
Beau 1748–1789

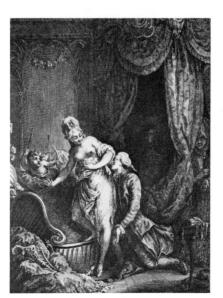

Casanova fell in love with a
castrato – with difficulty got him
into bed, to discover 'he' was a
girl. (Actresses assumed this
disguise in cities which were
forbidden to them.) He had a brief
affair with Teresa, but as she was
an actress he did not think her
respectable.

Teresa Lanti Anonymous; Bolognese
School, 18th century

Temptations of Love

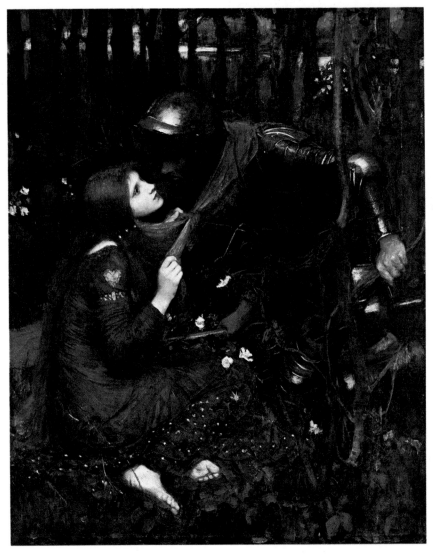

La Belle Dame Sans Merci
John Waterhouse 1849–1917

Eve Carlos Verger, 20th century ►

This is the most seductive picture I have ever seen, and if you look at Eve's face you will see she is not only enjoying the advances of the snake but encouraging, and in her turn, tempting him. One has a certain sympathy with the seducer and a deep compassion for Adam.

There are women who are never content with fidelity. They seek the challenge of the unknown, the erotic and the dangerous. These women destroy their own happiness and everyone else's whom they meet.

Avoid such Eves, do not play with fire if you are a man, bar them from your home if you are a woman.

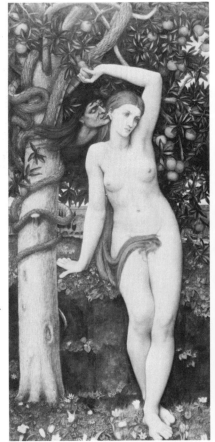

The Knight has been enchanted by La Belle Dame, whom he has kissed. She takes him to her elfin grot, gives him roots and honey to eat, lulls him to sleep and deserts him. His dream is a vision of other pale Kings and Knights in her thrall.

> 'I saw their starved lips in the gloom
> With horrid warning gapèd wide,
> And I awoke and found me here
> On the cold hill's side.'

KEATS

Eve Tempted J. R. Spencer Stanhope ►
1829–1908

> 'The Tempter whispers in her ear
> Soft and silky words which charm,
> She pauses so that she can hear.
> How could she come to any harm?
> She will only look. She will not stay.
> One moment – then she'll go away.
> A baited trap, the insidious spell!
> Too late she tries to turn and go,
> Eden is lost and Heaven as well –
> How could she guess?
> How could she know?'

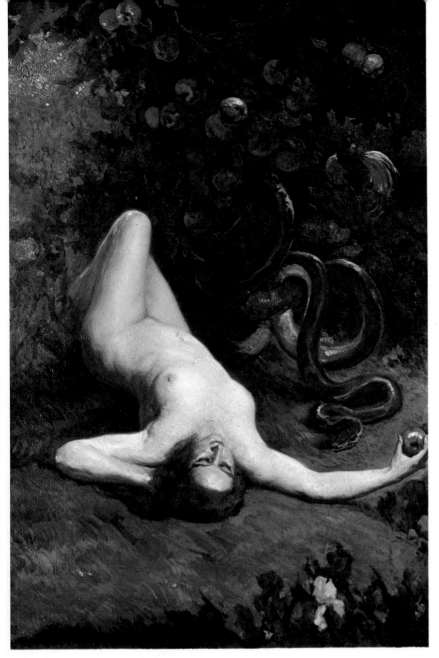

The Beguiling of Merlin
Edward Coley Burne-Jones 1833–1898

Merlin adores Nimuë (or Viviene) who, to be rid of him, traps him under a stone. But in Tennyson's poem, she extracts from him the knowledge of a charm, which she uses to trap him for ever in an old oak tree.

> 'For men at most differ as Heaven
> and Earth,
> But women, worst and best, as
> Heaven and Hell!'

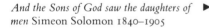

And the Sons of God saw the daughters of ▶
men Simeon Solomon 1840–1905

'And the Sons of God saw the daughters of men, that they were fair, and took to themselves wives of all which they chose.'

Most girls dream of falling in love with an angel but what would he be like? Weak, effeminate, eternally cluttered with a white nightgown. That is how the Victorian painters depicted them.

When I was fourteen and very unhappy away from my home, I was praying by my bed when I saw an angel outlined in white against the wall. He was tall, strong, very masculine but with wings. It was only when I was grown-up I realised he was like the Michelangelo angels in the Sistine Chapel.

I think our Guardian Angels are part of the Life Force. Strong, powerful, we can call on them for help and they will never fail us.

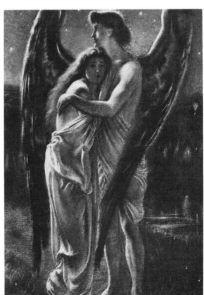

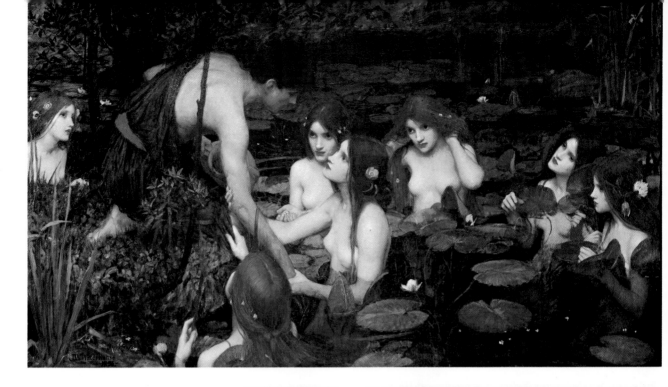

Hylas and the Nymphs John Waterhouse
1849–1917

Hylas, handsome and attractive, was beloved by Hercules and went with him on the Argonauts' quest.

On landing on the coast of Troao to take in fresh water, Hylas, looking into a woodland pool covered with water lilies, was seen by the water nymphs.

They were so charmed by his beauty that they carried him down into the depths of their watery abode.

Hercules, calling for Hylas, made the shores reverberate with his name, but the young man was never seen again. Hercules was heartbroken. He gave up his journey and went home.

In this picture, the same model obviously posed for *all* the nymphs but as she was very lovely it doesn't matter or lessen the allure of the picture.

John Waterhouse devoted himself to painting the *'femmes fatales'* of literature.

Siegfried and the Rhine Maidens
Albert Pinkham Ryder 1847–1917

Nibelung was a mythical King of a race of Scandinavian dwarfs dwelling in Nibelheim ('the home of darkness').

The Nibelungs were the possessors of the wonderful 'Hoard' of gold and precious stones guarded by the dwarf Alberich.

Siegfried, the hero of the poem, gained the Hoard and gave it to his bride, Kriemhild, as her marriage portion. After his murder Kriemhild carried it to Worms, where it was seized by her brother Gunther and his retainer Hagen.

They buried it in the Rhine, but were slain for refusing to reveal its whereabouts and the Hoard remains for ever with the Rhine Maidens.

The Holy Grail P. Marcius Simons, 19th century

The Grail, in legend, is the cup used by Christ at the Last Supper, in which Joseph of Arimathea caught his blood at the Crucifixion.

In Malory, King Arthur's knights, led by Sir Gawain, form a quest to seek it. Sir Launcelot glimpses it but his sins prevent him achieving a true vision.

His son Sir Galahad attains the quest through his purity.

Ferdinand Lured by Ariel John Everett Millais 1829–1896

Ferdinand, who is destined to meet and fall in love with Prospero's daughter Miranda, is stranded for this purpose on Prospero's magic island by the tempest whipped up by Prospero. Ariel is a spirit of the island, under the control of Prospero's magic, and acting as his servant. Invisible, he sings in Ferdinand's ear and lures him across the island to meet Miranda:

'Come unto these yellow sands,
And there take hands:
Curtsi'd when you have, and
 kiss'd, –
The wild waves whist –
Foot it featly here and there;
And, sweet sprites, the burden bear
Hark, hark . . .'

Ferdinand is the first man, other than her father and the monstrous Caliban, that Miranda has ever seen:

'O brave new world, that hath such creatures in't!'

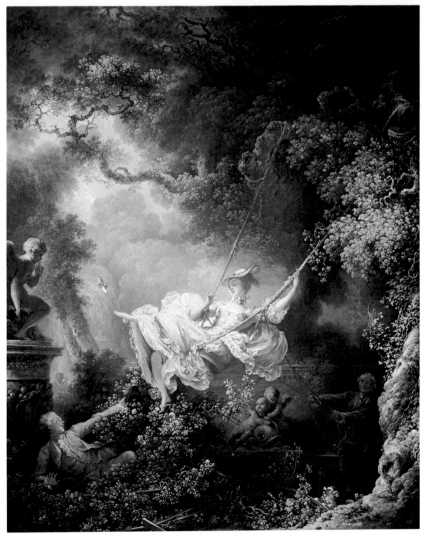

The Swing Jean Honoré Fragonard 1732–1806 ▶

Love Forbidden

The Indiscreet Wife Engraving after
Pierre-Antoine Baudoin 1723–1769

▼ *Love Among the Ruins* Edward Coley
Burne-Jones 1833–1898

The picture below stirs the
imagination as the painter intended
it to do.

Its wistful nostalgia is
characterized in the worried,
frightened expression on the girl's
face, and the protective love on the
man's tells its own story. The
thorns are symbolic, for love
forbidden always brings its own
punishment.

The Orgy William Hogarth 1697–1764
(The third scene from *The Rake's Progress*)

The Rake's dining-room, where
the girl in the foreground is
preparing to dance naked on the
table – on the tray being brought
through the door.

The Rake is having his watch
stolen by the woman caressing him,
who passes it to her accomplice.
In the background a girl is setting
fire to a map of the world –
symbolising the attitude of the
Rake.

On the walls are portraits of
Roman Emperors, whose faces the
Rake has torn out – except for that
of Nero, the most wicked.

The conical glasses and wicker
bottles signify gin, and the beauty
spots conceal pockmarks.

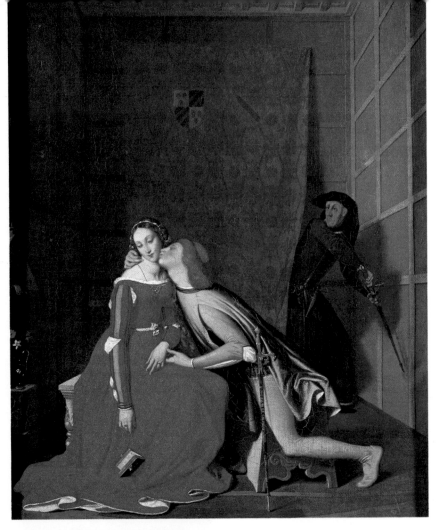

Paolo and Francesca Jean Auguste Dominique Ingres 1780–1867

The beautiful Francesca, daughter of the Count of Ravenna, was given in marriage by him to Giovanni Malatesta, an ill-favoured man, in return for his military services. She fell in love with Paolo, her husband's handsome brother, and their affair being discovered, the lovers were put to death in 1289. In Dante's *Inferno*, Francesca tells how her fall was brought about because she read the story of Launcelot and Guenevere. I think it is terrifying that one couple committing adultery influenced others.

We should all question the effect today, of television, on the actions of young people. Can the increase in crime really be accidental? Can we believe complacently that the brain, which is so receptive, does not store what it sees and hears?

◄ *The Doctor's wife and her friend bathing in a stream* Louis Binet, 18th century

Peeping Toms appear in every age and these two gentlemen doubtless find the Doctor's wife and her friend very delectable. But I wonder what the Doctor had to say about it?

The Lovers Surprised Studio of Baudoin ►

On these two pages we have two of Baudoin's pictures on the same theme. Here the peasant girl looks guilty while her lover escapes into the loft. Opposite, the gentry's amorous play is watched by a maid who will doubtless blackmail them!

Nelson

Horatio Nelson, Viscount Nelson
William Beechey 1753–1839

A mixture of professionalism and genius, of courage, and of dedication, the small, thin body of Nelson with its alert face, prematurely greying hair and sensual mouth, has, since his death, inspired every British sailor.

He was Rear-Admiral Sir Horatio Nelson when he lost his arm at Teneriffe. It seemed as tragic as the lost battle, but it made him a great lover.

A man's sexual capacity is increased by being crippled – the Amazons always broke the legs of their prisoners.

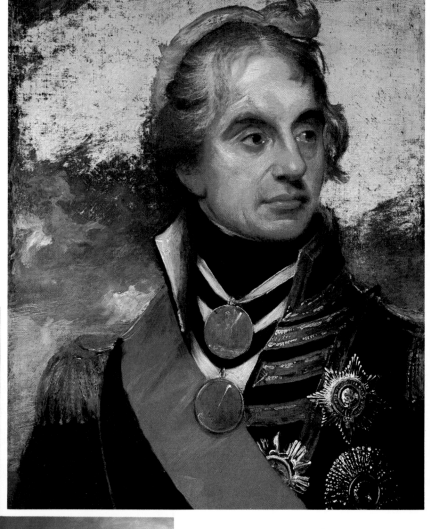

Lady Hamilton George Romney 1734–1802

Exquisitely beautiful, the perfection of glowing health, sweet-tempered, daughter of a Cheshire blacksmith, she was the mistress of Charles Grenville who handed her over to his uncle Sir William Hamilton, British Ambassador at Naples.

Nelson was the hero of the Nile, she enchanting, irresistible – they became lovers in February 1799. In January 1801 Nelson, at sea, learnt he had a daughter: for secrecy, their letters described the mother as 'Mrs Thomson'.

Lady Hamilton George Romney

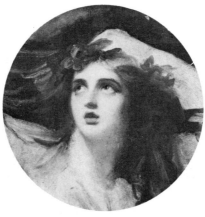

Lady Hamilton as Cassandra
George Romney

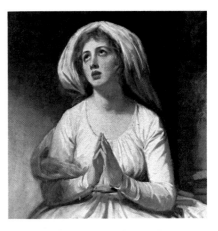

Lady Hamilton at Prayer George Romney

Written after the Birth of Horatia on
30th January, 1801
San Josef, Torbay. February 1st, 1801

'I believe poor Mrs Thomson's
friend will go mad with joy. He
cries, prays, and performs all
tricks, yet dare not show all or any
of his feelings . . . I believe he is
foolish: he does nothing but rave
about you and her. I own I
participate of his joy and cannot
write anything . . . May the
heavens bless you and yours in the
fervent prayer of your unalterable
and faithful . . .'

The baby was secretly placed
with a nurse. Horatia remained
with Lady Hamilton until her
death, married Reverend Philip
Ward and had many children.

Lady Hamilton as a Bacchante
George Romney

Nelson's last letter to Lady Hamilton,
19 October 1805

March 1st, 1801

'Now my dear wife, for such you
are in my eyes and in the face of
heaven . . . I love, I never did love
anyone else . . . I am sure my love
and desires are all to you, and if
any woman naked were to come
to me, even as I am this moment
from thinking of you, I hope it
might rot off if I would touch her
even with my hand.'

Lord Nelson to His Guardian Angel,
1800

'From my best cable tho' I'm
forced to part
I leave my anchor in my angel's
heart.
Love, like a pilot shall the pledge
defend
And from a prong his happiest
quiver lend.'

Answer of Lord Nelson's Guardian
Angel

'Go where you list, each thought
of Emma's soul
Shall follow you from Indus to the
Pole:
East, West, North, South, our
minds shall never part;
Your Angel's loadstone shall be
Nelson's heart.'

Lady Hamilton as Circe George Romney

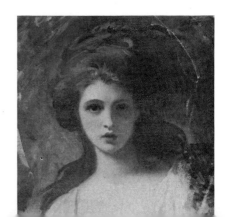

Love to the Rescue

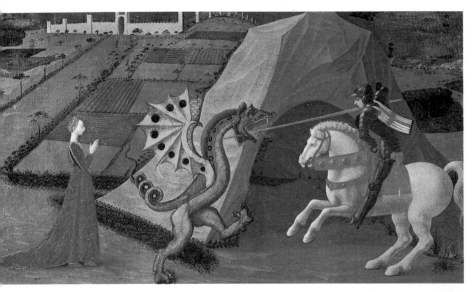

◀ *St George and the Dragon* Paolo Uccello 1397–1475

The story of St George and the Dragon has fired the imagination of countless painters and is part of the history of Britain. I love this picture and its very saucy dragon.

The myth of St George and the Dragon is a late addition to his legend, and its origin is obscure – perhaps inherited from Perseus and Andromeda, and adopted as a symbol of the triumph of the Christian hero over evil.

Uccello is famous for his imaginative use of perspective.

The Two Gentlemen of Verona ▶
William Holman Hunt 1827–1910

Julia is in love with Proteus and follows him disguised as a page. He loves Silvia, who has fled from her father to rejoin Valentine whom she loves, when she is captured by robbers and rescued by Proteus. He is pressing his suit, when Valentine appears. Proteus is so struck with remorse that Valentine gives up his claims to Silvia. Julia swoons and Proteus, touched by her constancy, gives her his heart.

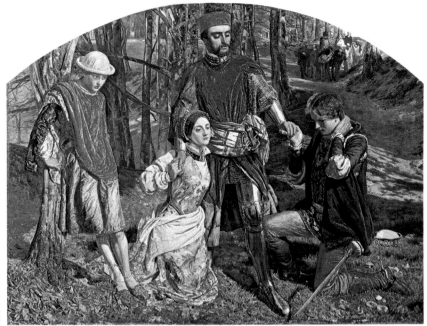

◀ *Perseus and Andromeda* Charles-Antoine Coypel 1694–1752

Perseus was the son of Zeus and Danaë. Polydectes, in love with Danaë, disposed of Perseus by sending him to fetch the gorgon Medusa's head. On his way back he discovered Andromeda on a rock about to be devoured by a dragon, which he killed.

The Laidly Worm Walter Crane 1845–1915

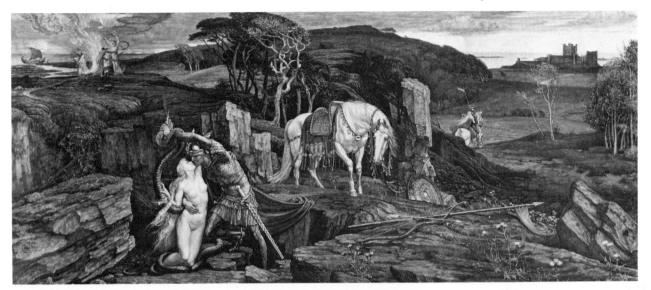

◀ *The Death of Nessus* Jules Elie Delaunay 1828–1891

Hercules won the beautiful Deianira from many ardent suitors because she was fascinated by his gigantic strength. They were married and were very happy.

Travelling, they were stopped by the river Evenus and the centaur Nessus offered to carry Deianira safely across. However, having reached the other side he attempted to rape her. Hercules killed him with a poisoned arrow.

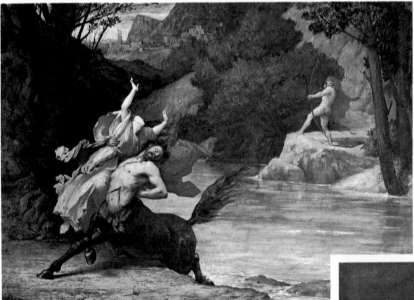

The Storm William Etty 1787–1849 ▶

I think this dramatic and exciting picture has a message of courage and hope for all those who are buffetted by the troubles and tragedies of life.

、 There is hope in the bravely flying improvised flag and undoubtedly the two people have the will to survive.

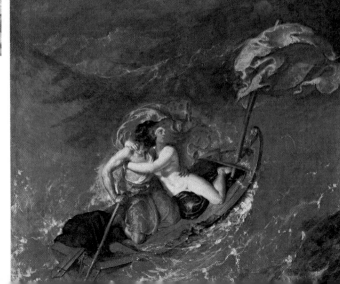

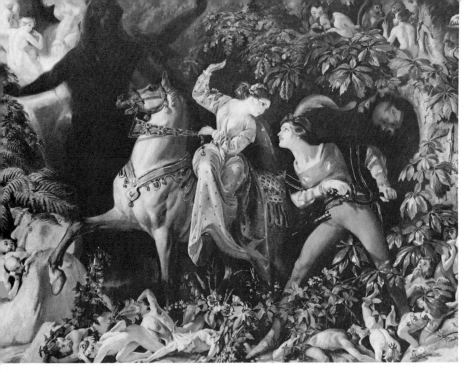

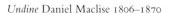
Undine Daniel Maclise 1806–1870

This is my favourite story.

Undine is a water spirit who can gain a soul if she marries a mortal. She falls in love with the Knight Huldebrand but her wicked uncle, Kühleborn, objects to the arrangement and torments them.

One day, on the Danube, Huldebrand rebukes Undine and she is snatched from the boat into the water and lost.

Huldebrand is about to marry again, when Undine rises from a well, goes to his room and kisses him. He dies in her arms and they become twin streams.

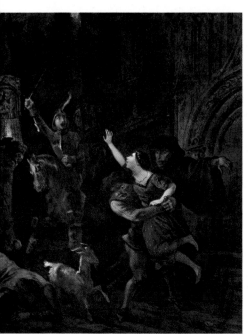

The Abduction of Esmeralda Louis Boulanger 1806–1867

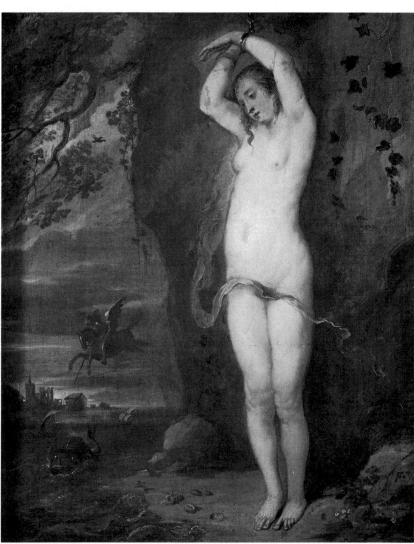

Claude Frollo, the wicked Archdeacon of Nôtre Dame, is infatuated by Esmeralda, a gypsy dancer. He pays Quasimodo, the grotesque hunchback bell-ringer, to kidnap her. She is rescued but Frollo kills her lover. Finally she is hanged and in revenge Quasimodo flings Frollo from the battlements.

St George and the Dragon Raphael
1483–1520

St. George and the Dragon Paolo Uccello
1397–1475

A prodigy – in 1500, at seventeen,
Raphael was working for
Perugino; Leonardo was forty-
eight and Michelangelo twenty-
five. Within ten years the
provincial Raphael was admitted
to be their equal.

At about twenty-five he went
to Rome to paint for Julius II and
became the principal master in the
Vatican, excepting only
Michelangelo. At his death his
social position as an artist, the
friend of Cardinals and Princes,
was unique.

◄ *Andromeda Chained to the Rock*
Frans Wouters 1612–1659

Perseus and Andromeda Titian *c.* 1487–1576

To the right and to the left, two
versions of the same old story. The
Wouters Andromeda has very
unshapely hips and a fat stomach.
Titian's is far more elegant and
very much more sophisticated.

As traditionally Perseus has to
marry Andromeda after he has
rescued her, I should choose the
Titian!

Another delightful St George but
in this picture he looks rather like a
creature from outer space. As the
Princess was obviously taking the
dragon quietly for a little walk it
seems somewhat unsporting to kill
him while he is still on a lead!

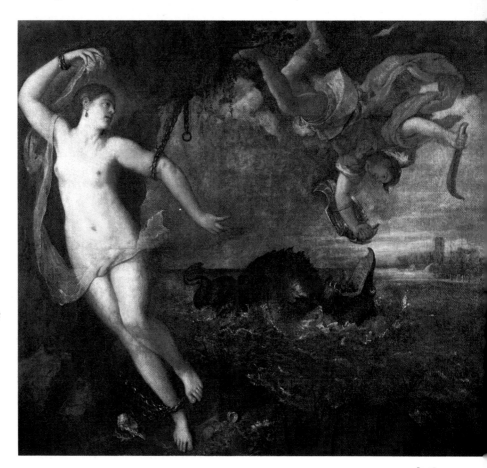

Clandestine Love

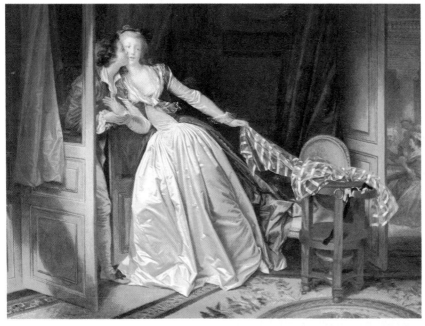

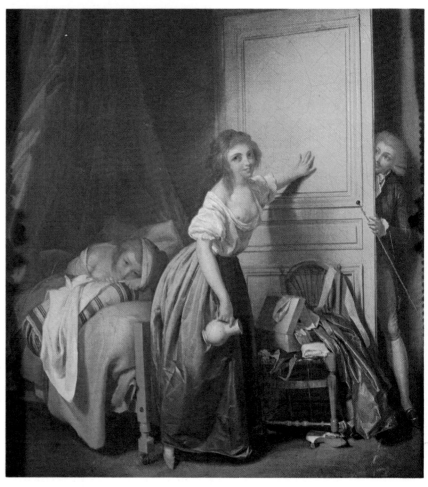

Love in a Garden French, 18th century

I feel so sorry for this loving couple. Of course, some prying creature is watching, and there will be a row, if not punishments and restrictions to be faced!

The Stolen Kiss Jean Honoré Fragonard 1732–1806

Nothing could be more graceful or more enticing than this delightful picture of a stolen kiss. Fragonard makes the whole art of love so delicious, an art which makes one regret the slapdash manners and behaviour of modern lovers.

To be wooed is no longer in fashion, it is just 'Will you or won't you?' but how delightful a flirtation was which gradually became serious, accompanied by flowers, letters, poems and presents!

The Tell-tale School of Boilly, 18th century

This is a typical French interpretation of 'indiscretion', though I feel it is taking quite unnecessary risks.

In real life, women so often forget to lock their doors, which I should have thought an obvious precaution. But who counts the risks? 'It is as safe to play with fire as it is to dally with gallantry.'

The Hurried Departure School of Boilly, 18th century

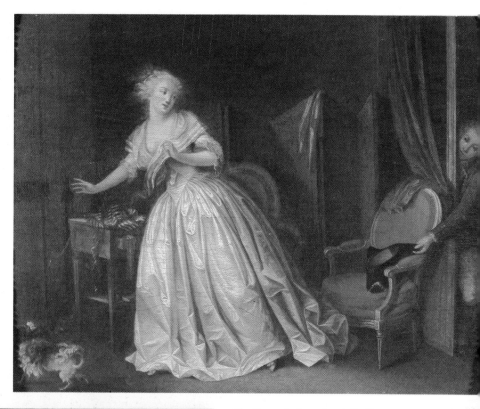

What lover has not gone through the horror of wondering if he has left anything behind? An incriminating hat once caused one of the greatest scandals in political circles. But love is always worth the risk of exposure.

In the eighteenth century Lord Chesterfield wrote to Fanny Shirley, saying:

'Think, I beg you, whether there would not be a way on my return for us to pass a night together, or even a day, in bed. For example, could you not find some pre-text for staying a night in town and have me let in by your maid through the back door. . . . Thus far, my happiness has been imperfect and I begrudge your clothes the part which they have had in our embraces. . . .'

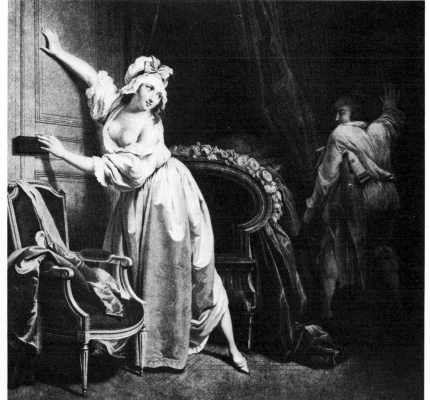

The Favourite Lover Louis Boilly 1761–1845

Here is a wise and sensible woman who does lock her door after her favourite lover has arrived and will therefore enjoy their love-making without fear of being disturbed.

Noise is the reason so many modern lovers are frustrated and disappointed. Noise of passing trains, of barking dogs can all put men off making love, and a mother who listens for a child to wake can be the same.

I believe that to keep one's marriage happy and love alive it is essential every year to have a second honeymoon. A married couple should go away for three days or longer alone, to forget the children, the mortgage, the rates, the taxes, and remember that the most important thing in their little world is Love.

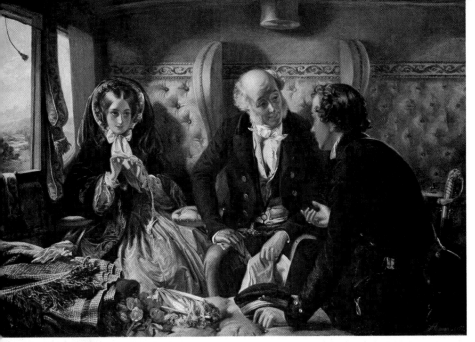

There were many under-the-table jokes in this era. One of the best was a man who at a pompous dinner party paid a small boy to tie everyone's shoe laces together. At another a lady grew more and more frigid with her dinner partner to find it was the dog who was caressing her ankle. I agree with Oscar Wilde's remark: 'It is only the dull who like practical jokes'.

Playing Footsie 1908 ▼

Travelling First Class Abraham Solomon ▲ 1824–1862

The first version of this painting showed the elderly husband asleep, and the young man openly talking to the girl. This caused such a moral outcry that a variation was painted the same year. This seems extraordinary today.

In the 1920s I travelled from London to Cardiff with a complete stranger who proposed marriage before we reached Wales!

◀ *The Secret Admirer* Jean Baptiste Le Prince 1734–1781

Is the elderly man a husband or a father? Le Prince was a pupil of Boucher and a great traveller. In Russia the Tsarina gave her private apartments in the Winter Palace a touch of Paris. In 1762 Le Prince returned to the French capital still full of his experiences in Russia.

He reciprocated the Tsarina's compliment by making the Russian style all the rage in Paris. His most acceptable pictures are designs for the Beauvais tapestries.

The Awakening Conscience William Holman Hunt 1827–1910

I wish I knew what the woman had done! Following the success of *The Light of the World*, Holman Hunt intended this picture as a pendant to it.

The Victorian world was always moralizing, and poverty, prostitution, illicit love, illness, death, bereavement and adultery were all favourite themes.

The Awakening Conscience provoked a grudging acceptance for the subject's uncompromising modernity. Nietzsche wrote cynically: 'And what saved her virtue? The voice of her conscience? Oh no, the voice of her neighbour!'

Broken Vows Philip Calderon 1833–1898 ▲

A beautiful dark girl, wearing an engagement ring, swooning from shock, leans against an ivied wall. On the other side her fiancé dallies with a blonde. Their linked initials have recently been carved in the middle rail of the fence.

On the ground, a bracelet with a cross is a symbol of her soon-to-be-shattered engagement as she overhears the loving words her fiancé is saying.

◀ *La Nuit* after Baudoin, 18th century

Napoleon

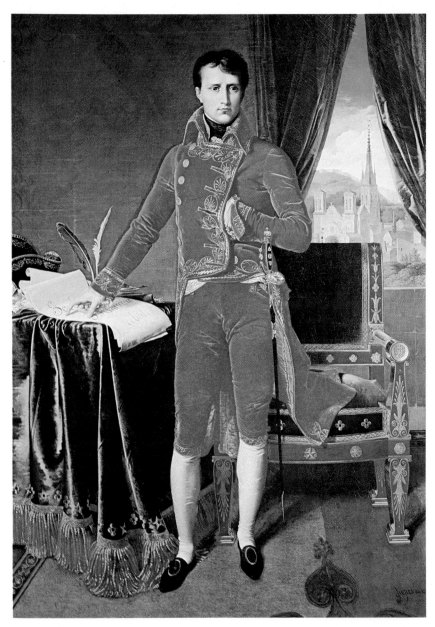

Napoleon Bonaparte as First Consul
Jean Auguste Dominique Ingres 1780–1867

Joséphine Antoine Jean Gros 1771–1835

When on Christmas Day 1778 Napoleon Bonaparte (1769–1821) first set foot in France he could not understand the language. This amazing man rose to be Emperor, and the conqueror and terror of half Europe.

Five feet six and a half in height, he loved hot baths and would sit in one for an hour. He worked a sixteen-hour day. He liked very feminine women and was a superb lover. Joséphine, because of it, never gave him any peace.

When planning the Italian Campaign he made love then locked himself away saying: 'Love must stand aside after Victory.'

Joséphine de Beauharnais, fascinating, passionate, promiscuous, extravagant, was always in debt. Her first husband having been guillotined, she was penniless. She married Napoleon who was madly in love. He wrote: 'Not a day passes without my loving you, not a night but I hold you in my arms.' He sent her frantic pleas for replies. She was unfaithful but there was a link between them which he described as 'a magnetic fluid'.

His brother Lucien persuaded him to divorce her. Napoleon agreed. All night Joséphine knelt outside his door with her children, crying. When Lucien called next day, he found Napoleon and Joséphine in bed together!

Napoleon crowned Joséphine after he himself had been crowned by the Pope. When he asked her for a divorce so that he could have an heir she sobbed 'It is not the throne I mind losing, it's you – my husband, my lover, my all.'

After Joséphine died Napoleon went alone to her bedroom. and shut himself in. When he came out, his cheeks streaked with tears, he said: 'Good woman, she loved me truly.'

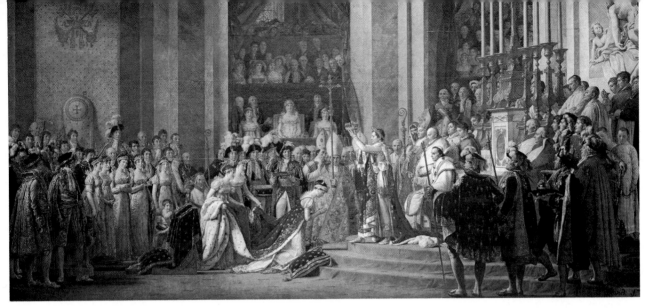

The Coronation of Napoleon and Joséphine
Jacques-Louis David 1748–1825

The Coronation took place in December 1804 at Nôtre Dame. Joséphine looked lovely but her sisters-in-law were furious because they had to be her train bearers. The train – orange red velvet lined with crimson, was very heavy and the two sisters deliberately let Joséphine try and walk without them lifting it. Napoleon spoke to them sharply in Corsican and sulkily they picked it up.

Napoleon had trouble with his sisters over their titles – they made so many complaints that he said sarcastically: 'One would think to hear you that I had just despoiled you of the heritage of our late father the King.' But he gave in and they became 'Highnesses'.

On the night of the Coronation in the Tuileries, ablaze with thousands of lights, Napoleon dined alone with Joséphine. He thought her crown 'suited her so well' that he made her wear it during dinner. Afterwards they went to bed.

Joséphine could now meet Kings and Queens on equal terms, and it went to her head. Napoleon wrote to her: 'Great Empress . . . deign from the height of your Grandeur to concern yourself a little with your slaves . . .'

Eugénie-Bernardine-Desirée Clary Bernadotte Engraving after François Gérard

Desirée Clary was very pretty at sixteen; Napoleon fell in love with her and wrote: 'Love from one who is yours for life.' It was a dream romance and he ended it. She wept at first but had a happy marriage with an army officer called Jean Bernadotte.

Madame Walewska Robert Lefebvre

Countess Marie Walewska, sensitive, loyal and passionate, met Napoleon at a ball. He wrote: 'I saw only you, I admired only you, I desire only you.'

He told her 'If you persist in refusing me your love, I'll grind your people in the dust.' She gave herself for Poland.

Empress Marie-Louise Louis Gabriel Eugène Isabey 1803–1886

Eighteen, with slanting cat-eyes, Marie-Louise was more sensual than Joséphine. On her wedding night, delighted with Napoleon's love-making, she asked him to 'do it again'. Impatient to have a son, he carried her off to bed before she reached Paris.

[85]

Confessions of Love

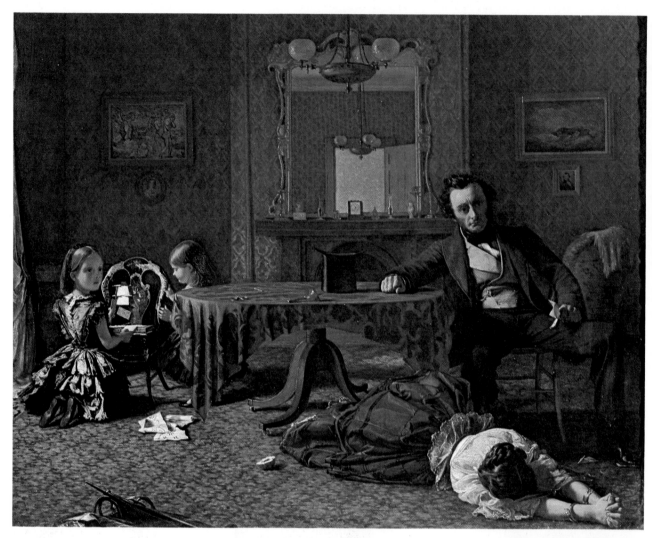

Past and Present I Augustus Leopold Egg
1816–1863

These two confessions are typical of the dramatic way in which the Victorians thought of women who were unfaithful. The sobbing wife and the stunned husband are just as poignant as the elderly man stricken by what his young wife tells him.

I think confessions are always a coward's way of shifting the burden of guilt, and this wife should have kept her sins to herself.

The Confession Frank Dicksee 1852–1928

The First Cloud William Quiller Orchardson 1835–1910

Orchardson liked this dramatic moment in the life of a newly married couple. He painted it twice. I hope she soon gets over her huff. The best rule for all married people is 'Never let the sun go down on your wrath' and, of course, have a double bed.

It is impossible, close to the person one loves, to go on quarrelling all night!

With his realistic manner of painting that can be almost painful, van Reznicek has squeezed every ounce of drama out of this confession. The man is shocked by what he has heard, the woman prostrate.

They are both ghosts from the past, showing how lax we have become in our standards and our morals. Who do we know who would behave like that today?

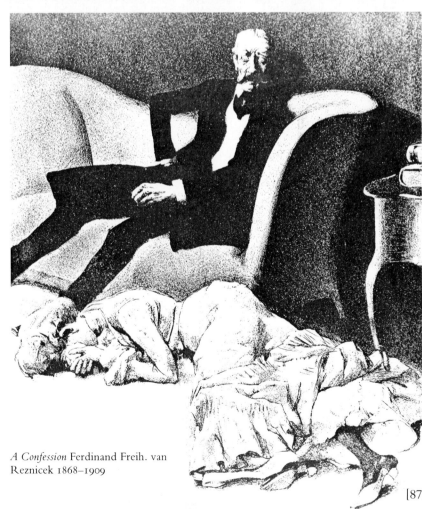

A Confession Ferdinand Freih. van Reznicek 1868–1909

Wicked Love

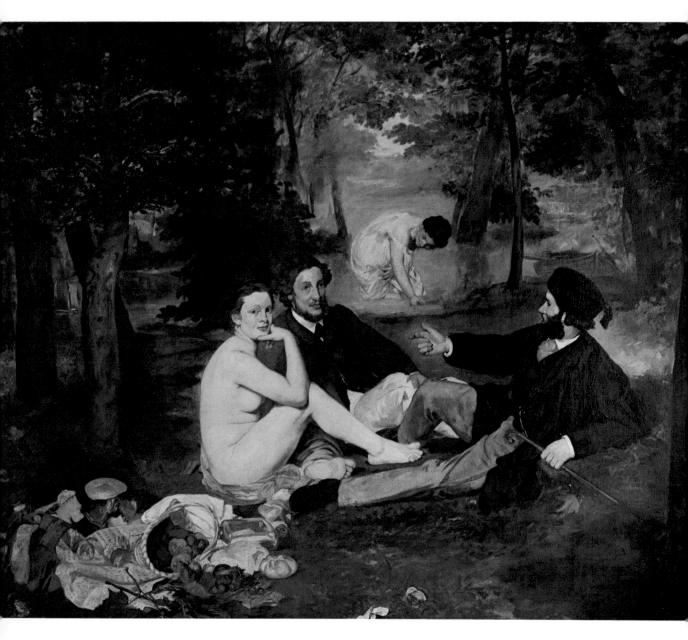

Déjeuner sur l'Herbe Edouard Manet
1832–1883

This picture caused what seems
to have been an incredible
sensation at the Salon des Refusés
in May 1863. No exhibition of
paintings had ever attained so
great or so excited a crowd. Seven
thousand entrance tickets were sold
in the first few hours. It was

Manet's picture, with the presence
of nudity in a non-classical context,
which became a symbol of the
Salon in its most audacious and
offensive aspect. The Emperor
gave the lead and accused the
Déjeuner of indecency.

No one doubted that it was
obscene and immoral. Yet some
came away from the Salon 'grave,
anxious and disturbed'. The

Déjeuner's break with tradition
opened a new world to painting
and the absolute truth.

Manet found himself at the
centre of a group of young artists
whose meetings finally gave rise to
the Impressionist movement,
though he hated his association
with it, and longed for official
recognition.

Diana and Nymphs and Fauns
Peter Paul Rubens 1577–1640

Diana, the goddess of chastity, is on the right of the picture, preparing to defend her nymphs from the marauders. The nymphs in mythology were always being pursued, and for centuries it was accepted that it was the man who chased the woman.

At the beginning of this century men were considered so dangerous that no unaccompanied woman was allowed to be alone with one. To me it is rather sad that women have become so emancipated that they are not only safe from the 'unbridled lust' of mankind, but they are now the pursuers not the pursued.

They miss so much that their grandmothers and great-grandmothers enjoyed!

Bacchanalian Revel Nicolas Poussin 1594–1665

In origin Dionysus was simply the god of wine; afterwards he became god of vegetation and warm moisture; then he appeared as the god of pleasures and the god of civilisation.

Finally, according to Orphic conceptions, as a kind of supreme god. Dionysus was honoured throughout Greece, but the character of the festivals which were dedicated to him varied with regions and epochs.

The appearance of Dionysus altered at the same time as his legend. He was first depicted as a bearded man of mature age, his brow generally crowned with ivy.

The Harlot's Progress: Plate 1 Engraving
after William Hogarth 1697–1764

For centuries, procurers enticed
away country girls coming to
London to seek employment. This
girl from York, beguiled by the
promise of easy money, ignores
the Parson who has come to meet
her, and will be taken to a brothel.

◀ *The Serious Client* Hilaire Germain Edgar
Degas 1834–1917

Degas captured vividly the
characteristic gestures and postures
of his subjects and his pictures were
usually composed from notes taken
on the spot. This print was sold
at Sotheby's in April 1977 for
£26,000.

The print on the right, of a
Parisian *Maison de Plaisir*, is typical
of the period. Later the 'houses'
were violently denounced as
'grossly immoral', and closed. But
prostitution in a far more
dangerous form took to the streets
and 'night clubs'.

'*This way we are Sure to be Paid*'
Xavier Sager

I find this picture rather sad
because a millionaire who had
always loved women said to me
when he grew old: 'At my age – I
have to pay'.

Society is very harsh on the
aged. A man can be tolerated if
he fancies young girls, a woman
crucified if she takes a young lover.
Love is incorrectly connected only
with youth. Wine improves with
age – so, often, does love.

Comme ça on est sûres d'être payées

Faun and Bacchante Roman Fresco from ▶ Pompeii

It is extraordinary how the Romans, who were rather stolid in many ways, could produce fresco drawings in their brothels that are so light and alive that they can still be an inspiration.

Their gods had not the beauty or the spiritual significance of the Greeks, but I find this Bacchante an enchanting incentive to gaiety and *joie de vivre*.

We have forgotten to caper with joy, to sing with gladness and embrace life as a lover. We have grown suspicious of laughter, fearing that we might appear too frivolous, and have been indoctrinated with the idea that life is earnest! We slave-drive ourselves in the pursuit of money until when we earn it we have no idea how to spend it and have fun.

Put a picture of this fresco in your bedroom, and when you get up in the morning ask yourself if that is how you feel – if you don't, why not? If the Romans put it where the wicked foregathered perhaps they were wiser than history reports.

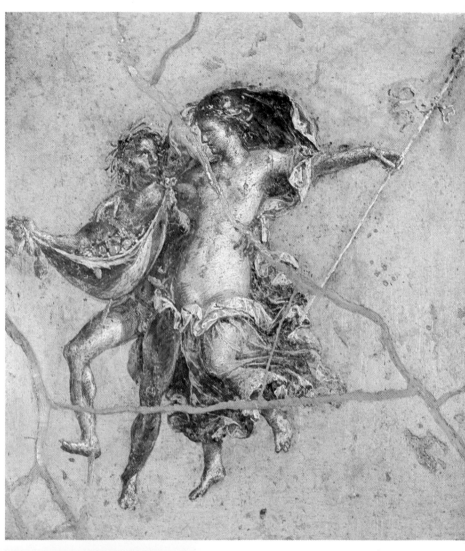

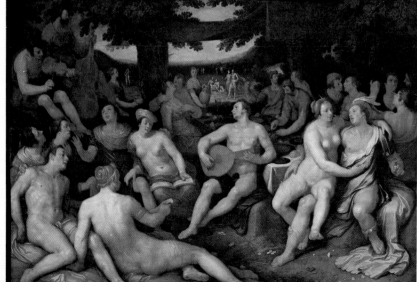

◀ *The Corruption of Men before the Flood* Cornelius van Haarlem 1562–1638

I can see the corruption in this picture but I often wonder, in the new era of 'anything goes', if today we know the meaning of the word. We accept the behaviour of people with what we call tolerance, but I suspect it is really a laziness to save ourselves the trouble of interfering.

Meanwhile, children growing up have difficulty in deciding what is right and what is wrong because there are no guidelines.

Metternich

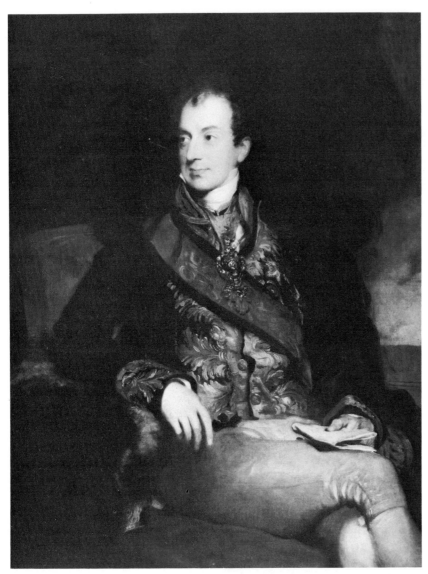

Prince Metternich Thomas Lawrence 1769–1830

Clement Metternich (1773–1859), Chancellor of the Austro-Hungarian Empire, was the great peacemaker of Europe.

He became master of the persistent and persuasive diplomacy which made him achieve the seemingly impossible at the Congress of Vienna.

Handsome, elegant, he had charm, wit, a brilliant approach to new ideas. A skilful courtier to his fingertips, he never lost mastery and poise.

He was a virile, experienced and satisfying lover. Every woman he loved rose to heights of emotional ecstasy beyond the power of expression.

He liked very feminine women, and wrote of Madame de Stael: 'I find this masculine woman overpowering.'

Princess Eleonore von Kaunitz

Metternich married Princess Eleonore von Kaunitz because he was ambitious and she belonged to a wealthy family. Passionately in love with him, she became his friend and confidant until she died.

He was able to make every woman with whom he had sexual contact fall madly in love with him. An incurable and unaffected romantic, he believed that love expressed by sex conjured up something divine and immortal. All this came from the rapture and beauty of his first act of love.

In Strasbourg he met one evening one of the loveliest young women in France, Marie Constance, Duchesse de Caumont la Force, aged eighteen. That night Clement became a man and he never forgot the magic she aroused in him. It was a divine rapture of body and soul he sought again with every woman he loved.

He wrote: 'She loved me with all the simplicity of her heart. I lived only for her and for my studies. She had nothing to do except to love me.'

Princess Katherina Bagration Engraving after Jean Isabey

Katherina Bagration, Russian-Polish, twenty years old, was a spy. Metternich called her his 'naked' angel'. To her he was Apollo. His wife Eleonore brought up their child.

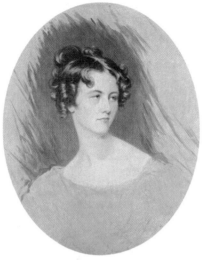

Marie Antoinette von Leykham Thomas Lawrence

Metternich's second wife was 'angelic in every way, dazzling and exuberant'.

She stimulated in him all the fire of youthful adoration. She died in childbirth.

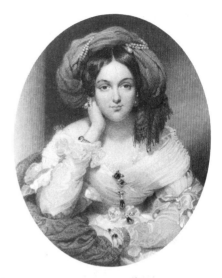

Countess Melanie Zichy-Ferraris

Metternich's third wife was Hungarian, and married him at twenty-three. Seductively attractive, tempestuous, excitable, sensitive and generous, she bore him five children and died five years before his death at eighty-six.

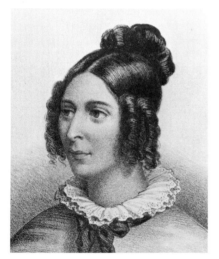

The Duchesse d'Abrantés

This was '*une grande passion*'. It was Eleonore who saved their affair from becoming a scandal. Napoleon said to her: '*C'est un diable*, that husband of yours.'

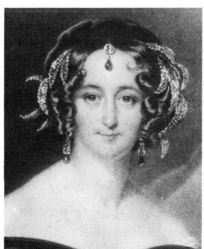

The Duchesse de Sagan

With Wilhelmina Metternich there was laughter, frivolity and delightful conceits. A volcano belching ice – with her there was a sexual link nothing could break.

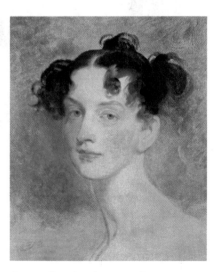

Princess Dorothea de Lieven Thomas Lawrence

Intelligent and witty, Metternich wrote to her saying: ' . . . you also burned with the fever of desire, my dear, and at last you are mine!'

Punishment for Love

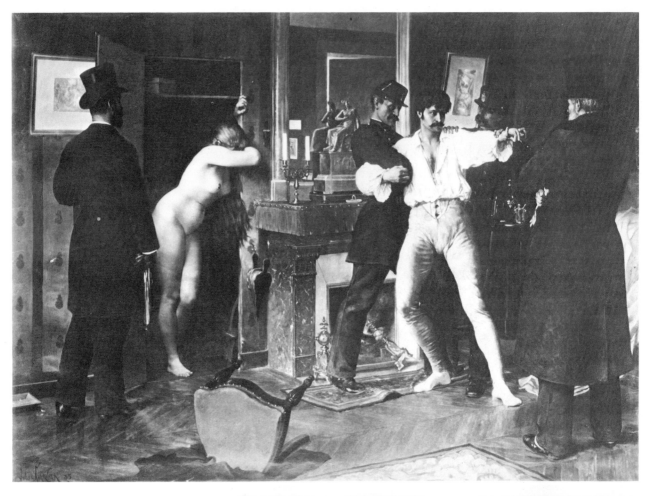

The Proof of Adultery Jules Garnier
1847–1889

In 1883, under the Code
Napoléon, married women did
not have citizenship: 'The wife
owed obedience to her husband;
*he could have her condemned to
solitary confinement for adultery* and
get a divorce from her. If he killed
her, he was excusable in the eyes
of the Law.'

Balzac wrote: 'The destiny of
woman and her sole glory are to
make beat the hearts of men . . .
she is a chattel and properly
speaking only a subsidiary to man.'

Sodom and Gomorrah Jan Brueghel ►
1568–1625

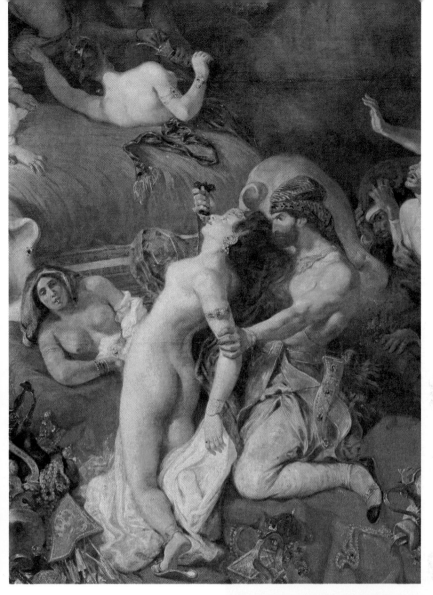

The Death of Sardanapalus (detail) Eugène Delacroix 1798–1863

'Lying on a superb bed on top of a vast pyre, King Sardanapalus of Nineveh and Assyria commands his eunuchs and the officers of the police to slaughter his wives, his pages, and even his favourite horses and dogs, since none of the objects that have contributed to his pleasure must survive him.'

In Byron's tragedy, Sardanapalus is in love with a beautiful Greek slave girl, Myrrha. Defeated by his enemies, Sardanapalus refuses to surrender, but has a funeral pyre built for himself and Myrrha.

Men always expect a woman to be ready to sacrifice herself for them – if not by death, by living in the wilds of nowhere, by moving continually from place to place, by giving up any interest which conflicts with theirs.

What should we do? Refuse? Of course not, that is the price one pays for Love!

The Fall of Nineveh Engraving by John ▶ Martin 1789–1854

This painting was Martin's last and most grandiose attempt to reconstruct an ancient city, and represents the destruction around the funeral pyre of King Sardanapalus.

After a siege of three years the enemy broke into the city to find a mass of drunken soldiery and courtiers, while the King consigned himself and his harem to his funeral pyre. Right of the picture his goods are stacked for burning.

In 1830, Martin sent the picture to Buckingham Palace. William IV took one look and said: 'How pretty.'

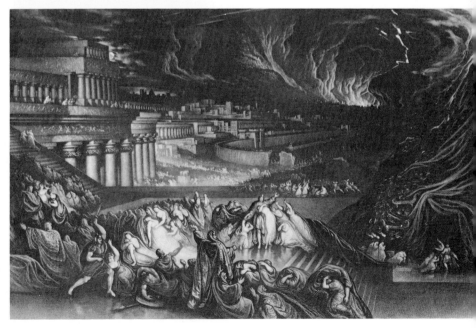

Love's Enchantress

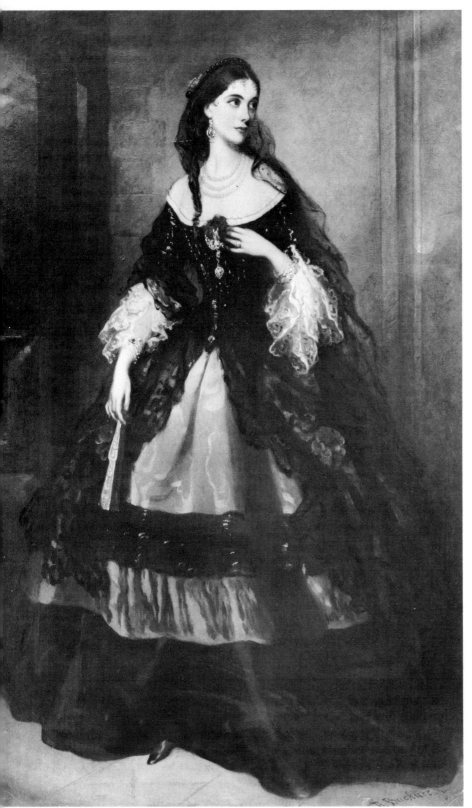

Marilyn Monroe

She had a childish naïveté, a luminous quality, a wistfulness, radiance, and the soft tender sexy little voice which no man can resist. Marilyn suggested that 'sex might be dangerous with others but ice-cream with me'.

◀ *The Countess of Cardigan* Richard Buckner, 19th century

Adeline Horsey de Horsey, beautiful, with dark expressive eyes, fell in love with the Earl of Cardigan who led the Light Brigade at Balaclava. He was separated from his wife.

Adeline spoke five languages, sang, wrote music, and found Cardigan, the centre of scandal, irresistible. He invariably carried a riding switch to be used on his horse or anyone who annoyed him! On meeting Adeline he recognised her as 'the only woman in the World'.

At seven o'clock one morning she was awakened by thunderous knocking on the door. Cardigan came into her bedroom – 'My dearest, she's dead . . . let's get married at once.'

Madame Recamier Jacques-Louis David ▶
1748–1825

'She possessed the double enchantment of lover and virgin!' *La Belle Juliette* was the daughter of a banker from Lyons.

She married a man much older than herself. She became a raging beauty, had a Salon, and all her life, well into middle-age, she aroused passionate emotions in men, but had the magic gift of transforming them into devoted friendships. Her last conquest was the poet Chateaubriand.

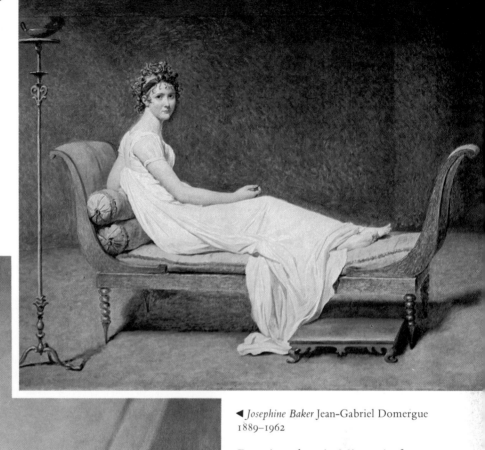

◀ *Josephine Baker* Jean-Gabriel Domergue
1889–1962

Born in a slum in Missouri of a Jewish father and negro mother, she stunned Paris in 1925 where she was called a 'danger to civilization'.

The Ebony Venus, doing the charleston on a drum, was a revelation, the embodiment of erotic, primitive emotions. She was a white man's sexual fantasy, a 'sinuous idol who enslaves and incites all mankind'.

But feathers, sequins and the famous bananas on the snake hips changed in World War II to the *Croix de Guerre*, and the *Rosette de la Résistance*.

The wanton idol with the seductive appeal of a French *gamin* became a *Chevalier de la Légion d'Honneur*.

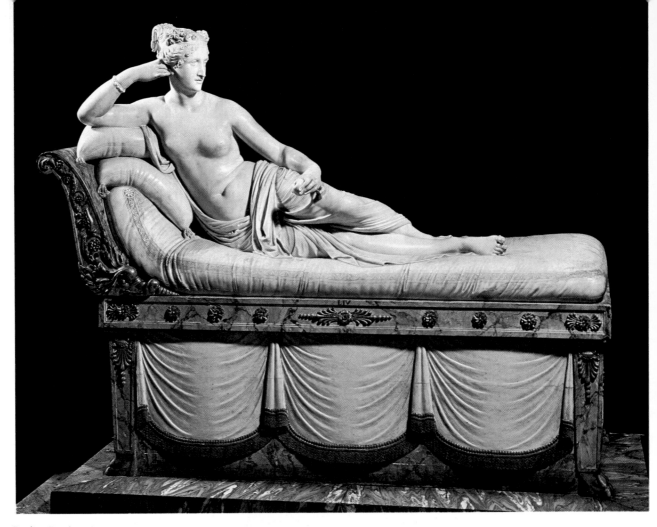

Pauline Borghese Antonio Canova
1757–1822

The favourite sister of Napoleon, with the classic beauty of a goddess. She bathed in milk, and had a negro carry her to the bath so that she could appreciate the whiteness of her skin.

Her only flaw was a badly shaped ear which she hid with her hand when Canova was sculpting her in the nude. She pursued any man she desired, and designed the liveries of her footmen in Haiti so as to reveal their masculinity.

She declared that her husband, Prince Borghese, was impotent (which was untrue) and had tempestuous affairs with members of her brother's staff. She was the only loyal member of Napoleon's family, visited him on Elba, and helped him in exile on St Helena.

Colette as a Faun

Great French romantic novelist, at twenty, shy, sensitive, she married stout, balding Willy. He had pitifully paid 'ghosts' to write the books and articles he signed.

He told her to write and locked her in her room for four hours a day. Willy became famous and treated her abominably.

On the stage 'she emitted an indefinable troubling odour of sensuality'. Dancing, writing, lovers – Colette began to live. She married. When war came and he went to the Front she joined him for four months, disguised as a nurse. Divorced, remarried, happy, she poured out novels.

At seventy-two Colette had arthritis but would take no sedative saying: 'Aspirin changes the colour of my thoughts.'

A Jersey Lily (Lillie Langtry)
John Everett Millais 1829–1896

A Grecian profile, alabaster skin, pale gold hair and her black dress took London by storm and captured the facile heart of Edward Prince of Wales.

She became his acknowledged mistress but had an illegitimate daughter with Prince Leopold of Battenberg. She set the fashion, was mobbed in the Park, and went on the stage.

◄ *Louisa, Duchess of Manchester* Engraving after R. Thorburn, c.1850

German, auburn-haired, exquisitely beautiful, she was the only Edwardian lady to capture two Dukes.

As the Duchess of Manchester she dominated London society, yet for thirty years she was the mistress of the Marquis of Hartingdon, later eighth Duke of Devonshire.

She wielded power without pity and she could hold her man! She lost 'Harty-Tarty' for a brief interval to 'Skittles'. When he arrived back unexpectedly, and walked in at teatime, Louisa only smiled and asked coolly, 'Is it one lump or two?'

Both feared and successful, in her old age she wore a red wig and was only interested in whist.

Sarah Bernhardt Georges Clairin 1843–1919

The most famous and notorious actress in the World, her outrageous conduct, her lovers, her lightning marriage, her quarrels, were always explosive.

Her mother's lover, the Duc de Morny, sent her on the stage and she had a son by the Prince de Ligne.

She was the darling of the public and darling of the critics; she brought an inexpressible magic to every part she portrayed. She conquered not only by charm but by a horrifying realism. But she suffered for this, often, after she had prolonged her agony on the stage, collapsing in her dressing-room.

The Prince of Wales, when her lover, played the corpse in *Fédera* over whom she wept.

Jane Digby

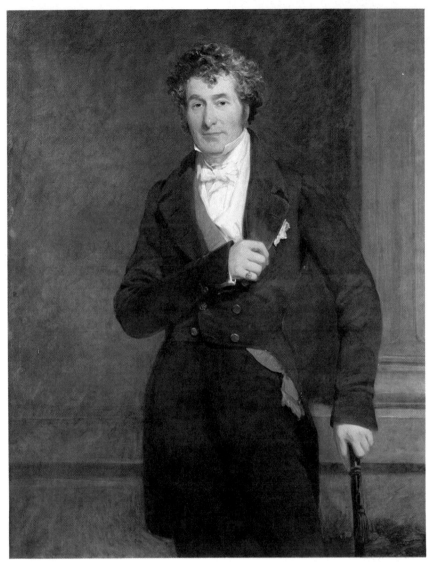

Edward Law, Lord Ellenborough Frederick Richard Say c.1827–1860

'Innocent Employment for Foreign Princes'
Newspaper cartoon, 1830

Jane Lady Ellenborough James Holmes ▶
1777–1860

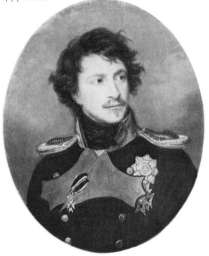

Ludwig 1 of Bavaria Joseph Stieler 1781–1858

A great romantic, the greatest beauty of her day, irresistible, fascinating, reckless, with 'blue eyes which could move a saint', her love affairs read like a naughty Almanach de Gotha.

First she had the House of Lords thundering over her adultery, but Lord Ellenborough, a pompous bore, neglected her. Pregnant, she bolted to join Prince Felix Schwarzenberg in Paris. Alas, the Prince's ardour had cooled.

Two daughters later, Jane found herself alone but a celebrity. She moved to Munich and this time her lover was a King. Ludwig 1 was a worshipper of beauty and besotted by beautiful women. He fired Jane with a love for Greece. She became 'Ianthe'. It was a serene idyll while it lasted. She married Baron Carl-Theodore von Venningen, young, handsome and rich. Again it was rather boring and Count Spyridon Theotoky,

noble, poor, proud and irresistible to women, appeared.

Jane fell in love. He offered adventure, the burning isles of Greece, Byronism! They slipped away from a Court Ball, the Baron in pursuit, there was a duel, Theotoky was wounded. They were married. The Count was appointed Aide-de-Camp to King Otto of Greece (son of King Ludwig 1).

King Otto became Jane's lover,

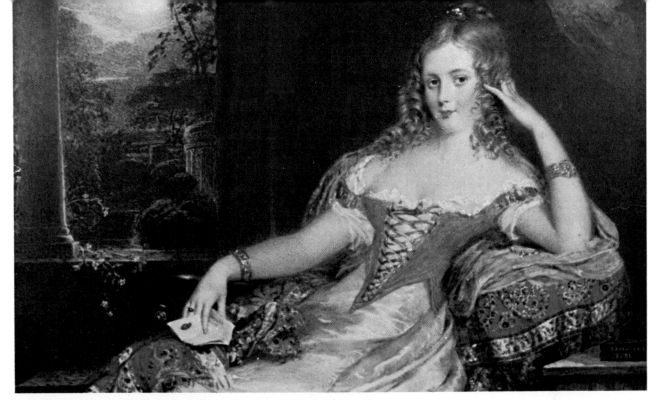

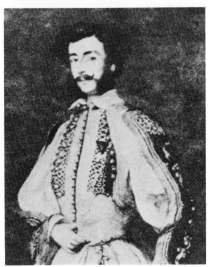

Count Spyridon Theotoky

Otto I of Greece

Medjuel el Mezrab Francis Marshall

provoking scandal and recriminations from the Queen. Jane fell in love with the Chief of the Pallikares, a bandit. She lived in the mountains until he fancied her maid, when she left for Syria.

While negotiating for a camel caravan to take her across the desert, she met Sheikh Abdul Medjuel el Mezrab. Blue-blooded, educated, speaking several languages, with glittering impenetrable black eyes, Jane had

met her fourth and last husband, the real great love of her life.

Jane was loved and accepted by the Mezrab tribe. She lived in a tent, hunted with Medjuel; there were falcons, Persian hounds and dromedary races. There was also war between the tribes.

In Damascus Jane was a Peeress, in the desert the Queen of the tribe; she waited on her husband and gloried in it. For twenty-five years Jane's marriage to Medjuel

was wildly, ecstatically passionate.

At sixty Jane was still irresistibly beautiful and another Sheikh was pressing his suit. When she died, aged seventy-four, Medjuel hurled himself from the cortège, then, riding her favourite black mare, galloped up to the open grave.

With her Bedouin husband and her Arab horse with her at the end, Jane's 'life's poetry never sank to prose'.

Love Debased

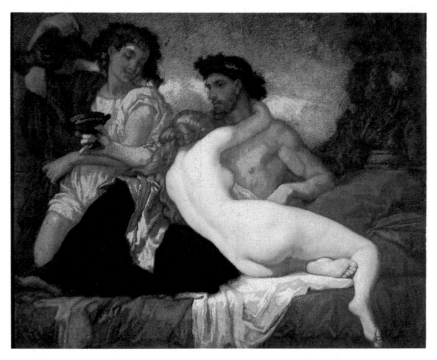

L'Orgie Romaine Thomas Couture 1815–1879

Mogador, who posed for this picture, first astonished Paris by polkaing 'like a demon' at the Bal Mabille. After a success as an equestrienne she became one of the great courtesans of the Second Empire. After repenting she died in an Old People's Home aged eighty-five.

◄ Cora Pearl as Cupid in *Orphée aux Enfers* 1867

Cora was ugly and English. Her jewels were worth a million francs and she was the most extravagant courtesan of the period. On stage, she had diamonds attached to the soles of her shoes. When a man killed himself after she had spent his entire fortune she merely said: '*Sale cochon, il a gâté mon tapis*'.

Odalisque with a slave Jean Auguste Dominique Ingres 1780–1867 ►

◄ *Odalisque* Mariano Fortuny 1838–1874

Aimée Dubecq de Rivery, cousin of Empress Joséphine, was captured by Algerian Corsairs who realised her worth and sent her to the Sultan in Constantinople. She was clever enough to make the best of life in the Harem. The Sultan fell in love with her and she gave him a son. When Sultan Abd ül Hamid died in 1789 his nephew Selim took his place and fell in love with Aimée.

She became one of the greatest figures in the East, of much importance to France. Her whole career was foretold by a fortune teller.

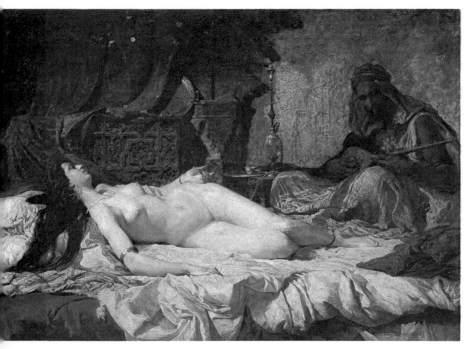

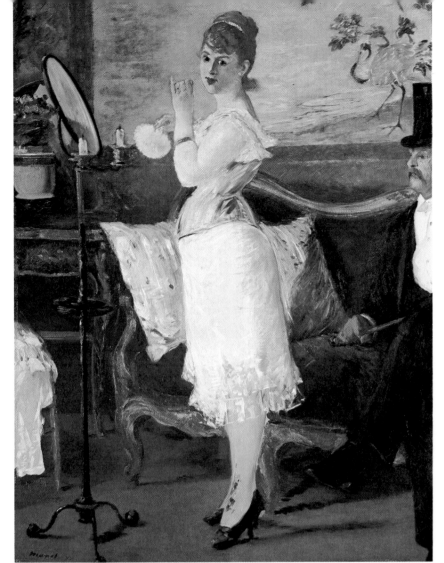

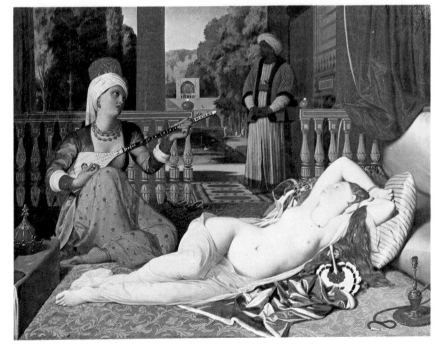

Nana Edouard Manet 1832–1883

Blanche d'Antigny was the inspiration for Zola's novel and Manet's painting. Mistress of a Russian Prince, she went with him to St Petersburg for four years. In defiance of protocol she attended the Royal gala performance at the Opera wearing a gown ordered by the Empress. Expelled, she captivated Paris as an actress.

Her lovers were incalculable. Maharajahs, Khedives and Shahs frequented her *hôtel* on their visits to Paris.

Skittles

From the back streets of Liverpool, Catherine Walters, known as Skittles, became the most famous courtesan in England. She was a great horsewoman and the only woman to go over the jumps of the National Hunt Steeplechase.

She had the face of an angel and the foul vocabulary of a fishwife. The Marquis of Hartington, son of the eighth Duke of Devonshire, fell in love with her, gave her a house and settled on her an annuity of £2000 a year for life.

When the Countess of Stamford, once a circus rider, expelled her from the hunting field she asked, 'What the hell is the good of her giving herself airs, she's not the Queen of our profession, I am.'

Romans of the Decadence Thomas Couture
1815–1879

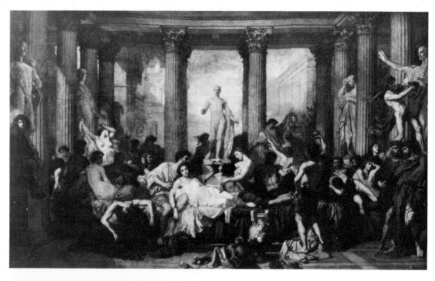

In Roman times, large numbers of prostitutes would assemble in brothels for the purpose of intercepting men who had been raised to a high pitch of sexual excitement by the gladiatorial shows and the mutilations by and of wild animals.

In private houses erotic dances amused the guests. Juvenal wrote: 'The girls ... quiver to applause ... a stimulous for languid lovers, nettles to whip rich men to life.'

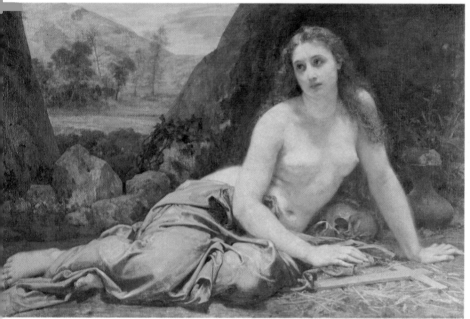

▼ *The Whore of Babylon* William Blake
1757–1827

Revelations 17: 'And I beheld a woman sitting upon a scarlet beast, full of blasphemous names, and having seven heads and ten horns. The woman was arrayed in purple and scarlet, and glittered with gold and precious stones and pearls. She held in her hand a golden cup, full of abominations and the impurities of her fornication, and upon her forehead was written a mystic name, BABYLON THE GREAT, the mother of the harlots and of the abominations of the earth.'

The Repentant Magdalen Paul Baudry
1828–1886

Modelled by Blanche d'Antigny – Nana. There is nothing in the histories of her to show *she* was ever repentant. One of her adverse critics wrote of her 'Mlle Blanche d'Antigny isn't an actress she's an intrigue. Some makers of publicity omelettes have whipped up this one too – she isn't pretty, she doesn't act well, and sings badly. But she has *people* . . . who create her celebrity for her and work at her notoriety . . . one curious fact, moreover, which the moralist must take into account, is the part played by this lady's diamonds – they perform better than she does.

Blanche revelled in her diamonds. In London she wore jewels worth £3000. She also fell in love. When he died she borrowed money, saying 'I don't want him to be buried with the money I've earned in bed.'

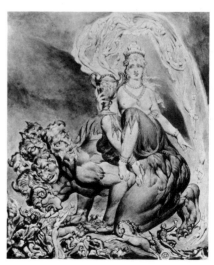

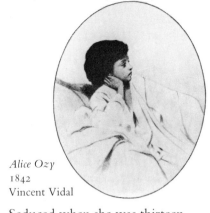

Alice Ozy
1842
Vincent Vidal

Seduced when she was thirteen, she had wit, elegance, coquetry and a financial sense.

The Duc d'Aumale fell in love with her when he was nineteen and she became his mistress.

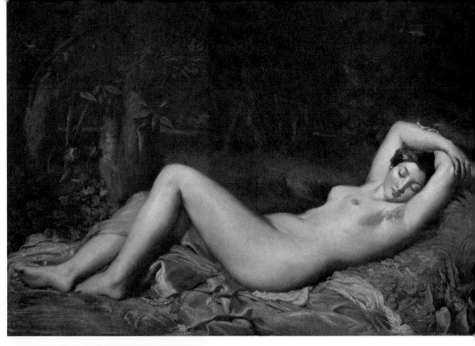

▲ *Baigneuse Endormie* Theodore Chasseriau 1819–1856

This picture was modelled by Alice Ozy. The young Duc d'Aumale established her in the first rank of courtesans. She had many lovers but when she was young always seemed innocent and romantic.

Her witticisms became the talk of Paris. When asked if a certain courtesan was to take the veil she replied 'No doubt she is. She's just discovered that God took the form of a man.'

In later life she was alone, and lonely. She died aged seventy-two and left her fortune – 2,900,000 francs – to a theatrical charity for the children of needy actors.

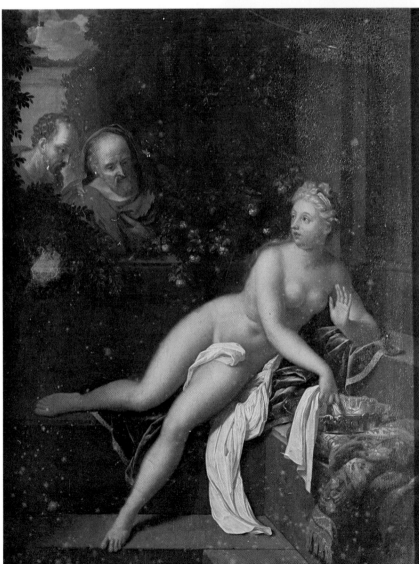

◄ *Susanna and the Elders* Adriaen van der Werff 1659–1722

Susanna was the lovely wife of Joakim, a wealthy merchant of Babylon.

She was accused of unchastity by two of the Elders of the city, because she had repelled their advances. Daniel exposed their plot by examining them separately – the evidence they gave against her conflicted, and they were put to death.

[105]

Love Triumphant

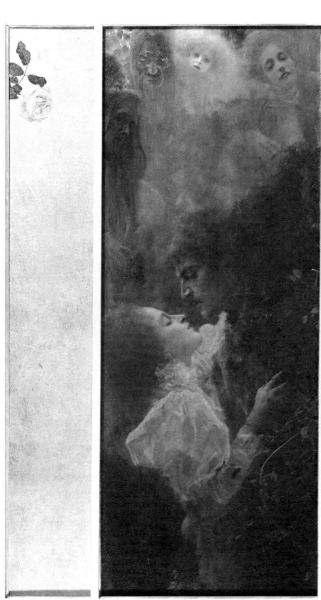

Cover design by Francis Marshall
for *The Daring Deception*

Love Gustav Klimt 1862–1918

In the background of this painting, the lovers are watched wryly by a succession of figures – young and old. Love is triumphant over age and death, and real love remains for all eternity.

> 'Nor shall my love die when my
> body's dead;
> That shall waite on me to the
> Power shade,
> And never fade.'

<div align="right">CAREW</div>

Cover design by Francis Marshall
for *The Marquis who Hated Women*

'I love you.' She hid her face against his shoulder and he knew she had surrendered. He was the conqueror, the victor, after a long battle during which there had been times when he had been afraid to guess the outcome.

'It is all over, my darling,' he said gently. 'You are safe, we are together, and nothing shall ever hurt you again.'

The Triumph of Amphitrite
François Boucher 1703–1770

Amphitrite, the daughter of
Nereus and Doris, was the wife of
Poseidon (Neptune), the feminine
personification of the sea. When
Neptune wooed her, he came to
her riding on a dolphin. He
rewarded the fish for his services
by placing him among the stars.

His palace was deep in the
Aegean Sea and his chariot was
drawn by sea horses. Was Neptune
different to any other man in
love? I am sure he cried:

'Oh! Might I kiss those eyes of fire
A million scarce would quench
 desire.'

BYRON

The Lover Crowned Jean Honoré
Fragonard 1732–1806

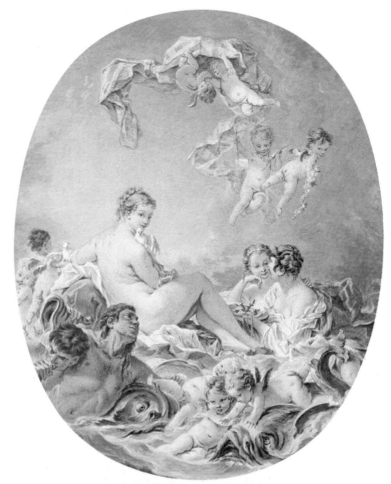

Every woman who is in love wants
to crown her lover, or rather give
him presents. Catherine the Great
gave her numerous lovers lands
and titles, but to me the loveliest
presents were the poems Elizabeth
Barrett wrote with love to Robert
Browning:

'I love thee to the level of every
 day's
Most quiet need, by sun and candle
 light.
I love thee freely, as men strive for
 Right;
I love thee purely, as they turn
 from Praise.
I love thee with the passion put to
 use
In my old griefs, and with my
 childhood's faith.
I love thee with a love I seemed to
 lose
With my lost saints – I love thee
 with the breath,
Smiles, tears, of all my life! – and,
 if God choose,
I shall but love thee better after
 death.'

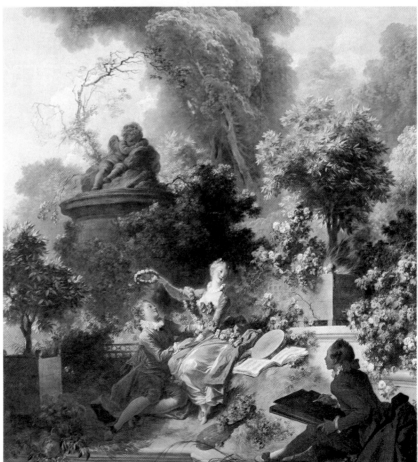

Byron

George Gordon, 6th Lord Byron
Thomas Phillips 1770–1845

Two men conquered the World in the last century – Napoleon and Byron. One ruled men's bodies, the other their minds. Byron was, as a child, humiliated and tortured, because his foot was distorted from birth and his mother, who drank, called him 'Lame Brat'. His nurse introduced him to sex when he was nine.

In 1812 'I awoke to find myself famous'. Handsome, romantic, besieged by women, haunted by debts, he died for strife-worn, down-trodden 'poor Greece' and because of it Greece's cause roused the British, the French and the Russians against the Turks.

He met his death in Greece and also found there an unlooked-for immortality.

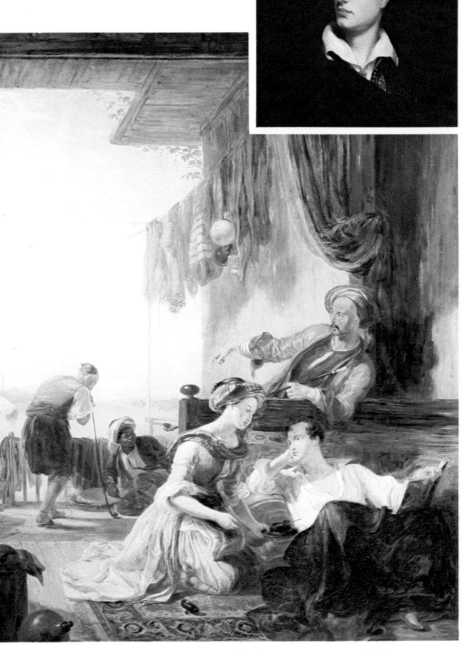

Lord Byron reposing after crossing the Hellespont William Allan 1782–1850

On Byron's four-month visit to Turkey in 1810 he stayed by the Hellespont. Here, in legendary days, young Leander swam every night from Abydos to Sestos where Hero awaited him, until he was drowned in a storm. Byron swam the same distance of four miles in seventy minutes. In Turkey the ideal of feminine beauty conformed with his own – exquisitely curved, resilient and devoted: there is not an unwomanly woman among his heroines. 'Gentle', 'soft', 'graceful', 'warm', 'lovely', with 'soft snow feet', voices 'low and sweet'.

'Pique her and soothe in turn,
 soon Passion crowns thy hopes.'

Lady Caroline Lamb in page's costume
Thomas Phillips

Spoilt, wild, delicate, odd, intelligent, idealistic, unbalanced, her husband adored her. She met Byron – 'That beautiful face will be my fate'. He awoke her sexually, 'the tumult, the ardour, the romance bewildered my reason'. He grew bored – she pursued him hysterically.

The Honourable Augusta Leigh
James Holmes 1777–1860

Augusta Leigh, very pretty, striking and interesting, was Byron's half-sister. Completely in tune with each other, their affection developed into an intense passion. She sent him a lock of her hair and to her words of love Byron added 'La chevelure of the *One* whom I most loved.' She was twenty-nine, he was twenty-four.

He told Annabella when courting her that no one would possess so much of his love as Augusta.

Annabella Millbanke George Hayter

Annabella was rich, arrogantly conscious of her superior intellect, with a crusading zeal for a rake's reformation. 'I should like her better if she was not so perfect,' Byron remarked. But in a desperate flight from his many troubles he proposed.

Married by special licence, he felt captured and behaved abominably on their honeymoon, taunting her with his love of Augusta and saying that her younger child was his. Their daughter was born in 1815.

Contessa Teresa Guiccioli

Voluptuously beautiful, Byron met her in Venice in 1816, when he had left England and his wife. Married for one year to an elderly man, Teresa found Byron 'a celestial apparition'.

The Guicciolis moved to Ravenna, Byron rented a floor of their Palazzo and owned a menagerie of two guinea hens, an eagle, a crow, a falcon, and an Egyptian crane. He and Teresa lived in a 'romantic trance' and he really loved her. She brought him golden beauty and intelligence.

Marguerita Cogni

'A very tall, formidable girl of twenty-three', a baker's wife and his housekeeper. Her tantrums amused Byron and he claimed he could 'manage her'. In a few months he paid her off because he felt 'I cannot exist without some object of love.' He meant Augusta.

Clare Claremont Anonymous portrait

Her sister eloped with Shelley. She walked with them from Paris to Switzerland. She wrote to Byron and 'confessed her love' for him – he met her and they became lovers.

She gave him a craven idolatry. He gave 'that odd-headed girl' a child.

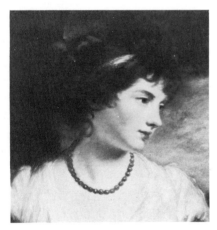

Jane Elizabeth, Countess of Oxford
John Hoppner 1758–1810

A beautiful, licentious blue-stocking, her maturity appealed to Byron's temperament as mother and mistress in one. He said: 'I never felt a stronger passion which she returned with equal ardour.' Lady Oxford said: 'We lived like gods on a plane removed from daily misery.'

The Lovers' Hour

The Greatest Game in the World – his move
Charles Dana Gibson 1867–1944

The creator of a vitalizing ink line, which captured not only America but the world, was a modest and thoroughly honest man who used his talent to express his most earnest convictions. He had a lot to reveal about the character of his era and had more than a little to do with the shaping of it.

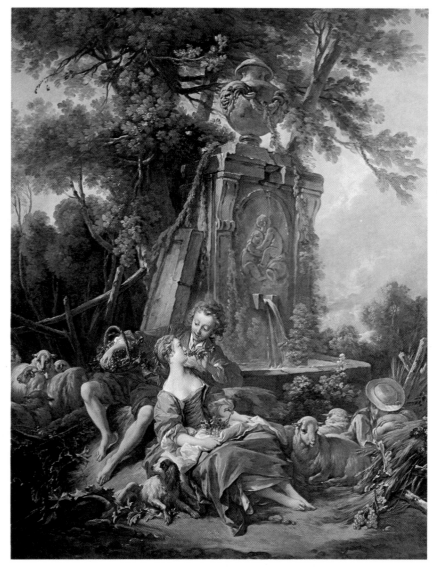

An Autumn Pastoral Francois Boucher 1703–1770

An autumn pastoral by the greatest painter of young love is an encouragement to those who are too easily deceived into believing love ends with youth.

Real love deepens and often becomes more intense as lovers grow older. Also making love is an Art, and an Art has to be studied, developed and understood.

Someone once said: 'Love is too good for the very young.' I think that is often true.

Young people use love as if it is a meal and they are hungry. To the older and wiser, love should be savoured and enjoyed slowly and with appreciation.

Also those who are older are grateful, gentle and sympathetic.

Many men become great lovers because a woman loves them, not only with her body but with her soul.

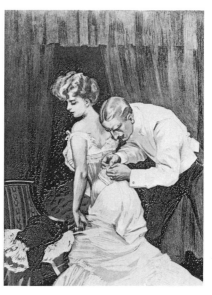

Untying the Knot Ferdinand Freih. van Reznicek 1868–1909

The heavily boned, tightly laced corset of the 1900s was an impossible garment to get into without help. If a lady's maid was not available it was the job of a husband or lover to thread the pink silk laces through the appropriate holes and draw in the soft waist to a fashionable circumference of eighteen inches.

An intricate and difficult task until a man became experienced!

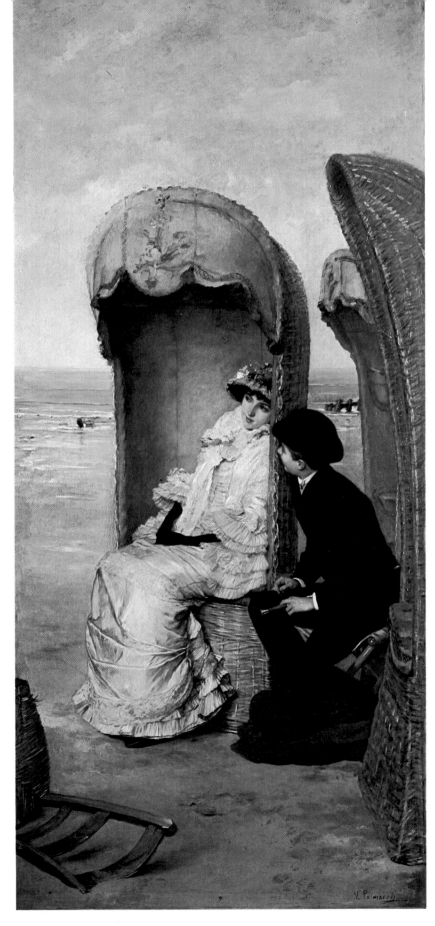

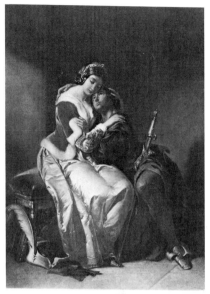

Thine Own Daniel Maclise 1806–1870

This picture by Daniel Maclise, the most successful English historical painter of the 19th century, is sheer romanticism. Much of his mature working life was taken up with his frescos for the Houses of Parliament, his two most famous being *The Meeting of Wellington and Blücher* and *The Death of Nelson.*

◄ *Idyll* Cayetano Palmaroli 1801–1853

The sea has attracted lovers since the beginning of time but I think it can often be a doubtful pleasure with too much wind, too much sand, too much sun! But since the bathing machine, from which George IV as a young man was introduced to the sea at Brighton, designers have tried to produce comfortable seaside furniture.

This ornamented effort is far more attractive than the awful collapsible deck chair, but alas, there is no room in it for two!

The Music of Love

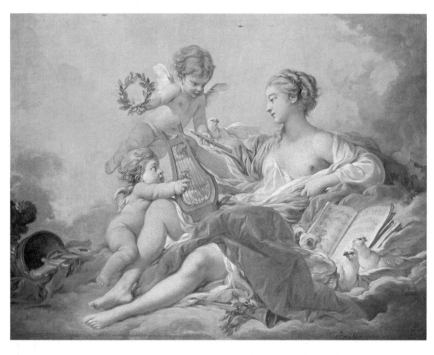

Allegory of Music François Boucher
1703–1770

The legend of the Muses is fascinating. After the defeat of the Titans the gods asked Zeus to create divinities who were capable of celebrating the victory of the Olympians. The master of the gods then went to Pieria, where he shared Mnemosyne's couch for nine consecutive nights. She gave birth to nine daughters who formed the choir of the Muses.

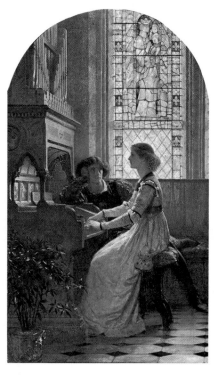

Harmony Frank Dicksee 1852–1928

Music is perhaps mankind's most inspiring expression of what is within his soul, and music can elevate the mind or debase it. War songs were deliberately inflammatory, and crooning is seductive. The most appropriate quotation for this picture must be:

> 'Dust as we are, the immortal spirit grows
> Like harmony in music; there is a dark
> Inscrutable workmanship that reconciles
> Discordant elements, makes them cling together
> In one society.'
> WORDSWORTH

Daphnis and Chloë Joseph Marius Avy, 20th century

The story of two lost Greek children who were brought up by shepherds. They fall in love and are finally married, after the discovery of their real, and wealthy, parents.

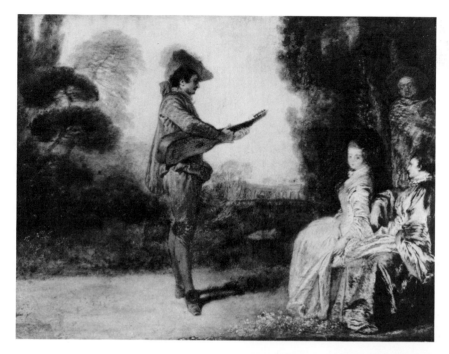

◄ *L'Enchanteur* Jean Antoine Watteau 1684–1721

The ladies are looking bored by the young man's performance and I don't blame them! I hate musicians to play *at* me when I want to talk at a dinner table or elsewhere.

I am sure he was the type of man who 'just happened' to have his 'music' with him. Yet any personally performed music is preferable to the portable radios which are carried everywhere.

I heard one blaring in the exquisite moonlit garden of the Taj Mahal! After a time those who continually listen to potted sound do not hear it!

The Muses Eustache Le Sueur 1616–1655 ►

Here are three of the Muses: Clio – with the trumpet – the Muse of History, Euterpe – with a flute – the Muse of fluteplaying, and Thalia – with a comic mask – the Muse of Comedy. They had the gift of prophecy – 'they said that which is, what will be, and what has been' – but they were mostly goddesses of Song.

> 'Their tireless voices flow from their mouths in sweet accents and their bewitching harmony as it spreads afar brings smiles to their father's palace – their father who wields the thunderbolt.'

But they weren't all sweetness and charm; like all goddesses they were easily offended and punished anyone who dared to compete. When a Thracian Bard boasted he was better than them, they struck him blind and dumb!

> 'What passion cannot Music raise and quell?'
>
> DRYDEN

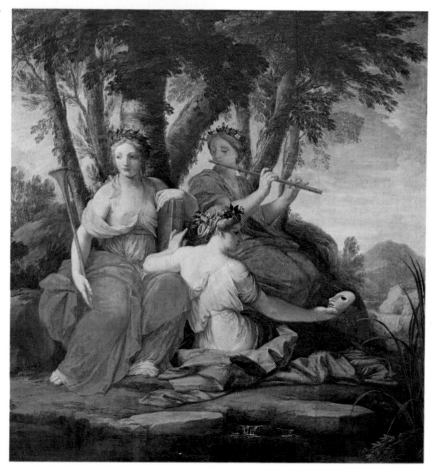

Louis Napoleon

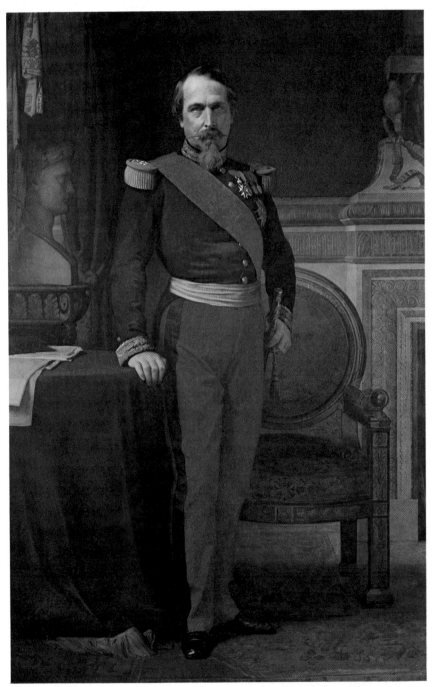

Louis Napoleon III, Emperor of France
Hippolyte Flandrin 1809–1864

'The most faithful of friends, the most inconsistent of lovers', no one has ever attempted to count the number of women he slept with. Penniless in London in 1846 he

Elizabeth Howard, Comtesse Beauregard

'The great debauchee of the Century', La Païva was the most successful of *la garde* – the *grandes cocottes* – with two million francs' worth of diamonds and precious stones. Born in a Moscow ghetto she had a horror of animals, birds, children, anything which did not bring in money.

Her fabulous house in the Champs-Élysées became the centre of Prussian espionage.

La Païva

lived with Elizabeth Howard, an actress. Two years later in Paris he gave her a suite at Saint Cloud and she paid his debts. After his *coup d'état* he made her Comtesse Beauregard and she had custody of his two illegitimate sons.

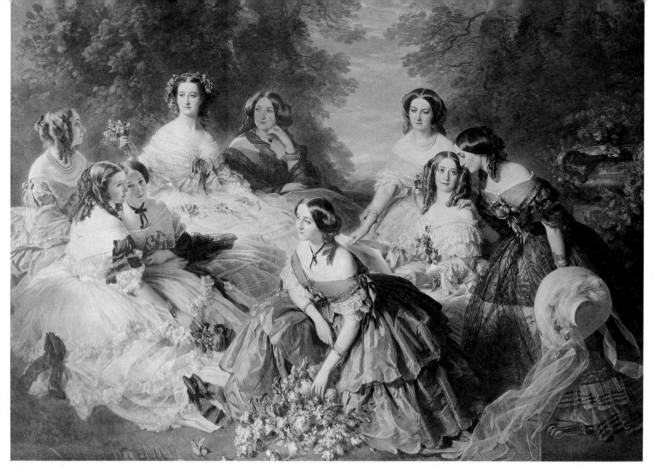

▼ *The Contessa Castiglione as the Queen of Hearts* Pierson

▲ *The Empress Eugénie and her Ladies in Waiting* Franz Winterhalter 1806–1873

▼ Marguerite Bellanger

Extremely beautiful, La Castiglione was sent by her lover, King Victor Emmanuel, who wanted an alliance with the Emperor, as a lure. Louis Napoleon found her lacking in spirit, but she became his mistress.

'All fire and flame', Eugénie was Spanish, shallow, immoderately ambitious, exceedingly beautiful and extravagant. The Emperor was wildly in love with her.

A disastrous influence, she encouraged him to support the tragic Mexican enterprise, and it was partly her fault that he was forced into the disastrous Franco–Prussian War in 1870 which ended the Second Empire. The Empress's American dentist helped her escape to England as the Germans marched into Paris.

Henchel von Donnersmach took the salute from the steps of La Païva's house in the Champs-Élysées. He married her and gave her the Empress's diamond necklace as a present. Once again in exile, the Emperor's calm dignity and moral courage was admired by everyone.

The Emperor made love to Marguerite so often that Empress Eugénie arrived at her house with her lawyer saying: 'Mademoiselle, you are killing the Emperor. This must stop! I order you to stop! I will pay!' Marguerite refused.

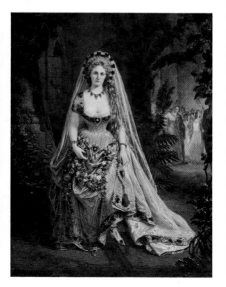

Soothsayers of Love

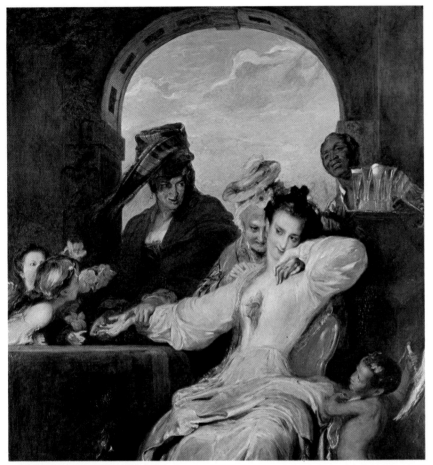

Joséphine and the Fortune Teller
David Wilkie 1785–1841

When Joséphine was a young girl
in Martinique she consulted a
fortune teller called Euphemia
David who predicted that her
second husband would be 'an
apparently insignificant man:
nevertheless he would fill the
World with his glory and many
nations would bow before him as a
mighty conqueror. She would
become a Queen but she would
die unhappy, repudiated.'

The Wheel of Fortune

Fortune telling is a gamble, like
this gypsy wheel which often
appears at race meetings. A
Governess I knew had her fortune
told hoping to hear of a new
position. The Fortune Teller told
her, 'You will marry a millionaire.'
She was furious, asking how
could she meet a millionaire? As
she was leaving, an old client
arrived. The Fortune Teller
introduced them and he offered
the Governess a lift in his car. He
was a millionaire and they were
married!

◀*The Fortune Teller* Pietro Longhi
1702–1785

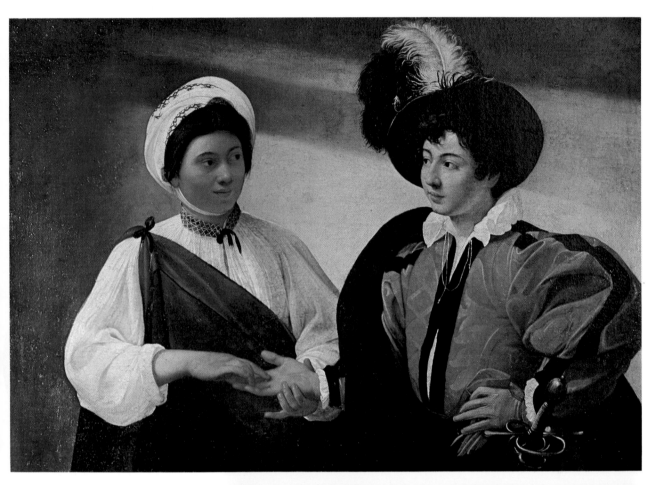

The Fortune Teller Michelangelo da
Caravaggio 1573–1610
Catherine de Medici with the 'magic
mirror' of Nostradamus ▶

These Soothsayers are using their
instruments; cards, veins, crystal
balls are often only a medium of
concentration. Nostradamus was
the greatest prophet of all time.

He predicted for Catherine de
Medici through a mirror. His
book, published in 1555, foretold
the Great Fire of London, the
French Revolution, the discovery
of wireless and Edward VIII's
abdication. He predicts that with
the dominance of Communism,
Paris, New York and London will
be destroyed in twenty-seven
years of pain and bloodshed.

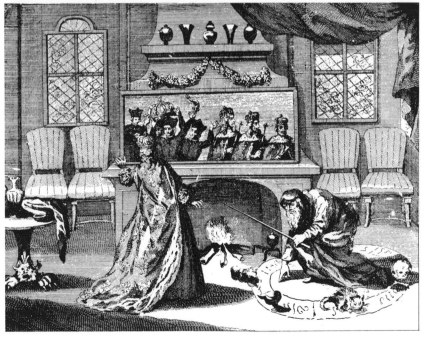

Fortune Telling by Tarot Cards *c.*1500

The Necromancer Jean-Baptiste Le Prince
1734–1791

Necromancy is foretelling the future with the aid of the dead. The usual form is a spiritualistic séance. The medium is in a trance, her spirit leaves her body, which is taken over by another. This is not taking place in the picture, and it is obvious that the old man is reading the palm of the girl while her lover listens.

This is called chiromancy, commonly known as palmistry. It originated in the earliest Aryan civilization. Cheiro was the greatest chiromant of this century. He read Lord Kitchener's hand in 1894 and said, 'I can see nothing but success and honours for you in the next two decades. You will become one of the most illustrious men in the land. But after that your life is at great risk. I see a disaster at sea taking place in your sixty-sixth year.'

Lord Kitchener was in HMS Hampshire when it was blown up by a German mine off the Orkneys in 1916.

The origin of the cards is lost in mystery. Some people think the Tarot is the Book of Thoth, the god of Wisdom of the Egyptians, others connect it with the twenty-two paths of the Hebrew Cabala – the cards are thought to have been introduced into Europe by the Bohemians (gypsies).

The earliest recorded pack was painted in Paris in 1392. During the French Revolution and early Napoleonic Wars people flocked to a Mlle Lenormand who had a great gift for Cartomancy.

The King of Naples cut the King of Diamonds four times in succession, but refused to believe Lenormand when she said it was evil. She flung the pack at him and insisted he would be either hanged or shot when he was a prisoner.

He was executed in 1815 by a firing squad.

The Tarot Cards symbolize every phase of both ordinary and spiritual life. But the effect of each has to be considered in relation to the others and one has to be experienced to read them.

The Fortune Teller George de la Tour
1593–1652

While the young man is having his palm read, his pocket is picked and his watch stolen by the Fortune Teller's accomplice.

The line of the Heart runs across the palm below the mounts of Jupiter, Saturn, Apollo and Mercury. An unbroken line means happiness. If it rises from Jupiter (the first finger) it indicates the highest type of love. If it rises from Saturn (middle finger) the lover will be more passionate and selfish in satisfying his desires.

The Fortune Teller Le Valentin 1591–1634 ▶

Many famous men and women have consulted palmists. When I was young I visited Mrs Robinson, whose clients included Lillie Langtry who took Edward VII to see her, Oscar Wilde and Lord Roberts.

She told Winston Churchill in 1898 that she saw an exciting and brilliant future ahead of him, but he asked her not to publish it. Her prophetic picture of him was 'of a man holding back a pair of iron gates against a mob of millions with arms outstretched.'

Napoleon's divorce and exile were both predicted by an Egyptian soothsayer and he also frequently consulted an Italian astronomer.

Selection of Tarot cards from Italian minchiate packs, 18th century

In January 1967, before attempting to break his own World Record, Donald Campbell – British motorboat racer – told his fortune by cards. He shuffled and drew two cards – the Ace and the Queen of Spades. 'These are the same cards' he said, 'that Mary Queen of Scots drew on the night before her execution.

His boat turned a somersault at three hundred miles per hour. Campbell's body was never recovered.

Love and Witchcraft

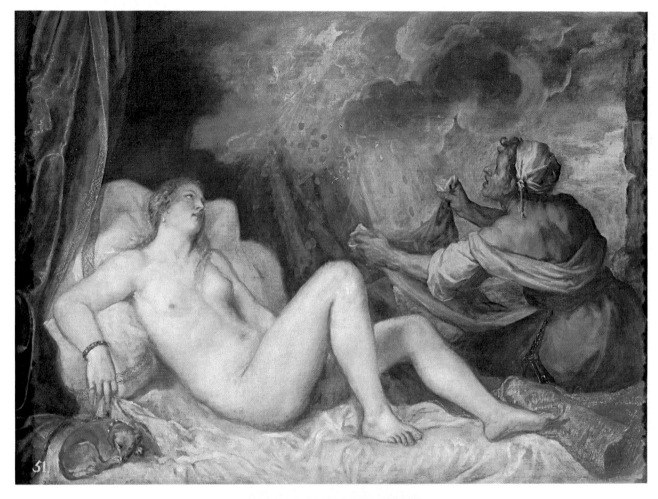

Danaë Titian *c.* 1487–1576

Danaë was the daughter of
Acrisius, King of Argos. He was
told by an oracle that he would be
killed by his daughter's son, so he
confined her in a brazen tower.
Zeus visited her in a shower of
gold and she gave birth to Perseus.
Danaë and her son were cast adrift
in an open boat and fell into the
care of King Polydectes.

After his adventures of killing
Medusa and rescuing Andromeda,
Perseus took part in some Funeral
games. Throwing a quoit, he
quite by chance killed a man in the
crowd. It was Acrisius, and the
prophecy was fulfilled.

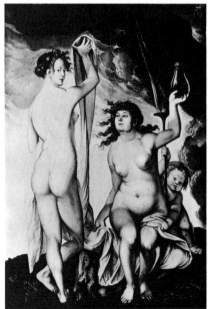

Two Witches Hans Baldung 1484–1545

'Fillet of a fenny snake,
In the cauldron boil and bake;
Eye of newt and toe of frog,
Wool of bat and tongue of dog,
Adder's fork and blind-worm's
 sting,
Lizard's leg and howlet's wing,
Scale of dragon, tooth of wolf,
Witches' mummy, maw and gulf
Of the ravin'd salt-sea shark,
Root of hemlock digged i' the dark,
Liver of blaspheming Jew,
Gall of goat and slips of yew
Sliver'd in the moon's eclipse,
Nose of Turk and Tartar's lips,
Finger of birth-strangled babe
Ditch-deliver'd by a drab,
Cool it with a baboon's blood,
Then the charm is firm and good.'
 SHAKESPEARE

Circe Dosso Dossi 1479/90–1542

A beautiful witch celebrated for her magic and venomous herbs, who lived on the island of Aeaea.

Odysseus visited it on his way home but his companions, who had preceded him into her Palace, were changed by her potions into swine. Odysseus was, however, protected with the help of Hermes against her witchcraft, by the herb 'moly'. He demanded the restoration of his friends.

Odysseus stayed a year with Circe, fathering Telegonus.

Two Witches 1508

Morgan le Fay Frederick Sandys 1832–1904

One of King Arthur's sisters, she was not only very beautiful but possessed magic powers.

It was Morgan le Fay who revealed the adultery of Queen Guenevere with Sir Launcelot to her husband King Arthur. In Malory, she tries to kill the King by means of her lover, Sir Accolon, to whom she secretly sends Arthur's magic sword, Excalibur. She also tries to kill her husband King Uriens, but he is saved by Sir Uwaine, their son.

Morgan le Fay was one of the three Queens who carried King Arthur in the boat to Avalon.

George IV

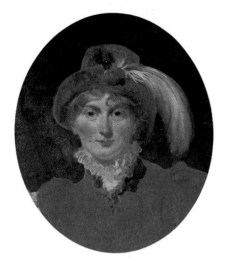

Princess Caroline of Brunswick
Sir Thomas Lawrence 1769–1830

Isabella, Marchioness of Hertford
John Downman 1750–1824

Mrs Robinson ('Perdita') Thomas
Gainsborough 1727–1788

George, Prince of Wales, married Princess Caroline so that Parliament should pay his debts. When she arrived he found she was coarse, vulgar, dirty and smelt, which was repulsive to a man who was fastidiously clean.

The Prince was drunk at the wedding. When eventually he made his way to his bride's room he fell insensible into the fireplace where he remained all night. They separated and the immoral, uncontrolled behaviour of the Princess made her and the Prince the laughing stock of Europe. At the Coronation she was locked outside the doors of Westminster Abbey.

An Excursion to R(agley) Hall, 1812 ▲
George Cruikshank

A Kingfisher (Lady Conyngham and ▶
George IV)

Lady Conyngham, his last mistress, was fat, kindly, religious and very rapacious. The King adored her, she wore the Stuart jewels and appropriated wagon-loads of Royal treasures when he died.

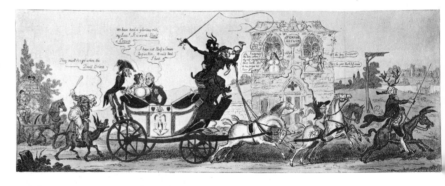

Very rich, handsome, stately, well-corseted and a grandmother, the Prince was infatuated with Lady Hertford in 1808. She was hated and hissed at by the mob, who supported the Queen.

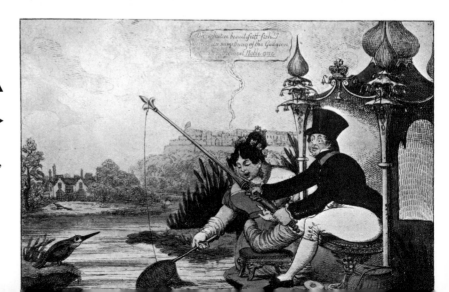

▲ *Mrs Fitzherbert* Miniature by
Richard Cosway 1742–1821
The Prince Regent in Garter Robes
Sir Thomas Lawrence 1769–1830

George IV was born in 1762, but
did not come to the throne until
1821. He was clever, witty,
cultured with exceptionally good
taste, and an extraordinary talent
for mimicry. Wellington
described him 'as a man of unusual
accomplishments'.

He was also a hard drinker,
permanently in debt and always
hopelessly, passionately in love.

His first infatuation was for
Perdita Robinson, an actress, and
his father George III had to buy
back his love letters for £5000. In
1784 he met Mrs Fitzherbert, a
commoner, a Catholic and older
than him. After being together for
a year they were secretly married.
To pay his debts the Prince had to
take a Royal wife. He was
miserable and returned to Maria
Fitzherbert.

After eight years they parted
and never met again. But when
George IV died in 1830 her
miniature was found around his
neck.

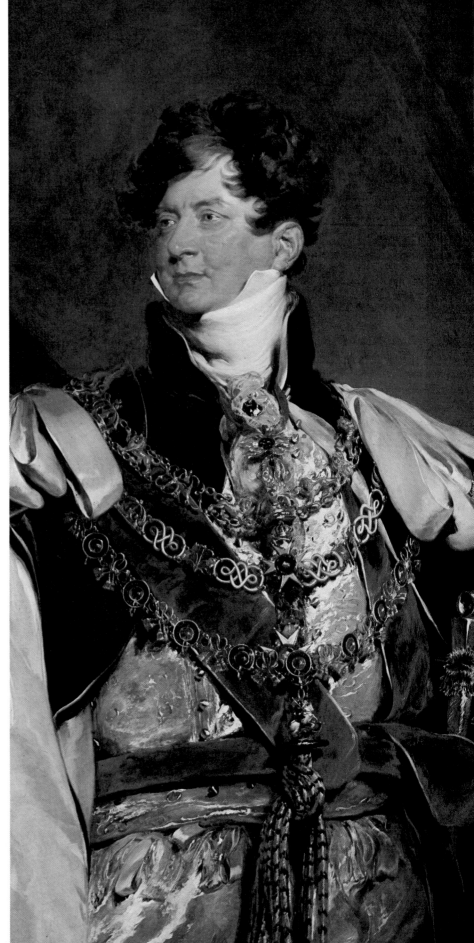

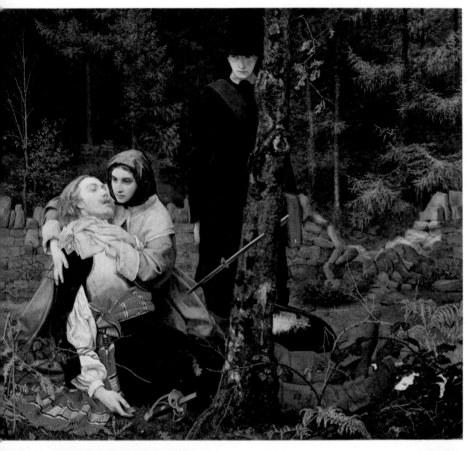

The Wounded Cavalier William
Shakespeare Burton 1824–1916

This romantic heart-rending
picture was painted in the grounds
of an old Cavalier house near
Guildford, and in order to observe
the surroundings more accurately,
the artist is said to have placed his
easel, and himself, in a deep hole
by the scene. The handsome,
dashing Cavaliers were much
more popular than the gloomy
puritanical Roundheads.

King Arthur receives his fatal
wound in the final battle of the
Knights of the Round Table. He is
carried to Avalon, the enchanted
isle – to be healed of his wound,
and wait for his return as King.

Three queens, one of whom is
the wicked witch Morgan le Fay,
accompany him. To the right of
the picture is Arthur's vision of the
Holy Grail.

La Mort d'Arthur James Archer 1823–1904

Ophelia John Everett Millais 1829–1896

Elizabeth Siddal was the model for
Ophelia, and in obedience to the
Pre-Raphaelite principle of truth
to nature, she posed lying in the
bath, heated underneath with
candles. The Times critic wrote:
 'There must be something
strangely perverse in an
imagination which souses Ophelia
in a weedy ditch . . . while it
studies every petal of the . . .
anemone floating on the eddy . . .'

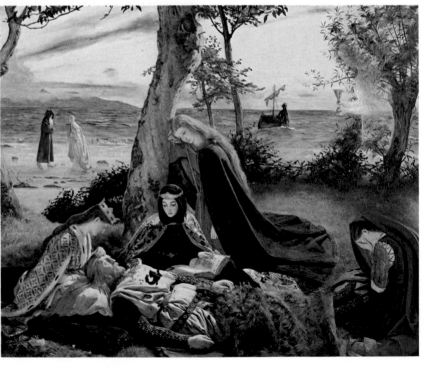

The Bluidie Tryst Joseph Noel Paton
1821–1901

This is a sad story of a Highland
lady who was teased by her lover
Knight, until, wildly jealous, she
killed him. As he dies he says:

'Alas sweet lady, I spoke but in
jest and thou hast slain the truest
lover who ever lived. I loved none
but thee.'

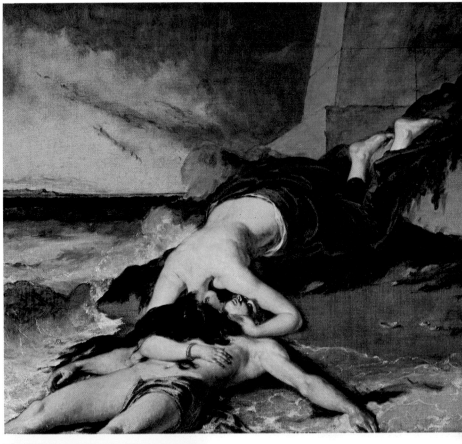

Hero and Leander William Etty 1787–1849

Hero was a priestess of Aphrodite
at Sestos, on the shore of the
Hellespont, beloved of Leander of
Abydos, on the opposite shore.
Leander swam across to Hero each
night, Hero directing his course by
holding up a torch. In a storm he
was drowned, and Hero threw
herself into the sea in despair.

◄ *The Funeral of Atala* Anne-Louis
Girodet de Roucy 1767–1824

A subject taken from a story by
Chateaubriand of the tragic
romance of a young Red Indian,
Chactas, and an Indian maid, Atala.

This picture was exhibited in
the Salon of 1808 and was part of
the private collection of Louis XVIII.

[125]

The Doubt: Can These Dry Bones Live?
Henry Alexander Bowler 1824–1903

When someone we love dies, besides the loneliness and the ghastly aching void in our lives, we all face the same frightening questions: 'Where are they?' 'Shall I ever see him again?', 'Is there really another world?' I felt all these things when my beloved husband, with whom I had twenty-seven perfect years of happiness, died from wounds received in the First World War.

He had been nearer to death than almost any man alive, but when I asked him if he believed in life after death he said 'No'.

Three weeks after his death I had a manifestation which was so completely convincing that I knew he was trying to tell me he had been wrong and he was near me.

Disappointed Love Francis Danby
1793–1861

The young girl, jilted by her lover, weeps by a dark woodland stream on which are being borne away the torn fragments of her love letters.

Others, until now carefully preserved, lie in an open wallet at her side with her lover's miniature, all of which will soon be consigned to the stream. Perhaps the girl, too, will follow them, Ophelia-like,

> '. . . in the weeping brook, her
> clothes spread wide,
> And mermaidlike awhile they bore
> her up,
> Which time she chanted snatches of
> old lauds,
> As one incapable of her own
> distress,
> Or like a creature native and indued
> Unto that element.'

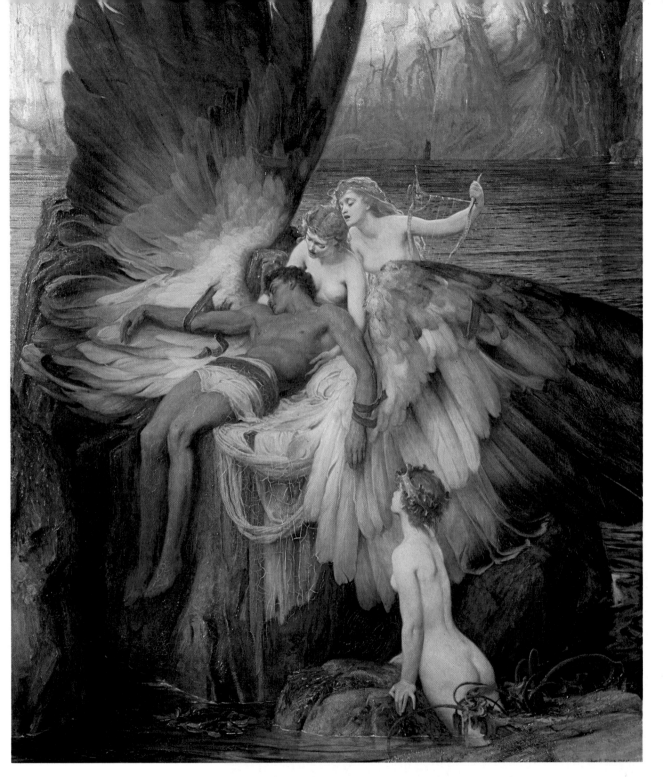

The Lament for Icarus Herbert Draper
1863–1920

Icarus was imprisoned with his
father, Daedalus, who built the
Labyrinth for King Minos, but
later he incurred the King's
displeasure. Daedalus constructed
wings of feathers secured with
wax, and they escaped, but Icarus
flew too near the sun. It melted the
wax, and he was drowned in what
came to be called the Icarian Sea.

To me this picture, which I find
very moving, is symbolic of man's
unquenchable spirit and his
inexpressible desire for freedom.

We all try to fly from the confines
of imprisonment in one way or
another and sometimes we are
lucky enough or clever enough to
succeed. But if we fail we have the
deep satisfaction of knowing we
have tried and have not lost faith
with our ideals.

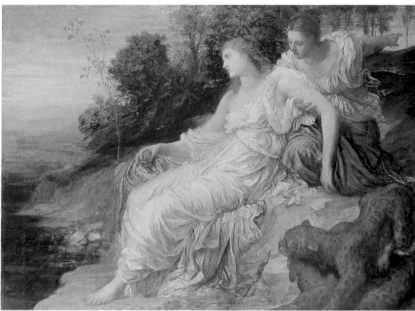

Isabella and the Pot of Basil William Holman Hunt 1827–1910

Isabella's brothers murder her lover, Lorenzo. She finds his body in the forest, puts the head in a flowerpot and plants basil over it. Observing how she cherishes the pot her brothers steal it. Without her basil, Isabella pines and dies.

Ariadne in Naxos George Frederick Watts 1817–1904

Theseus went to Crete to destroy a monster called the Minotaur. When he arrived King Minos, to test him, tossed a golden ring into the sea and told him to bring it back. When he succeeded, Ariadne, daughter of the King,

fell in love with him and gave him a ball of string to guide him through the Labyrinth in which the monster was kept.

He killed the monster, took Ariadne and her sister home with him, but ungratefully abandoned Ariadne on the Isle of Naxos.

Dante's Dream Dante Gabriel Rossetti 1828–1882

Dante fell in love with Beatrice, the daughter of a prominent Florentine, when he was nine. After nine years he met her but was too overcome to speak. He grew weak with love and when ill had a premonition of his beloved's approaching death. The sun grew dark, the stars seemed to weep, birds fell dead and the earth shook.

He had a vision of angels accompanying a pure white cloud to Heaven. He then saw Beatrice's body – a look of serenity on her face. As he called out her name, he awoke.

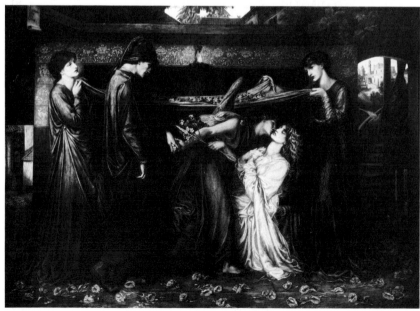

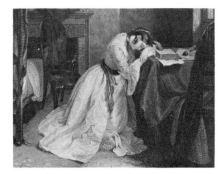

Illustration to *Clarissa Harlowe*

Clarissa is wooed by Lovelace, an unscrupulous man of fashion; her family oppose the match, but though she resists his advances, she is fascinated by him and he carries her off. She dies of shame and he is killed in a duel.

The Desperate Women Alfred Stevens 1817–1875

The opened note, the despair on the face of a grand courtesan of the Second Empire suggest her protector has left her. What does the future hold – perhaps suicide?

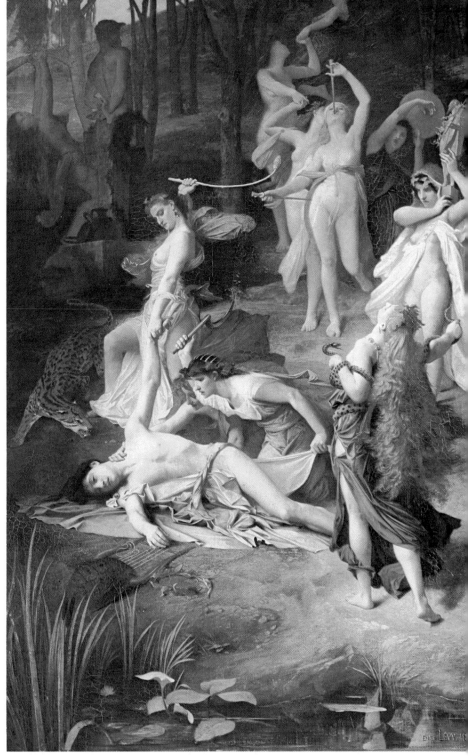

The Death of Orpheus Emile Levy 1826–1890

Orpheus was permitted to bring back his wife Eurydice, whom he adored, from the Underworld, provided that he did not attempt to look at her as she followed him back to life. He forgot his promise and turned to look at her, whereupon she vanished.

He was so desperately unhappy that he separated himself from mankind, and the Thracian women, whom he offended by his indifference to them, killed him.

Victorian Lovers

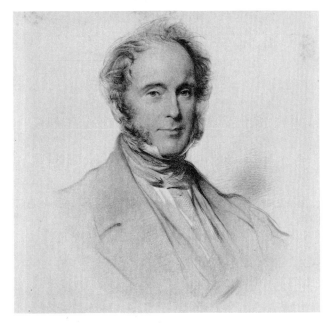

Viscount Palmerston Engraving after George Richmond

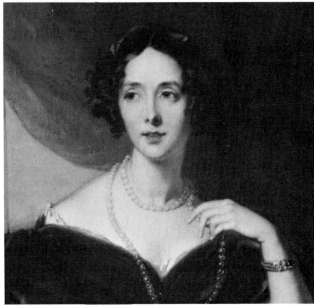

Lady Palmerston in 1840 John Lucas

Palmerston, known as 'Lord Cupid', was dashing, handsome, brilliant and fascinating to women. They also fascinated him.

Early in his career he was a member of Almack's, London's most exclusive club, which was governed by seven formidable Lady Patronesses. Among them were the Countess of Jersey, the Princess de Lieven (wife of the Russian Ambassador) and Lady Cowper.

Palmerston had an affair with all three, but fell in love with Emily Cowper, who was beautiful, lively and kind. Her husband, Lord Cowper, was nine years older than her, boringly dull with 'a slow pronunciation, slow gait and pace' Palmerston was reputed to be the father of her younger children.

Lady Holland wrote: 'It will be a union of the best-tempered persons in the World. *Never* did I see a man more in love and so devoted.'

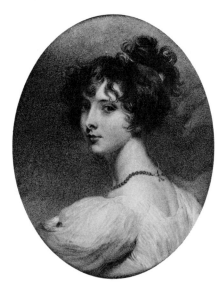

Emily Mary, Countess Cowper Engraving after Thomas Lawrence

The widowed Lady Cowper married Lord Palmerston when she was fifty-two and he was fifty-five. They honeymooned at Broadlands (now the home of the Earl Mountbatten of Burma) and were ecstatically happy.

Owing to hard work and exercise Lord Palmerston was trim, fit and still a passionate lover. He had once shocked Queen Victoria by trying to seduce one of her Ladies in Waiting.

At seventy-five Lord Palmerston became Prime Minister; he and Emily entertained lavishly and their guests were often amused by stories of his earlier love affairs.

The American Ambassador was amazed to see him at that age enjoying a five-hour pheasant shoot. In his eightieth year Lord Palmerston was cited as co-respondent in a divorce case. He denied the accusation and the case collapsed, but his friends continued, flatteringly, to believe the worst!

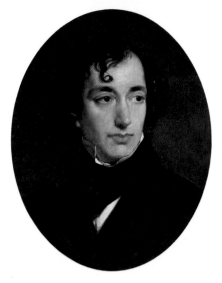

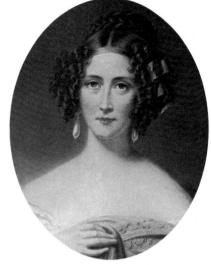

Benjamin Disraeli Francis Grant

Mary Anne, Viscountess Beaconsfield
James Godsell Middleton

Disraeli, brilliantly clever, romantic, dandified, an opportunist with vision, an orator, a political genius and a Jew, met Mary Anne, 'a pretty little thing, a flirt and a rattle', twelve years older than he, in 1832. After five years they were married because she was widowed and had money. They became two of the great lovers in history. Mary Anne recorded in her diary 'Gloves 2/6d – in hand £300. Married 28.8.39. Dear Dizzy became my husband.' When Dizzy returned from the House of Commons Mary Anne would wait on him like a slave – or a mother. He sent her notes: 'I have nothing to tell you except that I love you.' One day when she drove with him to the House, a footman slammed the carriage door on her fingers – she never murmured in case she should distract Dizzy. Afterwards he had the door preserved.

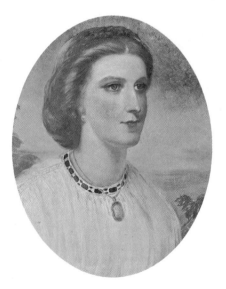

The Marriage Portrait of Richard and Isabel Burton Louis De Sanges

'The brow of a god and the jaw of a devil', two black, questioning, magnetic, tiger's eyes: Isabel knew he was her fate! Richard Burton spoke six languages (one of them pornography). His adventures in disguise were like the '*Thousand Nights and a Night*' he later translated so successfully.

As a Secret Agent, he learnt the secrets of the East: methods of castration, copulation with crocodiles, female circumcision and rape. He entered Meccah, the 'holy of holies' and Harar, another impenetrable city. Isabel, worshipping, waited for ten years.

Married – more waiting until Damascus and £1000 a year. Burton was *in*corruptible, his enemies gathered. The Foreign Office recalled him. Desperate for money, Burton translated *erotica* from the Arabic. His books were a triumphant financial success.

When he died, Isabel, a devout Catholic, burnt all his irreplaceable notes and manuscripts.

[131]

Abdication for Love

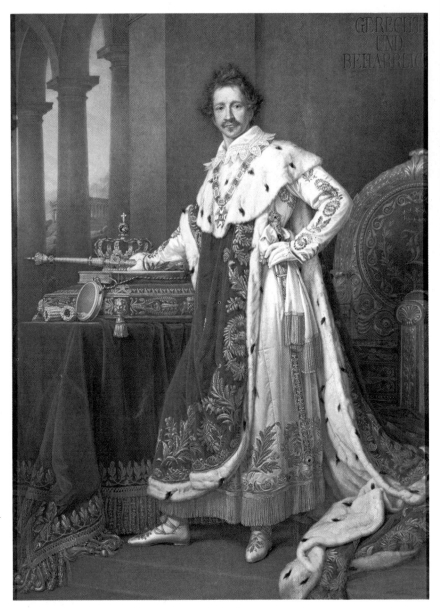

King Ludwig I of Bavaria Joseph Stieler
1781–1858

Lola Montez

In 1846 Ludwig, who worshipped beauty, was giving audience. Without waiting for permission, a woman thrust past the guards. She was so lovely that the King did not believe she was real.

Sensing his doubts, she drew the stiletto she always carried and ripped open her gown from breast to stomach. 'I am bewitched,' the King confessed. It was true. Lola Montez took over. The Chief of Police was banished, key Ministers dismissed. The students mobbed her, she closed the University.

After six months, revolution could only be forestalled if she left the country. The King abdicated after twenty-three years of a peaceful reign.

Dolores James was beautiful, talented and wicked – Irish-English father – Spanish-Moorish mother – Indian by education. Engaged at seventeen to an elderly Judge in India, she eloped with a young officer. She behaved so immorally he divorced her. After a journey to Spain Lola Montez appeared at Her Majesty's Theatre, London.

A success until recognised, she was hissed off the stage. More lovers. In Munich, by forcing the King to abdicate, she opened the way for ambitious Prussia. It was the first ominous move which would make the German Eagle, then the Swastika, emblems of terror across the face of Europe.

She married an Englishman and was arrested for bigamy. He died. She acted in New York in a drama entitled *Lola Montez in Bavaria*. She brought evil and disaster until she died.

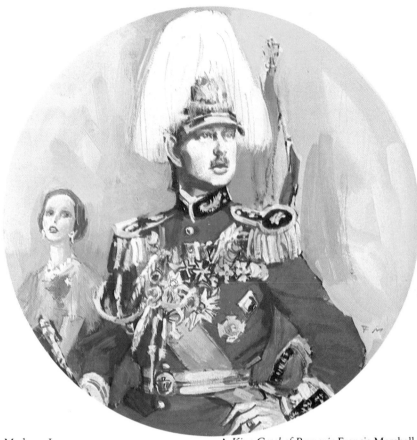

Madame Lupescu

▲ *King Carol of Rumania* Francis Marshall

King Carol had an emotional hunger for love and understanding.

Lonely, he became a playboy. His marriage was a failure. Helen Lupescu, beautiful, sophisticated, became the monarch. Carol slid to disaster and took his Kingdom with him. He abdicated in 1940 and crossed into neutral Portugal in the boot of a car. He lived with Lupescu in Estoril, the 'Graveyard of Royalty'.

King Edward VIII and Mrs Simpson ▶

Prince Charming, heir to a quarter of the World's surface, his numerous love affairs filled the gossip columns – Wallis Simpson, divorced and re-married, captured him physically as no other woman had ever been able to do. With her he was a boy in love for the first time. It was a question of the Throne or 'the woman I love'.

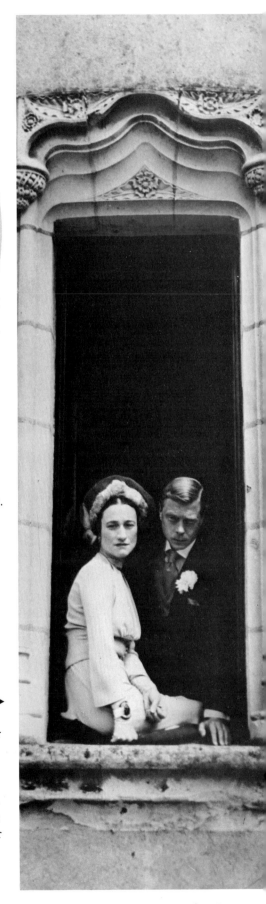

Souvenirs of Love

The Souvenir Jean Honoré Fragonard
1732–1806

'Love is a virtue that endures for
 ever,
A link of matchless jewels none can
 sever.
They on whose breast this sacred
 love doth place
Shall after death the fruits thereon
 embrace.
Amongst the many pleasures that
 we prove
None are so real as the joys of love,
For this is love and worth
 commending,
Still beginning, never ending.'

A Christmas card, with the message:
'May gladness crown thy life, and
 tears
Pass as the night when dawn
 appears.'

Souvenirs have always been the
treasures of love: the faded rose,
the dance programme with *his*
name against the dances. Men
keep souvenirs too. Samuel Butler
wrote: 'I knew a young man once
who got hold of his mistress's
skates and slept with them for a
fortnight and cried when he had to
give them up.'

The invention of a camera
introduced the best souvenir – a
snapshot of the person one loves.

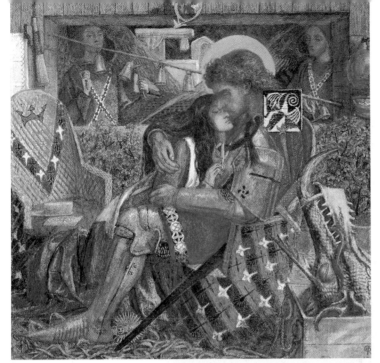

◄ *The Wedding of George and Princess Sabra* Dante Gabriel Rossetti 1828–1882

In *The Seven Champions of Christendom* (1597) St George rescues Princess Sabra, daughter of the King of Egypt, from the dragon, and marries her.

In Rossetti's sketch, Princess Sabra is cutting off a lock of hair which she will tie on St George's sleeve as a favour.

Hair lockets were the fashion in Victorian times. When George IV died dozens of pieces of hair were found among his possessions.

The Billet-doux Jean Honoré Fragonard ►
1732–1806

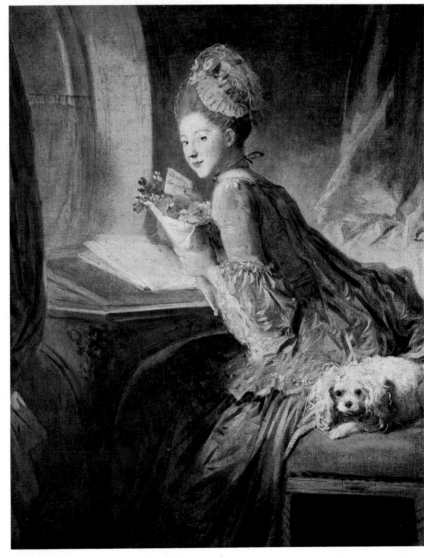

Love letters and poems are always very special and are kept for ever. I have all mine since the first I received when I was eighteen. One of the nicest arrived at breakfast after I had been out dancing very late the previous night. My partner sent me flowers and his note read: 'Good-morning Darling, I want these roses to see you.'

Receiving love letters was very difficult when my mother was a girl. Every letter was put on the breakfast table by the butler. My Grandfather would then say: 'I see I have a letter, Polly, who is it from?' With a crimsoning face my mother or one of her three sisters would mumble a name.

'Read it out', my Grandfather would order, 'Let us hear what he has to say!' Was it surprising their young men left letters in the Summer house, hidden in trees, or the girls bribed a servant not to take any letters addressed to them into the Dining Room.

My Mother used to say: 'My Father made us deceitful!' But it must have been very exciting!

Love Frustrated

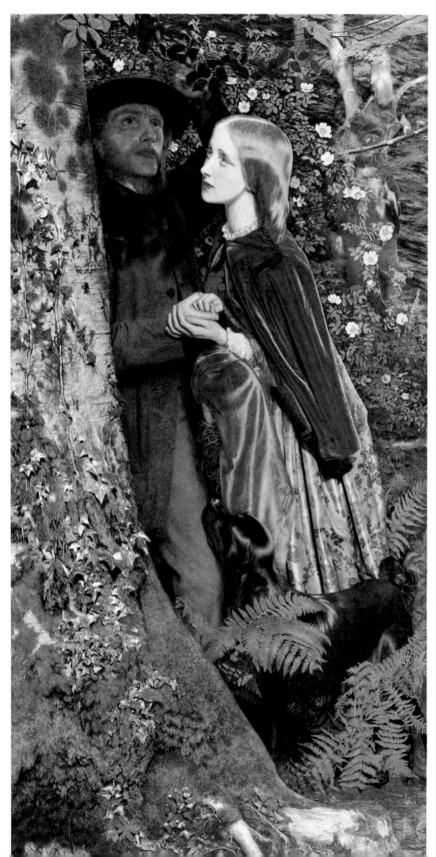

The Long Engagement Arthur Hughes
1830–1915

This picture of the anguished young curate, unable to marry through lack of preferment, is so sad I find it haunts me. He at least can look up to Heaven and feel that the burning of the flesh can be assuaged by his faith in God.

She, with the lines deepening around her eyes, has only her love for him. As Lord Byron said so truly, 'Man's love is of man's life a thing apart, 'Tis woman's whole existence.' Long engagements were considered sensible and were also fashionable in Victorian times, but they were often the death-knell of love.

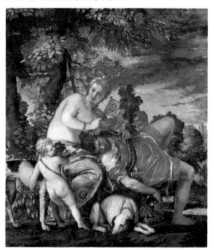

Venus and Adonis Paolo Veronese
1528–1588

Adonis is heavily asleep, and any woman in the circumstances would feel frustrated and doubtless cross when he does awake. Veronese's work shows the pageantry of sixteenth-century Venice in classical subject pictures.

He took too much licence with religious subjects and was called in front of the Inquisition.

Perhaps all young men at some time suffer the pangs and agonies of being torn apart for the one they love. In the last century money was the flaming sword which kept them outside Eden.

Looking for a poem to illustrate this handsome, Byronic, young man, who may be Byron himself, I found one written by George Granville, Lord Landowne – a relative of my husband – in 1732:

'But since cruel Fates dissever,
Torn from Love, and torn for ever,
Tortures end me,
Death befriend me
Of all Pains the greatest Pain
Is to love, and love in Vain.'

◀ *Apollo and Daphne* Theodore Chasseriau 1819–1856

Daphne, the daughter of the river god Peneus, rejected Apollo's suit and fleeing from him, prayed for the assistance of the gods, who changed her into a laurel, even as the god caught her. Apollo made the tree sacred to him, and adopted its leaves as his emblem – which is why poets are crowned with a wreath of laurel leaves.

Chasseriau was the lover of Alice Ozy, one of the famous demi-mondaines of the Second Empire (see page 105), for two years, the only man whom she really loved.

Edward VII

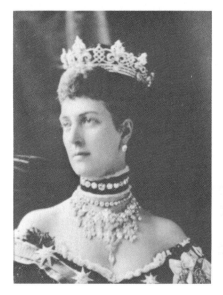

Princess Alexandra, 1883

Exquisitely beautiful, high-spirited, she accepted her husband's unceasing infidelities with dignity. 'After all,' she said when he died, 'he always loved me the best.'

Edna May

She personified the sparkle of the stage which Edward loved. In Paris, La Goulue, Queen of the Can-Can, would call: ''Ullo Wales!'

'Daisy' Lady Brooke

Lady Brooke, beautiful, fascinating, tempestuous, was the Prince of Wales's greatest physical passion. His letters began: 'My own adored little Daisy wife. . .'

Sarah Bernhardt, 1899

To the Manager of her Company she wrote: 'I've just come from the Prince of Wales. It's twenty past one . . . he kept me since eleven.'

Maxine Elliott

Famous American actress, she deliberately went to Marienbad – 'where matters could be more easily arranged' – to attract Edward. She succeeded!

The Hon. Mrs George Keppel

Fascinating, she was the King's last mistress and could always coax him into a good humour. Queen Alexandra led her by the hand to his death bed.

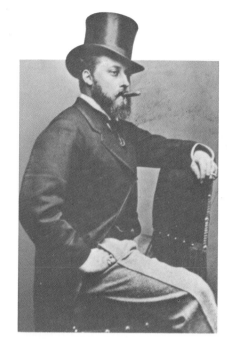

Edward, Prince of Wales, *c.1875*
Edward VII Lucas Fildes

Brilliant in his understanding of people and as a peace-maker, he was very sensuous, debonair, and became a King with 'enthusiasm and zest'.

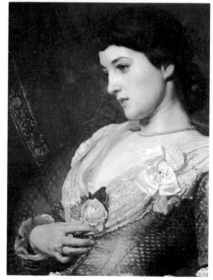

Lillie Langtry Edward Poynter

She rode with the Prince on a horse given her by an American, who complained: 'Lilies can be dreadfully boring when not planted in a bed.'

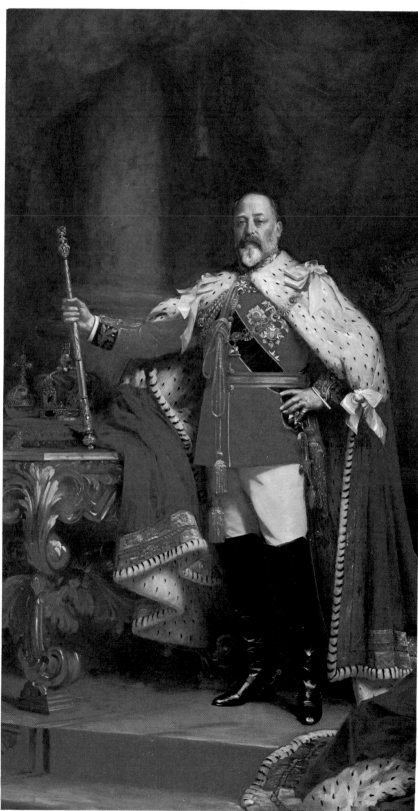

The Kiss of Love

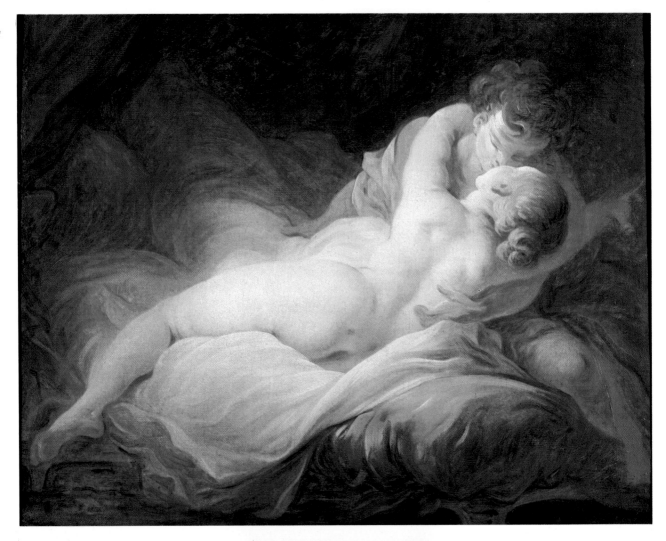

The Happy Lovers Jean Honoré Fragonard
1732–1806.

'Then his lips came down on hers
and she felt the rapture streak
through her. But now it was even
more intense, more wonderful and
more glorious.

 She moved closer and still closer
to him, wanting her body to melt
into his, to become a part of him.

 As she did so she felt flames of
fire flicker through her.

 "I love . . . you! I love . . . you!"
she wanted to say and wished as he
swept her up into the sky that she
could die.'

18th century engraving

'But you would have felt my soul
 in a kiss
And known that once I loved you
 well:
And I would have given my soul
 for this
To burn for ever in burning hell.'
 SWINBURNE

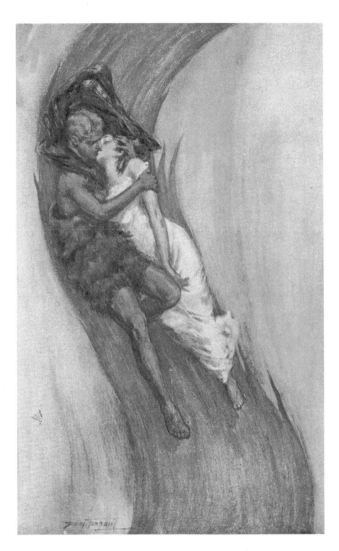

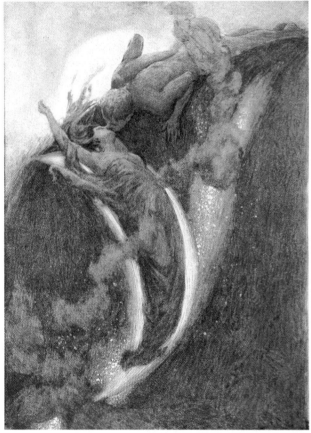

Love's Language Dudley Tennant

How does Love speak? . . .
In the embrace where madness
 melts in bliss,
And in the convulsive rapture of a
 kiss –
Thus doth Love speak.'
 ELLA WHEELER WILCOX

Dawn Dudley Tennant

'Refreshed by his long sleep, the
 Light
Kisses the languid lips of Night, . . .
All glowing from his dreamless rest
He holds her closely to his breast,
Warm lip to lip and limb to limb,
Until she dies for love of him.'
 ELLA WHEELER WILCOX

[141]

A Receipt for Kisses Charles Dana Gibson
1867–1944

'To one piece of dark piazza add a
little moonlight; take for granted
two people. Press in two strong
ones a small, soft hand. Sift lightly
two ounces of attraction, one of
romance; add a large measure of
folly; stir in a floating ruffle and
one or two whispers. Dissolve half
a dozen glances in a well of
silence; dust in a small quantity of
hesitation, one ounce of resistance,
two of yielding; place the kisses
on a flushed cheek or two lips;
flavour with a slight scream, and
set aside to cool. This will succeed
in any climate, if directions are
carefully followed.'

Charles Dana Gibson created the
'Gibson Girl' and the 'Gibson

Man' – lovely, handsome,
incredibly competent and self-
assured. They were the dream of
an American artist and millions
followed his dream.

Women modelled their clothes,
their hair and features on the
Gibson specification. His pictures
carried a message of hope, a
tantalizing search for a superior
life.

The Turning of the Tide Charles Dana
Gibson 1867–1944

'He took her in his arms and his
mouth possessed hers. For a
moment she was too surprised to
feel anything, then as his lips grew
more insistent she felt as if the
world swung dizzily round them,
and they were alone in an
enchanted place.

'She gave him her heart and he
carried her up into the sky and
down into the depths of the sea.'

A Passionate Embrace Ferdinand Freih. van
Reznicek 1868–1909

This shows an excellent prototype
of the passionate, determined
Edwardian seducer. No woman at
the beginning of the century
would dare be close with such a
Casanova without expecting a fate
worse than death.

And how very disappointed she
was if it did not happen!

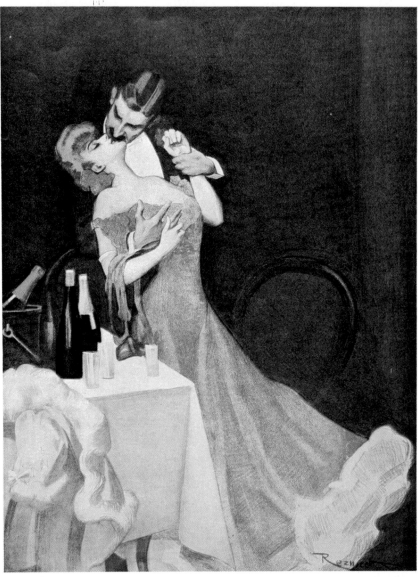

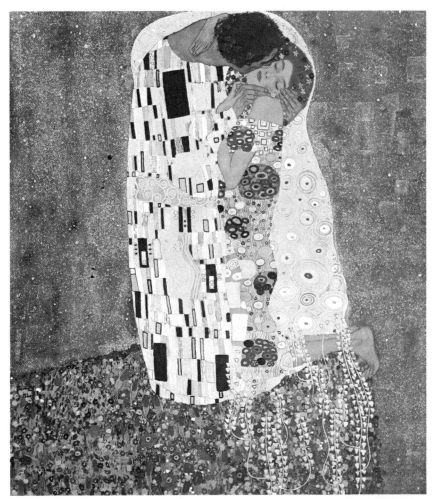

The Story of His Life Charles Dana Gibson
1867–1944

◀ *The Kiss* Gustav Klimt 1862–1918

'A long long kiss, a kiss of youth
 and love.
And beauty, all concentrating like
 rays.
Into one focus kindled from above;
Such kisses as belong to early days,
Where heart and soul and sense in
 concert move,
And the blood's lava, and the pulse
 ablaze.
Each kiss a heart-quake – for a kiss's
 strength,
I think it must be reckoned by its
 length.'

BYRON

The Careful Mamma 1882 ▶

'Now, Mr. Assessor, you may
confess to me all that your heart
feels. Mamma has no objection to
my listening to you, she has even
lent me her large fan.'

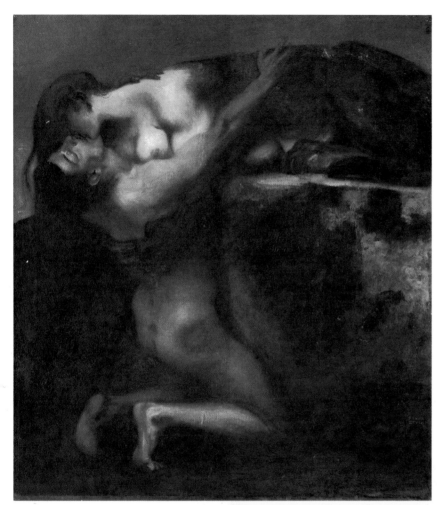

The Kiss of the Sphinx Franz Stuck
1863–1928

Le Langage des Baisers French postcard,
early 20th century

*Timid, frivolous, passionate, amorous,
languorous, voluptuous,* also shy,
innocent, insistent, fiery, possessive,
demanding, tender, gentle, gallant,
wanton, coquettish, enchanting,
fascinating, bewitching, appealing,
tantalizing, tempting, irresistible,
adoring, enslaved, seducing,
glorious, rapturous, ecstatic!

▼French postcard, early 20th century

This extraordinary picture is of a
Sphinx kissing a man.

I have always thought that the
mystical significance of the Sphinx
is that she portrays the two
natures of mankind: the physical
with her animal body, and the
spiritual with her lovely face
seeking eternity. The Egyptian
priests were versed in everything
that was secret and exotic.

I believe the Sphinx has a
message for the world today, if
only we could discover it.

Love's Farewell

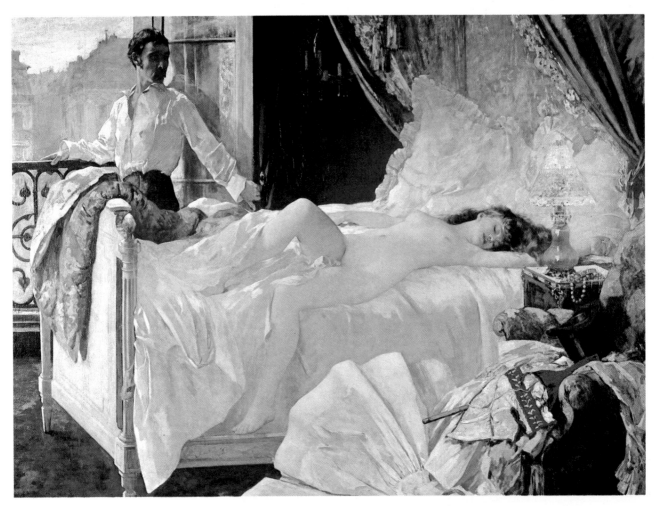

Rolla Henri Gervex 1852–1929

Is the man saying goodbye for the moment or for ever? We know that their love-making was fiery and impulsive, because of her clothes thrown on the chair.

To me this raises the pertinent question: if she had not surrendered so quickly and so ardently, would he have proposed marriage? So much happiness is lost by being too quick too soon.

The wise woman lets a love affair develop slowly, making every moment more intense, more enticing until desire is not a flame easily extinguished, but a fire that lasts.

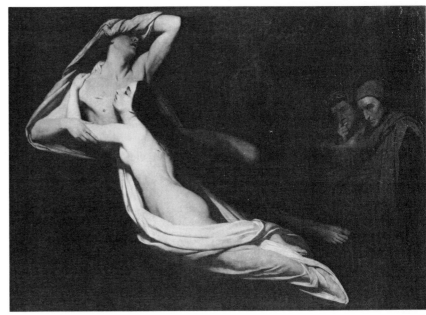

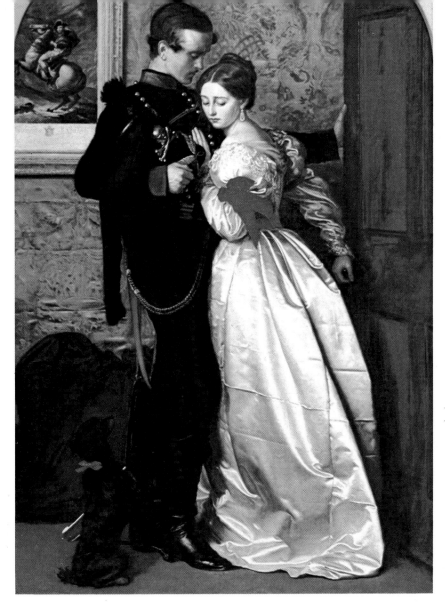

◀ *The Black Brunswicker* John Everett Millais 1829–1896

The scene is Brussels, the night of the Duchess of Richmond's celebrated ball, and the hero, an officer in the famous Russian Cavalry, is saying farewell to his English mistress.

She hopes to delay her lover from going off to Waterloo by holding fast the door he intends to open. Her pet dog is pleading with him to stay. Will her prayers keep him safe? What use are tears when they will not prevent his departure? She has a terrifying presentiment that he will be killed. 'Stay with me! Stay!' she pleads. But she knows it is hopeless.

Then he has gone and she can only cry in her heart.

> 'Yon rising Moon that looks for us
> again
> How oft hereafter will she wax and
> wane;
> How oft hereafter rising look for us
> Though this same Garden – and for
> *one* in vain!'

◀ *Francesca da Rimini* Ary Scheffer 1795–1858

This dramatic portrayal of Paolo and Francesca shows the agony that lovers feel, and expresses even more eloquently the irresistible force of love. They died for their love in 1289 and one wonders today how many people who proclaim their love in the Divorce Courts would really risk death for each other. How many would say with Elizabeth Browning:

> 'I love thee to the depth and
> breadth and height
> My soul can reach, when feeling
> out of sight
> For the ends of Being and ideal
> Grace.'

Ordered on Foreign Service Mezzotint by Charles Algernon Tomkins 1812–1897 after the painting by Robert Collinson 1832–1890 ▶

When will we see each other again? Will he forget? Will he find other women attractive in the foreign land to which he is going?

The woman who is left behind suffers most for she has nothing new to divert her thoughts, only the familiar which is empty and lifeless without him.

> 'Absence! Is not the heart torn by it
> From more than light, or life, or
> breath?
> 'Tis Lethe's gloom, but not its quiet,
> The pain without the peace of
> death.'

Loves I have Sought and Found

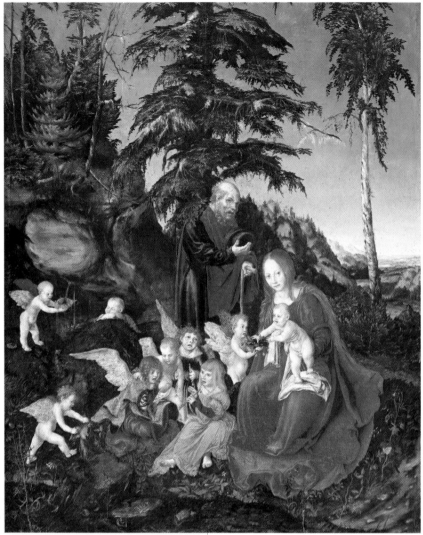

Me at sixteen months
◀ *Rest on the Flight to Egypt* Lucas Cranach 1472–1553

This picture symbolizes for me my love for my family which has always been the foundation stone of my happiness. My father was killed in 1918 but my mother was a guiding influence and my elder brother Ronald, who was the first Member of Parliament to be killed in the war, in 1940, has been my inspiration all through my life.

I like to think of myself as the little girl playing with the angels, and in the photograph above, taken when I was sixteen months, I do look a little like her I think.

I Love my Dogs
Duke is a jet black labrador of the Sandringham strain, an ideal companion, a gun-dog, and also a guardian.

Twi-Twi is a pure white Lion Pekingese from the Imperial Chinese breed, which came to England first in 1861. I love him because he is proud, independent and he protects me by biting newcomers, but:

'A dog will come when you call,
A cat will walk away.
A Pekingese will do what he please
Whatever you may say!'

◀ *The Virgin of the Lilies* Carlos Schwabe 1886–1926

This picture, which I find very moving, makes me think of the loving care I expended on my three children *before* they were born. Like the Ancient Greeks I believe firmly in pre-natal influence. I thought beautiful thoughts, I looked at beautiful things and willed my children to be beautiful, and they were!

My daughter was acclaimed as the most beautiful girl in England, and my sons have a kindness of heart, a sympathy and understanding, for which I thank God every day of my life.

Sir Galahad George Frederick Watts ▶ 1817–1904

Sir Galahad typifies for me the love we all seek, the love which is not only passionate and human, but ecstatically Divine. It is the Holy Grail which stands in a secret shrine in our hearts and for which we seek in every life until we find the person who is the other half of ourselves. Only then are we complete in mind and body.

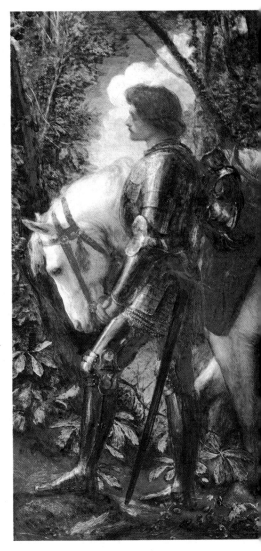

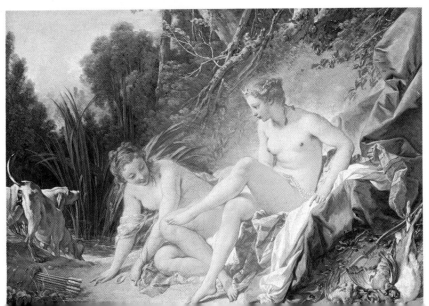

◀ *The Bath of Diana* François Boucher 1703–1770

When Renoir saw this picture he said it was 'the first picture that really captivated me and I have gone on loving it all my life as one loves one's first sweetheart'.

To me it means both beauty and cleanliness, an essential virtue which includes cleanliness of the mind. The British are, on the whole, a dirty race, unlike the Swiss who are so clean it is almost physiological. Beau Brummell cleaned up the eighteenth century.

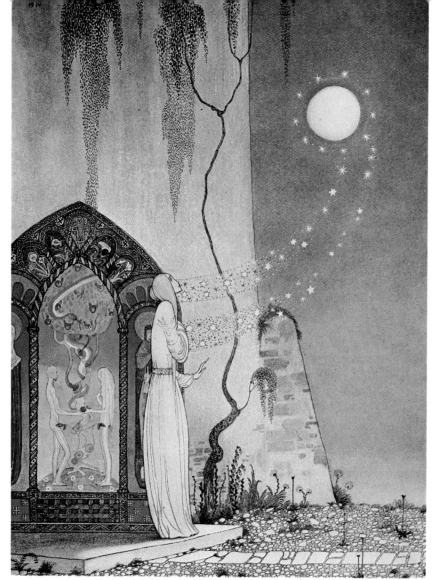

This picture, drawn in 1914, shows
more clearly than any other the
way I find inspiration for my
books and for myself. Love has
guided me, formed my outlook,
my character and my beliefs ever
since I was a child. Then the
direction was unconscious but now
consciously I seek what I need by
prayer, concentration, meditation,
positive thinking, whatever one
wishes to call it.

There is Power to which I can
link myself and draw on, not only
in extremes of fear, danger or
sorrow, but for the little things
which fill all our lives.

It is there when we require it,
a Divine inexhaustible force of
wonder and glory, of comfort and
understanding, of help and
inspiration, of ecstasy and rapture.
And if it is there for me it is there
for everyone else.

The Toilet of Venus Engraving by ▶
François Janinet after François Boucher
1703–1770

This picture portrays my love of
Beauty, and I sincerely believe that
women are put into the World to
make it a lovelier place because
they have passed through it.

Not only the beauty of the face
and the figure matter, although
we should make the very best of
what we have, but the beauty of
the mind and the beauty of the
heart and soul are more important.
The vibrations which come from
us all carry our real selves, for
better, for worse, outside the
confines of the body into the
world beyond.

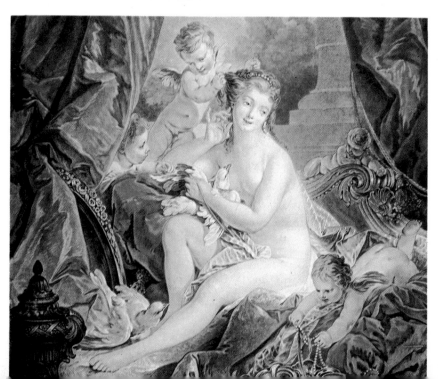

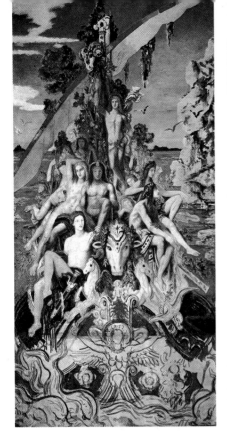

The Argonauts Gustave Moreau 1826–1898

Wild Poppies Claude Monet 1840–1926

Ambition is not just to be rich or important, it is confidence in oneself and a challenge. It is Jason sailing to find the Golden Fleece, the idealism of the First Crusade, the labours of Hercules, the reason Scott went to the North Pole.

This is the stimulus we need not only to develop and improve ourselves, but also the World in which we live. We must never be the weakest link, the parasite, the straggler.

Leaders grow and evolve, and the consolation for the struggle lies not with the reward but in the knowledge that we have not failed our own ideals.

The Plains of Heaven John Martin 1789–1854 ▶

This is a child's view of Heaven, and it is still mine. I forget those astronauts in outer space and think of a beautiful, comforting and happy place like this.

I love flowers because they delight not only the eye but the soul. I believe that women should be like flowers: lovely, colourful, fragrant, bringing into the life of those they love all the softness and tenderness which a man needs.

Men have been taught to be tough, strong, authoritative, but they are also sensitive and vulnerable. They respond to an appeal from a weak creature who needs protection, but they often require protection against the women who impose on them and demand, as a right, more than they are capable of giving.

The aggressive, 'equal-of-a-man' woman of today is de-sexing, emasculating man, and she is also destroying the idealistic, spiritual quality which has made him all through the ages, the chivalrous, gentle, Knight of our dreams.

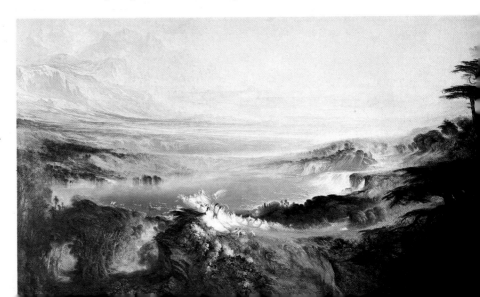

I Love Love

Cover design for *The Proud Princess*
Francis Marshall

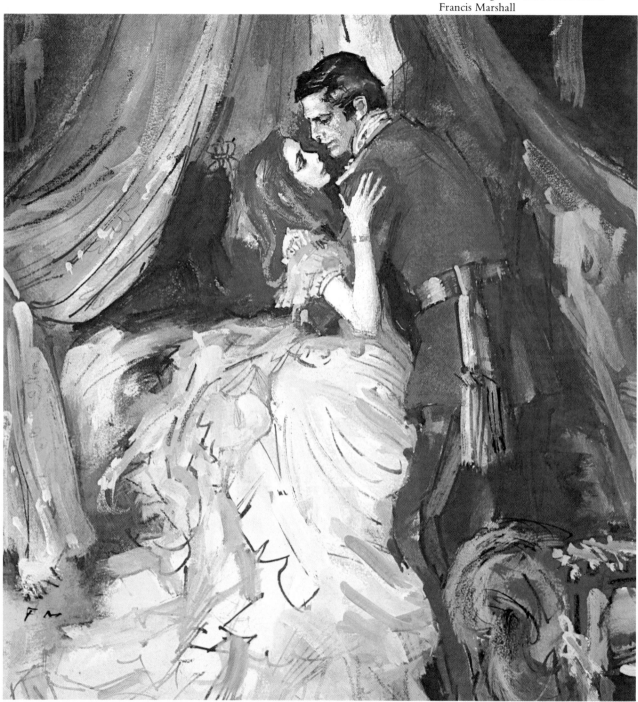

'He kissed her eyes, her cheeks, her ears and the softness of her neck so that she quivered with sensations she had never dreamt existed.

"My wonderful, brave, perfect little wife!" he murmured and pulled aside the top of her gown to kiss her breasts.

Everything seemed to vanish except the insistence and wonder of his lips. She could feel his heart beating.

"You are mine! Mine for eternity and beyond!"

Her body moved beneath his.

Then there was only the ecstasy of their dreams and the Divine glory which came from God.'

Illustrations Acknowledgments

The many museums, art galleries, firms, individuals and photographers who supplied the illustrations are gratefully thanked for their cooperation and are listed below. Every effort has been made to trace the primary source of illustrations; the producers wish to apologise if in any case the acknowledgment proves to be inadequate.

Reverse of frontispiece Francis Marshall. Collection Barbara Cartland

Frontispiece Photo: Norman Parkinson

8–9 Buscot Park, Oxfordshire, The Faringdon Collection Trust. Photo: Cooper-Bridgeman Library

9 Rubenshuis, Antwerp. Photo: Scala

10–11 Museo Arqueologico, Pamplona. Photo: Scala

11 (centre) Museo del Prado, Madrid. Photo: Scala
(right) Carmine Cappella Brancacci, Florence. Photo: Scala

12 (top) Uffizi, Florence. Photo: Cooper-Bridgeman Library
(bottom) Reproduced by permission of the Trustees of the Wallace Collection, London

13 (left) Alte Pinakothek, Munich. Photo: Giraudon
(top right) National Gallery of Art, Washington, D.C. Photo: Salmer
(bottom right) Musée du Louvre, Paris. Photo: Bulloz

14 (top) Real Academia de Bellas Artes de San Fernando, Madrid. Photo: Salmer
(bottom) Museo del Prado, Madrid. Photo: Scala

15 (both pictures) Musée du Louvre, Paris. Photos: Scala

16 (top) Victoria and Albert Museum, London. Photo: Picturepoint–London
(centre) Walker Art Gallery, Liverpool. Photo: Cooper-Bridgeman Library
(bottom) Mary Evans Picture Library

17 (top) Musée du Petit Palais, Paris. Photo: Bulloz
(left) National Gallery of Art, Washington, D.C.
(right) Private Collection. Photo: Maas Gallery, London

18 Mary Evans Picture Library

19 (left) National Gallery of Scotland. Photo: Tom Scott
(right) British Museum, London. Photo: John Freeman Ltd, © Aldus Books
(bottom) Bury Art Gallery and Museum

20 (left) Photo: Derrick Witty
(right) Musée Condé, Chantilly. Photo: Giraudon
(bottom) Musée de Senlis. Photo: Bulloz

21 (top) Musée des Beaux-Arts, Rouen. Photo: Snark International
(bottom) Musée de Versailles. Photo: Service de documentation photographique de la Réunion des Musées Nationaux

22 (top) Leeds City Art Gallery. Photo: Collection John Hadfield
(bottom) Collection Mrs Michael Joseph

23 (top) Private Collection. Photo: Maas Gallery, London
(bottom) Leicestershire Museum and Art Gallery

24 Museum der Bildenden Kunste, Leipzig

25 (left) Victoria and Albert Museum, London. Photo: Angelo Hornak
(top right) Musée Condé, Chantilly. Photo: Bulloz
(bottom right) Mary Evans Picture Library

26 (top) Musée du Louvre, Paris. Photo: Scala
(bottom) Copyright The Frick Collection, New York

27 (top left) Reproduced by permission of the Trustees of the Wallace Collection, London
(top right) Collection Barbara Cartland (bottom) Private Collection. Photo: Claus Hansmann

28 (left) Musée du Louvre, Paris. Photo: Cooper-Bridgeman Library
(right) Uffizi, Florence. Photo: Caisse Nationale des Monuments Historiques

29 (top left and centre) Musée Condé, Chantilly. Photos: Giraudon
(top right) The Metropolitan Museum of Art, Bequest of Mrs H. O. Havemeyer, 1929. The H. O. Havemeyer Collection
(bottom left and right) Musée Condé, Chantilly. Photos: Giraudon
(bottom centre) National Gallery of Scotland

30 (left) Detroit Institute of Arts. Photo: Joseph Klima, Jr.
(top right) Bibliothèque Nationale, Paris. Photo: Giraudon
(bottom right) Photographed from *The Compleat Lover* by Derek and Julia Parker, published by Mitchell Beazley Ltd

31 (top) Guildhall Art Gallery, City of London. Photo: Cooper-Bridgeman Library
(bottom) Mary Evans Picture Library

32 (both pictures) Reproduced by courtesy of the Trustees, The National Gallery, London

33 (top left) Bayerisches National-museum. Photo: Claus Hansmann
(top right) Mary Evans Picture Library
(centre) Photographed from the drawings of Charles Dana Gibson, published by John Lane
(bottom) Reproduced by courtesy of the Trustees, The National Gallery, London

34 (left) The Lady Lever Art Gallery, Port Sunlight
(right) Depositi della Soprintendenza, Florence. Photo: Salmer
(bottom) Copyright reserved. Photo: A. C. Cooper

35 (left) Museo d'Arte Moderna, Venice. Photo: Cooper-Bridgeman Library
(right) Museo del Prado, Madrid. Photo: Scala
(bottom) Museo del Prado, Madrid. Photo: © Museo del Prado

36 (left) Alte Pinakothek, Munich. Photo: Michael Holford
(right) Kunsthistorischesmuseum, Vienna. Photo: Cooper-Bridgeman Library

Index

Figures in *italics* refer to illustrations.